Nikon® D70
Digital Field Guide

Nikon® D70 Digital Field Guide

David D. Busch

WILEY

Wiley Publishing, Inc.

Nikon® D70 Digital Field Guide

Published by
Wiley Publishing, Inc.
111 River Street
Hoboken, N.J. 07030
www.wiley.com

Copyright © 2005 by Wiley Publishing, Inc., Indianapolis, Indiana

Published simultaneously in Canada

ISBN-13: 978-0-7645-9678-0
ISBN-10: 0-7645-9678-0

Manufactured in the United States of America

10 9 8 7 6 5 4 3 2 1

1K/RZ/QX/QV/IN

For general information on our other products and services or to obtain technical support, please contact our Customer Care Department within the U.S. at (800) 762-2974, outside the U.S. at (317) 572-3993 or fax (317) 572-4002.

Wiley also publishes its books in a variety of electronic formats. Some content that appears in print may not be available in electronic books.

Library of Congress Control Number: 2005923203

About the Author

David D. Busch was a roving photojournalist for more than 20 years, who illustrated his books, magazine articles, and newspaper reports with award-winning images. He's operated his own commercial studio, suffocated in formal dress while shooting weddings-for-hire, and shot sports for a daily newspaper and an upstate New York college. His photos have been published in magazines as diverse as *Scientific American* and *Petersen's PhotoGraphic,* and his articles have appeared in *Popular Photography & Imaging, The Rangefinder, The Professional Photographer*, and hundreds of other publications. He currently reviews digital cameras for CNET.com and *Computer Shopper*.

When About.com recently named its top five books on Beginning Digital Photography, occupying the #1 and #2 slots were Busch's *Digital Photography All-In-One Desk Reference For Dummies* and *Mastering Digital Photography.* His 78 other books published since 1983 include best-sellers *The Official Hewlett-Packard Scanner Handbook* and *Digital Photography For Dummies Quick Reference.*

Busch earned top category honors in the Computer Press Awards the first two years they were given (for *Sorry About The Explosion* and *Secrets of MacWrite, MacPaint and MacDraw*), and later served as Master of Ceremonies for the awards.

Credits

Acquisitions Editor
Michael Roney

Project Editor
Cricket Krengel

Technical Editor
Michael D. Sullivan

Copy Editor
Elizabeth Kuball

Editorial Manager
Robyn Siesky

Vice President & Group Executive Publisher
Richard Swadley

Vice President & Publisher
Barry Pruett

Project Coordinator
Maridee Ennis

Graphics and Production Specialists
Lauren Goddard
Denny Hager
Jennifer Heleine
Amanda Spagnuolo

Quality Control Technician
Brian H. Walls

Cover Design
Michael Trent

Proofreading and Indexing
Arielle Mennelle
Steve Rath

For Cathy

Acknowledgments

Thanks to Mike Roney, who is always a joy to work with, for his valuable input as this book developed; to Cricket Krengel for keeping the project on track; and to tech editor Mike Sullivan, whose more than a decade of experience shooting Nikon-based digital cameras proved invaluable. Mike also contributed some of the best photos in the book. If you get the urge to eat strawberries after reading Chapter 6, you'll know whom to blame!

Finally, thanks again to my agent, Carol McClendon, who once again found me a dream job at exactly the right time.

Contents at a Glance

Contents

Chapter 5: All About Lenses 77

Chapter 6: Photo Subjects 101

**Chapter 7: Downloading
and Editing Pictures 211**

Introduction

What a breakthrough the Nikon D70 has been for digital-photography enthusiasts in general, and Nikon fans specifically! Prior to 2004, when the D70 and its Canon rival, the Digital Rebel, became available, digital single lens reflex cameras (dSLRs) were well beyond the reach of the average serious amateur photographer. Indeed, even part-time pros struggling with a shoestring budget were hard-pressed to justify the $2,000 minimum investment for a decent digital SLR camera like the Nikon D100.

For most of us, a dSLR was something we all desired but couldn't justify. Today, we're living in a different world, one in which anyone with just $1,000 can afford a dream camera. For about the same price as an electronic-viewfinder-equipped camera with non-interchangeable lens, it's now possible to buy an SLR with a 6-megapixel sensor that will outperform anything else in its price range, including film-based cameras.

The Nikon dSLR Revolution

Five years from now, you'll look back and see just how important the D70 was in changing the face of photography. It's a safe bet that this camera will be remembered warmly as a classic. Although Kodak led the initial charge, Nikon has been involved in digital-camera research since the mid-1980s. In 1986, it showed a prototype called the Nikon SVC, which had a 300,000-pixel sensor and saved images to a 2-inch floppy disk. The QV-1000C (with just 380,000 pixels) followed two years later. These early digital SLRs were possible thanks to the removable back panel of Nikon film SLRs, which could easily be replaced with a digital sensor.

Although Kodak offered a succession of digital SLRs based on Nikon camera bodies, Nikon didn't seriously begin competing in the digital SLR market on its own until Kodak branched out and began offering cameras based on Canon bodies, too. Partnering with Fuji in 1994/1995, Nikon created the E2/E3 series. These used a clumsy optical reduction system to allow existing Nikon lenses to produce a field of view similar to that offered by film cameras, despite the smaller sensor size.

Naturally, $20,000 1.4-megapixel cameras didn't compete well with other models, especially because the Kodak DCS 460 offered 6-megapixel resolution as far back as 1995. The modern age of Nikon digital SLRs finally arrived in 1999 with the Nikon D1, which offered 2.74 megapixels and was enthusiastically embraced by professional photographers. A slew of pro-level D1/D2-series cameras followed, culminating in the 12.4 megapixel D2x, which first became available in early 2005.

All these $5,000 to $10,000 (and up) professional models just whetted the appetites of those who were weaned on sub-$1,000 Nikon film bodies and were anxious to move into the digital realm without giving up any killer features such as autofocus, matrix metering, and tack-sharp interchangeable lenses. While the first Nikon D100 was tempting at its initial price of $3,000, the price tag was still too high for anyone who couldn't justify the camera as a business expense. What photo enthusiasts really wanted was a camera at the magical $1,000 price point.

The first shot fired in the consumer dSLR revolution came from a Canon. Introduced in late 2003, the Canon EOS Digital Rebel was priced at $899 for the body alone, or $999 with a serviceable 18–55mm zoom lens. Nikon upped the ante a little a few months later by announcing the D70, which was priced a few hundred dollars higher and had a few features lacking in the first Digital Rebel. Both Nikon and Canon fans as well as owners of other camera lines were winners in this skirmish, as other camera vendors began to offer new and improved models in the hotly contested $1,000 price range.

The D70, and its updated model, the D70s, remains one of the best sellers in this class, although the new Canon Digital Rebel 350 XT is likely to give the Nikon a run for its money. An even lower-cost Nikon model with fewer features, the D50, was introduced as this book was going to press. This bargain-basement dSLR should make the competition even more interesting.

The D70's Advantages

If you visit the online forums, you'll find endless debates on which digital SLR in the $1,000 price range is the best. Rather than enter the debate here (if you're reading this, you've almost certainly decided in favor of the Nikon camera), it makes more sense to provide a brief checklist of the Nikon D70's advantages.

Note

Throughout this book, when I refer to the D70, I mean both the original D70 and the virtually identical D70s, unless I'm talking about a distinctive feature of the newer model, such as the corded remote control.

Nikon lenses

The D70 offers a vast number of Nikon lenses. Other dSLRs may be able to use only a limited number of lenses made especially for them. Not all Canon lenses work on all Canon digital SLRs, for example.

In contrast, nearly all the lenses offered for Nikon SLRs since 1959 can be used with the Nikon D70. There's little incentive to use some of the earliest lenses — unless you already own them — because lenses produced before 1977 need a $35 conversion to avoid damaging the D70 body, and even then they operate only in manual-focus and manual-exposure modes.

But there are hundreds of newer lenses ("newer" being less than 25 years old), many at bargain prices, that work just fine on the D70. For example, one prized Nikon

70–300mm lens can be found used for about $100. A Benjamin will also buy you a 50mm f1.8D AF that's probably one of the sharpest lenses you'll ever use, or a Nikon 28–100mm zoom lens. The 18mm–70mm kit lens, available separately for around than $300, is a bargain at that price. Third-party vendors such as Sigma, Tokina, and Tamron, offer a full range of attractively priced lenses with full autofocus and auto-exposure functionality.

Full feature set

You don't give up anything in terms of features when it comes to the Nikon D70. Some vendors have been known to "cripple" their low-end dSLR cameras by disabling features in the camera's firmware (leading to hackers providing firmware "upgrades" that enable the features).

The D70, on the other hand, actually had a significant number of improvements over the more expensive D100, including a larger memory buffer and faster storage, improved metering, and a top shutter speed that was twice as fast. Indeed, the D70 proved to be a de facto replacement for its more costly sibling because it offered such a complete feature set at a lower price.

Fast operation

The Nikon D70 operates more quickly than many other digital SLRs. It includes a memory buffer that's more than twice as large as the one found in, say, the Nikon D100, so you can shoot continuously for a longer period of time (14 or more JPEG shots in a row, at minimum). It also writes images to the memory card up to twice as fast. Many D70 users report being able to fire off shots as quickly as they can press the shutter release for as long as their index finger (or memory card) holds out.

One popular low-end dSLR takes as long as 3 seconds after power-up before it can take a shot. If you don't take a picture for a while, it goes to sleep and you have to wait another 3 seconds to activate it each time. The D70 switches on instantly and fires with virtually no shutter lag. (Actually, it uses so little juice when idle that you can leave it on for days at a time without depleting the battery much.) Performance-wise, the D70 compares favorably with digital cameras costing much more. Unless you need a burst mode capable of more than 3 frames per second, this camera is likely to be faster than you are.

Great expandability

There are tons of add-ons you can buy that work great with the D70. These include bellows and extension rings for close-up photography, and at least three different electronic flash units from Nikon and third parties that cooperate with the camera's through-the-lens metering system. Because Nikon SLRs have been around for so long, there are lots of accessories available, new or used, and Nikon cameras are always among the first to be served by new gadgets as they're developed.

Digital Challenges

As you use your D70 and learn more about its capabilities, you'll want to keep in mind the challenges facing this pioneer in the low-cost dSLR arena. The Nikon D70 and other digital SLRs have advantages and disadvantages over both film cameras and non-SLR digital shooters.

Here are some of the key points to consider:

+ **ISO sensitivity and noise:** Most non-dSLR digital cameras offer ISO settings no higher than ISO 400, and may display excessive noise in their images at settings as low as ISO 200. The larger sensor and less noise-prone larger pixels in the D70 provide good quality at ISO 800, and relatively little noise at ISO 1600. This is true of all dSLRs, but the D70 does a particularly good job with noise. The D70 also has an effective noise-reduction feature. One adjustment you'll make in learning to use this camera is how to work with higher sensitivity settings while avoiding excess noise.

+ **Depth of field control:** As with all dSLRs, the longer lenses used provide less depth of field at a particular field of view, which, when you want to use depth of field as a creative element, is a very good thing, indeed. If you've used only non-SLR cameras before, you'll want to learn how to use selective focus and, especially, how to use the depth of field preview button.

+ **The lens multiplier factor:** The D70's sensor is smaller than a 35mm film frame, so the image from any lens you mount is cropped, producing a 1.5X multiplier factor. A 200mm lens is magically transformed into a 300mm telephoto, but the flip side of that is that a 28mm lens that's a wide-angle optic on a full-frame camera becomes a 42mm normal lens on the D70. To get true wide-angle coverage, you'll need a prime (non-zoom) or zoom lens that starts at 17mm to 18mm, like the kit lens. Superwide lenses, such as the $1,000 Nikon 12–24mm zoom, are expensive and even more difficult to justify.

+ **Intuitive controls:** The Nikon D70 works more like a "real" camera, which is a boon for photo enthusiasts who prefer that their shooter work more like a film SLR and less like a DVD player. Wouldn't you really rather zoom in and out by twisting a zoom ring on the lens itself, rather than pressing a rocking button while a tiny motor does the job for you? Do you prefer navigating a multilevel menu to change the white balance, or would you rather press the WB button and spin a dial on the back of the camera?

+ **Dirt and dust:** Small dust specks barely enter the consciousness of point-and-shoot digital owners and are usually minor annoyances in the film world, at least until it comes time to make a print from a negative or slide. But nearly invisible motes are the bane of D70 owners, because no matter how careful you are when changing lenses, sooner or later a dust spot or two will settle on the sensor. This dust is generally not difficult to remove and may not even show up except in photos taken with a small f-stop, but the mere threat drives many D70 owners crazy. Sensor dirt needn't be a

major issue, but any new D70 owner should be armed with an air bulb and other tools to keep that imager clean.

✦ **No LCD preview or composing:** If you're coming to the D70 from the non-SLR digital world, one of the first things you'll notice is that the LCD on a dSLR can be used only for reviewing photos or working with menus. There is no live preview, which usually isn't a problem until you want to preview an image taken through an infrared filter (which appears totally black to visible light), or use the LCD to frame a picture when holding the camera overhead or at waist level.

Quick Tour

Your Nikon D70 or D70s is good to go right out of the box. You can begin taking great pictures immediately, assuming you've charged the battery, inserted a digital memory card, and remembered to take off the lens cap!

This Quick Tour tells you everything you need to know to begin using the D70's basic features immediately. And, by the end of the Quick Tour, you'll already be taking great pictures with your D70. Once you've gotten a taste of what your camera can do, you'll be ready for later chapters that explain the more advanced controls and show you how to use them to capture good images in challenging situations, or to apply them creatively to create special pictures.

This Quick Tour assumes you've already unpacked your D70, mounted a lens, charged and installed the battery, and inserted a memory card; it also assumes you have a basic understanding of things like focusing, shutter speeds, and f-stops. If you've reviewed the manual furnished with the camera, so much the better. (You'll definitely need to do so to work with later chapters in this book.)

Note *Because the differences between the Nikon D70 and D70s are so slight, I'll use the term D70 to refer to both of them throughout this book, except when discussing a feature that is not exactly the same with both versions of this model.*

Selecting a Picture-Taking Mode

Once your D70 is powered up, you should choose a picture-taking mode for your first pictures. The mode dial is located at the left end of the top panel, where the rewind lever is located on most manual film cameras.

In This Quick Tour

Selecting a picture-taking mode

Using automatic or manual focus

Taking the picture

Reviewing the image

Correcting exposure

Transferring images to your computer

Note *If you're happy to let the camera do all the work and you really can't wait to take some pictures, set the camera's mode dial to P (programmed exposure) or A (full automatic) and skip the rest of this section.*

There are seven modes that Nikon calls the Digital Vari-Program (DVP) modes, which limit your fine-tuning choices. These modes create some basic settings that are specifically suited to particular types of pictures. More commonly called scene modes outside the Nikon world, these seven modes

are useful when you're just getting started using the D70, or when you're in a hurry and don't have time to set basic settings yourself. When you use one of the DVP/scene modes, you can be confident that you'll get pretty good results most of the time.

Cross-Reference *More information on all modes can be found in Chapter 1.*

✦ **Full Auto.** *When to Use:* When you want good results without making decisions, as when you hand your D70 to a friend and say, "Here, take my picture!'"

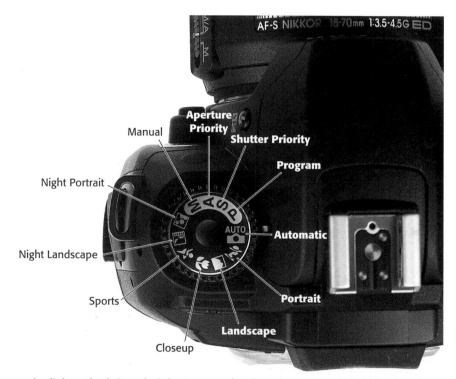

QT.1 The mode dial on the left end of the top panel (when the camera is held in shooting position) is used to select your shooting mode.

Don't Use: If you want every picture in a series to be exposed exactly the same. If you change shooting angles or reframe your image, the D70 might match your shot with a different image in its database and produce a slightly different (but still "optimized") look.

+ **Portrait.** *When to Use:* When you're taking a portrait of a subject standing relatively close to the camera, and to optimize focus, sharpness, flash red-eye protection, and tones to produce flattering people pictures.

Don't Use: If your portrait subject is *not* the closest object to the camera.

+ **Landscape.** *When to Use:* When you want extra sharpness and rich colors of distant vistas.

Don't Use: If you need to use flash as a fill-in to illuminate shadows in subjects relatively close to the camera who are posing in front of your vistas, as this mode disables the built-in flash.

+ **Close Up.** *When to Use:* When you're shooting close-up pictures of a subject from 1 foot or less, and the subject is centered in the viewfinder.

Don't Use: If you want to use focus creatively.

+ **Sports.** *When to Use:* When you're shooting fast-moving action and want to freeze your subjects.

Don't Use: If you want to incorporate a little blur into your photos to create a feeling of motion.

+ **Night Landscape.** *When to Use:* When you have a tripod available and want to shoot pictures outdoors in dim illumination.

Don't Use: If you don't have a tripod or other way to steady the camera during long exposures.

+ **Night Portrait.** *When to Use:* When you want to illuminate a subject in the foreground with flash, but still allow the background to be exposed properly.

Don't Use: If you're unable to hold the camera steady, or you can't use a tripod or other steadying device. Exposures can be long in this mode.

In addition to these seven DVP modes, four other modes inhabit the dial.

+ **Program.** *When to Use:* When you want your camera to make the basic settings, while still allowing you to have full control over these adjustments to fine-tune your picture.

Don't Use: If you haven't learned how or when to override the camera's decisions.

+ **Shutter Priority.** *When to Use:* When you want to use a particular shutter speed, usually to freeze or blur moving objects, and want the D70 to select the lens opening for you automatically.

Don't Use: If there is insufficient light or too much light to produce a good exposure at the preferred shutter speed.

✦ **Aperture Priority.** *When to Use:* When you want to use a particular lens opening, usually to control how much of your image is in sharp focus, and want the D70 to select a shutter speed for you automatically.

Don't Use: If there is insufficient light to produce a good exposure at your preferred lens opening; blurry photos can result. Conversely, Aperture Priority is not a good choice if there is too much light for your selected aperture with the available range of shutter speeds.

✦ **Manual.** *When to Use:* When you want full control over the shutter speed and lens opening to produce a particular tonal effect, or are using a lens that is not compatible with the D70's metering system.

Don't Use: If you are unable to measure or guess exposure properly.

Using Automatic or Manual Focus

To use autofocus, you must be using a Nikkor autofocus lens, designated with an AF in its product name, as in AF, AF-S, AF-I, and so forth. Older lenses as well as some current inexpensive and specialized lenses (such as those with the AI-S designation) are manual-focus only.

The camera body has a lever next to the lens mount that can be set to M (for manual focus) or AF (for autofocus). In addition, some lenses, including the 18-70mm kit lens, have their own levers. In this case, set the camera body lever to AF, and use the lens control to adjust focus mode. The M/A designation on the lens is used to remind you that focus can be manually overridden (by turning the outermost ring on the lens barrel) or left alone for the D70 to provide focus. The M position on the lens barrel means that focus will be set manually at all times.

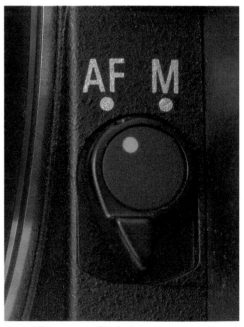

QT.2 The camera body focus-mode selector.

If you've chosen one of the DVP/scene modes (except Close Up), the D70 always chooses the focus area for you, using the Closest Subject method that selects the focus zone based on the object closest to your camera.

 Cross-Reference *You learn how to set focus zones in Chapter 1.*

To focus manually, twist the focus ring on the lens, as you would with a film SLR. To set focus automatically, partially depress the shutter-release button. If the D70 is set on automatic focus when using an AF lens, it will lock into sharp focus. Brackets in the viewfinder that represent the area used to calculate focus will flash red, and that green light in the viewfinder will glow, as long as the lens has a maximum aperture of f/5.6 or larger (f/5.6 to f/1.4).

If you want the focus and exposure to be locked at the current values (so you can change the composition or take several photographs with the same settings) hold down the AE-L/AF-L button.

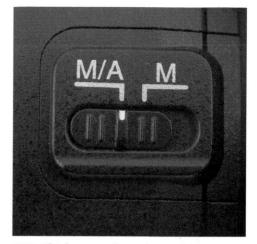

QT.3 The lens autofocus/manual lever.

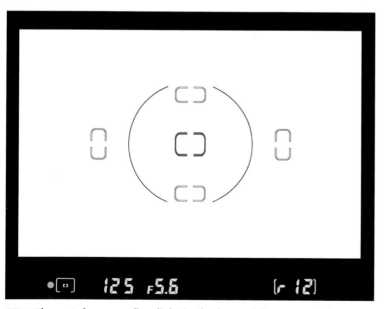

QT.4 The autofocus confirm light in the lower-left corner of the viewfinder.

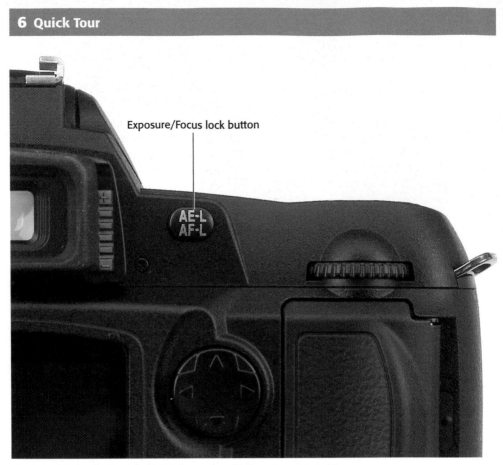

Exposure/Focus lock button

QT.5 Hold down the AE-L/AF-L button to lock exposure and focus.

Taking the Picture

Go ahead and press the shutter button all the way down. After the shutter is tripped and the mirror flips back into viewing position, the photo you just took will be displayed on the LCD on the back of the camera, unless you've turned off review display.

Cross-Reference *Learn how to change the review and playback options in Chapter 1.*

Press the trashcan icon if you want to delete the picture you just took. A message saying, "Delete? Yes" pops up. Press the trashcan icon again to permanently delete the image. Reviewing and deleting images are covered later in this Quick Tour.

A few more options

There are a few more options you might want to activate for your first pictures. Here's a quick tour of the most common features you might want to use.

Applying depth of field preview

The D70 has a button called the depth of field (DOF) preview that temporarily changes the lens opening to the one that is currently selected by the exposure system if you press

the shutter-release button now. Use the DOF preview to get a better idea of the range of sharp focus as it will appear in your final image.

The button is located on the body, under the right side of the lens (as you hold the camera). To use it, press the button, and the amount of your subject matter in sharp focus will more closely resemble what you'll get in the finished picture. Release the DOF preview button to restore the original bright view.

Using the self-timer and remote

Sometimes you'll want to delay taking the photo for a few seconds, or trigger the camera from a few feet away. Or, perhaps you're taking a long exposure and don't want to risk jiggling the camera when you press the shutter-release button. The self-timer provides this delay.

Cross-Reference *Learn how to change the self-timer's delay to 2, 5, or 20 seconds in Chapter 2.*

To use the self-timer, follow these steps:

1. **Press and hold the shooting mode button.**

2. **Spin the command dial (on the upper-right corner of the back of the camera) while watching the monochrome LCD display on top.**

3. **Stop when the Self-Timer icon appears.**

4. **Compose your photo and, when ready, press the shutter-release button all the way down.** The self-timer starts, with an accompanying beep and blinking light on the front of the camera to warn you that a picture is about to be taken. About 2 seconds before the exposure is made, the lamp stops blinking and the beeping speeds up.

Depth of field preview button

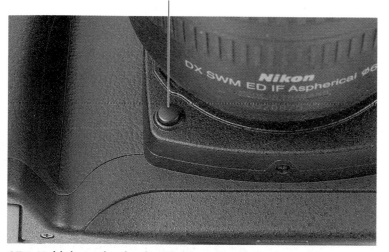

QT.6 Hold down the depth of field preview button to see how much of your image will be in sharp focus at the current lens opening.

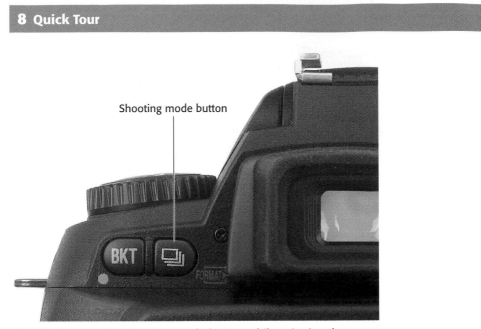

Shooting mode button

QT.7 Hold down the shooting mode button while spinning the command dial to choose the self-timer feature.

Tip *The D70 returns to its previous shooting mode after the picture was taken with the self-timer. You need to repeat the previous set of steps if you want to take another delayed photo. Nikon recommends covering the viewfinder eyepiece with the eyepiece cap to prevent light entering through the eyepiece, which could confuse the exposure meter. However, this extraneous light is seldom a problem unless a bright light source is coming from directly behind the camera.*

The D70 can also be triggered using the optional ML-L3 infrared remote, which works only from in front of the camera, because the infrared sensor is on the front panel, just above the D70 logo. The range

is about 16 feet. To activate the remote, use the same steps outlined earlier, but spin the command dial until either the delayed remote (a 2-second pause) or quick response remote (immediate activation) icons appear. The D70s can use the MC-DC1 Remote Cord, which plugs into the camera.

QT.8 The self-timer icon appears in the monochrome LCD display.

Delayed remote icon Quick response icon

QT.9 The delayed remote and quick response remote icons will appear on the monochrome LCD.

Reviewing the Image

You can review the images you've taken at any time. Hold down the playback button and press the up and down buttons on the multi selector to move forward and backward among the stored images. The display "wraps around" so that when you have viewed the last image on your memory card, the first one will be shown again. The left and right buttons change the type of information about each image that is displayed on the screen.

In addition, you can perform the following functions with the other buttons shown in Figure QT.10:

+ Press the playback button to cycle among display of a single full-sized

image, four thumbnails, or nine thumbnails on the LCD.

+ When viewing thumbnails, you can use the multi selector to navigate among the miniature images to highlight any of them. Then press the playback button again to enlarge the selected image to full size.

+ Press the playback zoom button to zoom in on a selected image. The multi selector will let you move the zoomed area around within the full-sized image.

+ Press the protect button to protect the selected image from accidental erasure.

+ Press the delete button to erase the selected image.

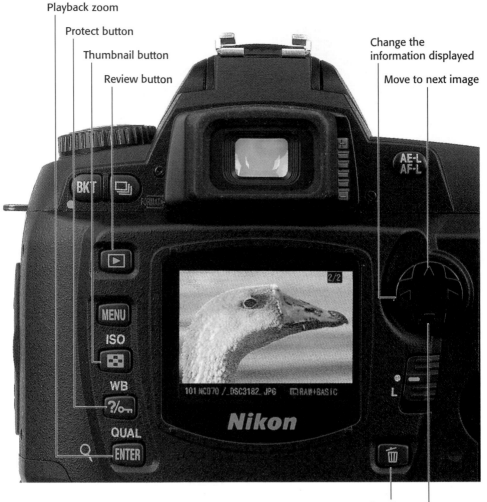

Playback zoom

Protect button

Thumbnail button

Review button

Change the information displayed

Move to next image

101 NC070 /_DSC3182. JPG RAW+BASIC

Delete button

Move to previous image

QT.10 Use the playback button and up and down keys to review the images on your memory card.

Correcting Exposure

Press the exposure compensation button (shown at the top in Figure QT.11) and rotate the command dial to the left (to reduce exposure) or to the right (to increase exposure). You'll see a display in the viewfinder like the one at the bottom of Figure QT.11, with the plus or minus exposure highlighted on a scale.

Each increment on the scale represents either one-third or one-half of an EV (exposure value). Each EV value is equivalent to doubling or halving the size of the lens opening, or doubling or halving the length of time the shutter is open. Try adding or subtracting one increment at first, and increase or decrease as necessary until the exposure suits you.

Exposure compensation button

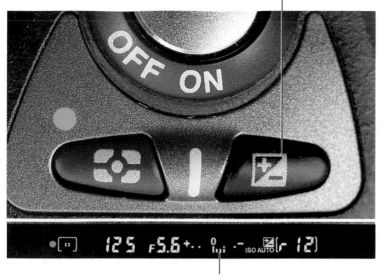

Viewfinder EV readout

QT.11 Hold down the Exposure Compensation button and spin the command dial to increase or decrease exposure.

Transferring Images to Your Computer

When you finish with a picture-taking session, you'll want to transfer the images from your memory card to your computer. You can link your D70 to your computer directly using the supplied USB cable or remove the memory card from the camera and insert it into a card reader.

To connect using the USB cable:

1. **Turn the camera off.**

2. **Pry back the rubber cover that protects the D70's USB port, and plug the USB cable furnished with the camera into the USB port.**

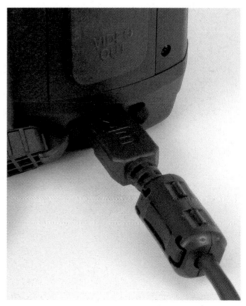

QT.12 Connect one end of the D70's USB cable to the camera, and plug the other end into a USB port on your computer.

3. **Connect the other end of the USB cable to a USB port on your computer.**

4. **Turn the camera on.** Your installed software will detect the camera and offer to transfer the pictures, or the camera may appear on your desktop as a mass storage device, allowing you to drag-and-drop the files to your computer.

To connect using a card reader:

1. **Turn the camera off.**

2. **Open the CompactFlash card door and press the gray button, which ejects the card.**

3. **Insert the card into your memory card reader.** Your installed software will detect the files on the card and offer to transfer them. The card may also appear as a mass storage device on your desktop, which you can open and then drag-and-drop the files to your computer.

The files created by the D70 are automatically assigned names, such as DSC_439.jpg (for JPEG files) and DSC_4321.nef (for RAW files).

 When using the D70 in Auto mode, the built-in electronic flash may pop up when needed. You can turn off this behavior in the Custom Menu Settings.

Using the Nikon D70

Exploring the Nikon D70

If you've taken your first picture or two (or 200!) with your Nikon D70 or Nikon D70s, you're probably eager to learn more about your camera's features and how to use them. The Quick Tour covered just the basics you need to know to get started. This chapter delves a little more deeply into the key features of the camera, what they're for, and how to use them.

I'm going to avoid the deadly trap that most camera manuals fall into when they provide three or four views of a camera (usually front, back, top, and perhaps side or bottom) and label everything willy-nilly without giving you a clue about what each control actually is used for. If you want to know where a specific button is located, you have to search for it in *Where's Waldo?* fashion amongst a thicket of labels. Then you may have to thumb through the manual to see exactly what the control does.

Although you've probably attempted to learn about your D70's buttons and wheels with the manual's confusing diagrams, this chapter's illustrations are more accessible roadmaps that will help you sort through the D70's features and controls much more quickly, especially when you're out in the field taking photos.

This chapter does not cover the D70's menu system. It concentrates on the buttons, dials, and other controls that you can access directly, without visiting menus. Some of the settings discussed in this chapter, such as flash options or white balance, are duplicated in the menus or have additional options available in there.

 Cross-Reference *You can learn more about the D70's menu setup options in Chapter 2.*

Up Front

The front panel of the Nikon D70 is shown in figure 1.1. You can't see all the buttons and controls from a straight-on perspective, so I'll show you separate, three-quarters-view looks at each half of the front panel, which I've color-coded red (the left side of the camera when looking at it head-on) and green (the right side of the camera from this angle). While this illustration shows the D70, the D70s is identical except for the model number plate.

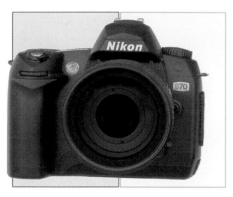

1.1 The "business end" of the Nikon D70.

The easiest way to hold the D70 is by wrapping your fingers of your right hand around the hand grip, with the left hand providing support and usually activating most of the controls. However, there are a few controls within the reach of the right hand's digits, as shown in figure 1.2. These controls and features include the following:

✦ **The handgrip:** The grip is the housing for the D70's battery, and also serves as a comfortable hand-hold for your fingers.

✦ **Depth of field preview:** This is a small button (see the figure) next to the lens mount. Press and hold

the depth of field preview button. The lens stops down to the taking aperture, the view through the finder may dim a little (or a lot), and you can see just how much of the image is in focus.

✦ **Sub-command dial:** This is a *secondary* control dial used to supplement the main command dial on the back of the D70. It's used when two different, related settings can be made, as in manual exposure mode when the shutter speed is set using the main command dial, and the aperture is adjusted using the sub-command dial. Another example of this use is in setting the white balance (which controls how the D70 reacts to illumination sources of different colors, such as daylight and incandescent light). The main command dial flips among the different light-source types, while the sub-command dial fine-tunes those settings. Although you can "swap" the command dials (turning the sub-command dial into the command dial, and vice versa) using the D70's menus, it's best to leave them in their default configuration to start out.

✦ **Front lamp:** This front-mounted source of illumination serves three different functions. Under dim lighting conditions that make auto-focusing difficult, this light source can be set to cast a little extra light on your subject to assist the auto-focus system. If you've set your camera to self-timer mode, so that a picture is taken after a short delay (or if you're using the optional remote control in delay mode), the lamp blinks in a pattern as a sort of countdown to the

eventual exposure. Finally, this lamp also can send out a little blast of light shortly before a flash exposure, which can serve to close down the pupils of your subjects' eyes, and reduce the demon red-eye effect.

Note *Nikon Speedlights as well as the Nikon SC-29 Speedlight cable have their own less-obtrusive focus assist lights that can take over for the one built into the camera.*

✦ **Shutter release:** Canted atop the handgrip are the shutter-release button and power switch.

The other side of the D70 has a few more controls, as shown in figure 1.3. These include the following:

✦ **Flash multi-button:** Nikon has kept the D70's design clean by assigning multiple functions to many buttons, and this flash control is one of them. It serves three different purposes, even though Nikon calls it the Flash Exposure Compensation button. Pressing the button when the built-in electronic flash is in its down/stowed position causes the flash to flip up (as shown in figure 1.4), ready for use. Holding this button while

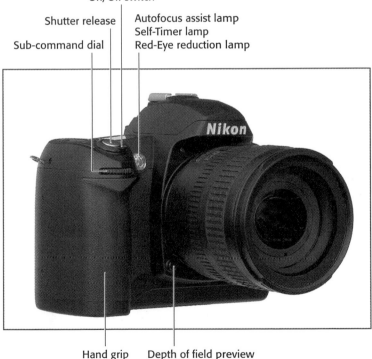

On/Off switch

Shutter release
Sub-command dial

Autofocus assist lamp
Self-Timer lamp
Red-Eye reduction lamp

Hand grip Depth of field preview

1.2 Nikon D70 left front side, viewed from the subject's position.

spinning the command dial on the back of the camera changes among flash sync modes, such as red-eye reduction, or slow sync (which combines flash and a regular exposure to lighten backgrounds). Holding this button while spinning the sub-command dial adds or subtracts from the flash exposure, making your flash picture a little lighter or darker, as you prefer.

✦ **Infrared receiver:** This is a dark red window (opaque to visible light) that captures a signal from the optional remote control. Because it's on the front of the camera you must use the remote from the front position.

✦ **Lens release:** Press and hold this button to unlock the lens so you can rotate the lens to remove it from the camera.

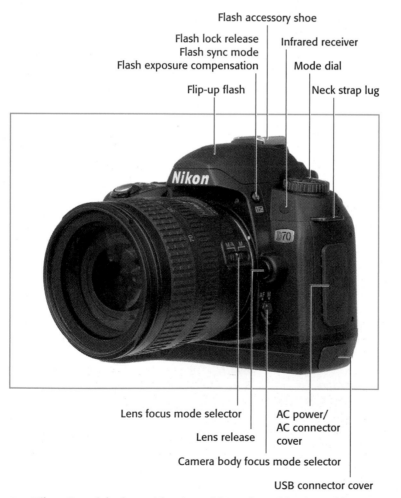

Flash accessory shoe

Flash lock release
Flash sync mode
Flash exposure compensation

Infrared receiver

Mode dial

Flip-up flash

Neck strap lug

Lens focus mode selector

Lens release

AC power/
AC connector
cover

Camera body focus mode selector

USB connector cover

1.3 Nikon D70 right-front side, viewed from the subject's position.

Flip up electronic flash/speedlight

Flash lock release
Flash sync mode
Flash exposure compensation

1.4 Pressing the flash multi-button (Flash Exposuer Compensation button) pops up the built-in electronic flash, ready for use.

✦ **Focus-mode selector:** The autofocus/manual (AF/M) lever on the camera body can be flipped to set the focus mode for lenses that don't have such a control on the lens barrel, or for manual focus lenses. Figure 1.3 also shows such a control on the 18–70mm kit lens.

✦ **AC Power/AV Connector/USB Connector covers:** On the side of the camera, you'll see two rubber covers that protect the D70's primary external connectors. These include the AC power connector, which can operate the camera without batteries (for, say, studio work or time-lapse photography). Just below the AC power connector is an AV plug that can link the D70 to an external monitor for viewing pictures or menus. The bottommost connector accepts the USB cable, which enables transferring pictures directly from the camera to your computer, and also lets you

control the camera's functions using the Nikon Capture software. The Nikon D70s also has a connector for the wired remote control accessory.

On Top

The top surface of the D70 has its own set of controls, shown in figure 1.5. In addition, a bird's-eye view provides the best perspective of some of the controls on the lens. I've divided these controls into a pair of bite-sized color-coded pieces, too, with red assigned to the lens controls, and green to the camera-body controls.

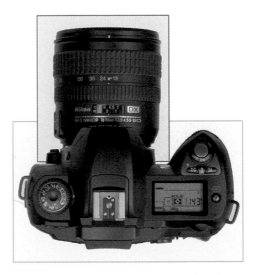

1.5 The top of view of the D70 and its kit lens.

You can see the basic controls found on many zoom lenses in figure 1.6. Not all these controls are found on all lenses, and some of them may be in different positions on different lenses (particularly those not produced by Nikon). The key components are

✦ **Focus ring:** This is the ring to turn when manually focusing the lens. If the autofocus/manual switch (AF/M) on the lens or camera is set to Auto, this ring has no effect. Some lenses, such as the kit lens, allow manual override of the camera's autofocus setting, and are marked with an M/A-M switch instead. By convention, turning the ring toward the right (when looking down on the lens from above) increases the focused distance.

✦ **Distance scale:** This is a scale that moves in unison with the lens's focus mechanism (whether activated by manually focusing or by the autofocus system) to show approximately the distance at which the lens has been focused. It's a useful indicator for double-checking autofocus, and for roughly setting manual focus.

✦ **Zoom ring:** This is the ring turned to change the zoom setting. With many lenses, turning this ring to the right increases the focal length, but you may find that the opposite is true with some lenses (which can be very frustrating!).

✦ **Zoom scale:** These markings on the lens show the current focal length set.

✦ **Lens hood alignment guide/bayonet:** Used to mount the lens hood for lenses that don't use screw-mount hoods.

Figure 1.7 shows a single focal length, or *prime* lens, a 105mm Nikkor macro lens used for close-up photography. This particular lens has some features not available on the kit lens, but that are found on some other zoom and non-zoom lenses. Of course, because it doesn't zoom, this lens lacks the zoom ring and zoom scale. Other components include the following:

✦ **Lens thread:** Most lenses have a thread on the front for attaching filters and other add-ons. Some also use this thread for attaching a lens hood (you'd screw on the filter first, and then attach the hood to the screw thread on the front of the filter).

✦ **Limit switch:** Lenses with an extensive focus range (such as this macro lens) often have a switch that can be used to limit the range used by the autofocus system. For example, if you're not shooting close-up pictures, you can set the lens to seek focus only at more distant settings, which can save a bit of time.

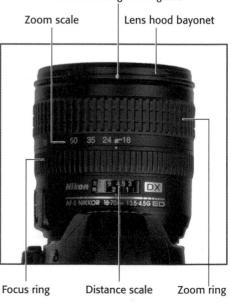

Lens hood alignment guide

Zoom scale Lens hood bayonet

Focus ring Distance scale Zoom ring

1.6 Key components of a typical zoom lens.

✦ **Aperture ring:** The kit lens, as well as many other newer lenses, use the camera's electronics exclusively to set the shooting aperture. These lenses, which include a *G* suffix in their name, have no aperture ring at all, and are compatible only with cameras that can set the f-stop through a control on the camera. Other lenses maintain compatibility with earlier cameras by including an aperture ring and a pair of aperture readouts (the numbers from f/32 down to f/2.8 in figure 1-7). The second, outermost readout is required by some cameras. These lenses include a *D* suffix in their name. Both G- and D-type lenses work fine with the Nikon D70 digital camera.

✦ **Aperture lock:** When using a D-type lens on the D70, you'll need to set the aperture ring to the smallest f-stop, and then lock it in that position using the aperture lock. Set it once and then forget about it, unless you need to mount the lens on an older camera or you've mounted the lens on an accessory such as a bellows or extension ring.

The top panel has relatively few controls. They include:

✦ **Mode dial:** This knurled wheel is turned to change from the various exposure and scene modes, discussed later in this chapter.

✦ **Flash accessory shoe:** Mount an external electronic flash unit (Nikon calls them Speedlights), such as the Nikon SB-600 or SB-800, on this slide-in shoe. The multiple electrical contacts shown in the

photo are used to trigger the flash and to allow the camera and flash to communicate exposure, distance, zoom setting, and other information. You can also attach other flash units made by Nikon and other vendors, but not all functions may operate.

✦ **Monochrome LCD control panel:** This LCD readout provides information about the status of your camera and its settings, including exposure mode, number of pictures remaining, battery status, and many other settings.

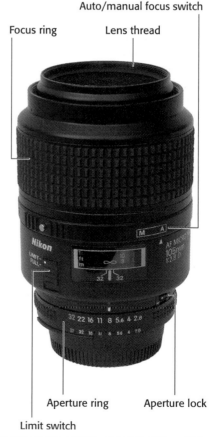

Focus ring — Auto/manual focus switch — Lens thread — Aperture ring — Aperture lock — Limit switch

1.7 Key components of a typical Type D lens.

✦ **LCD Lamp/Format #1 button:** Press this button to backlight the control panel for about 8 seconds when working under illumination that makes it difficult to view the panel's information without a little help. This button also can be used to reformat the D70's digital memory card, if you hold it down simultaneously with the Format #1 button on the back panel (described in the next section).

✦ **Sensor focal plane:** Some specialized kinds of close-up photography require knowing exactly where the plane of the camera sensor is located. This marker shows that point, although it represents the *plane,* not the actual location of the sensor itself, which is placed aft of the lens.

✦ **Metering Mode/Reset #1 button:** Press this button while spinning the command dial on the back of the camera to change from matrix to center weighted or spot metering modes (explained later in this chapter). This button also can be used to reset the D70's internal settings to the original factory settings if held down simultaneously with the Reset #2 button (described later in this chapter).

✦ **Exposure compensation button:** Hold down this button while spinning the command dial to add or subtract exposure from the basic setting calculated by the D70's autoexposure system.

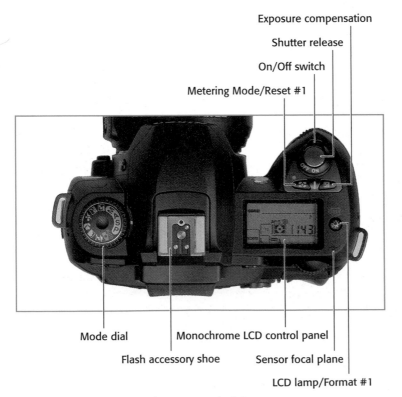

Exposure compensation

Shutter release

On/Off switch

Metering Mode/Reset #1

Mode dial Monochrome LCD control panel

Flash accessory shoe Sensor focal plane

LCD lamp/Format #1

1.8 Key components on the top panel of the D70.

✦ **Shutter-release button:** Partially depress this button to lock in exposure and focus; press it all the way to take the picture. Tapping the shutter release when the camera has turned off the autoexposure and autofocus mechanisms will reactivate both. When a review image is displayed on the back-panel color LCD, tapping this button will remove the image from the display and reactivate the autoexposure and autofocus mechanisms.

✦ **Power switch:** Flip this switch to turn the D70 on or off.

On the Back

The back panel of the Nikon D70 is studded with more than a dozen controls, many of which serve more than one function. Where other cameras may force you to access a menu to set image quality, change the camera's sensitivity, or to activate the self-timer, with the D70, just press the appropriate button, turn the command dial, and make the setting you want. I've divided this crowded back panel into four color-coded sections.

Upper left

The upper-left corner of the back panel includes just two buttons:

✦ **Bracketing (BKT) button:** Hold the bracketing button while spinning the main command dial (to select the bracketing function), and the sub-command dial (to choose the type of bracketing to be applied), as described later in this chapter. This button also serves as the Reset #2 button.

✦ **Shooting mode button:** Hold this button while spinning the main command dial to choose from single shot, continuous/burst mode, self-timer, or remote-control operation. This button also serves as the Format #2 button.

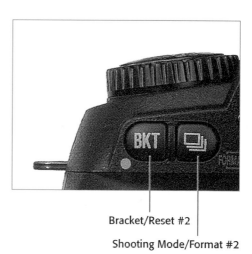

Bracket/Reset #2

Shooting Mode/Format #2

1.10 Key components on the upper-left corner of the back panel of the D70.

1.9 Key components on the back panel of the D70.

Upper right

There are only a few controls located on the upper-right corner of the D70. They include:

✦ **Viewfinder eyepiece:** The rubber eyecup shields the viewfinder from extraneous light, much like a lens hood — a necessary component because light entering the viewfinder can affect the exposure meter. The eyecup is removable and can be replaced by a cap to block that extra light when the camera is used on a tripod.

✦ **Diopter adjustment control:** Slide this lever to adjust the diopter correction for your eyesight.

✦ **AE/AF (autoexposure/autofocus) lock button:** Depending on settings you make in the Setup menu (see Chapter 2), pressing this button will lock exposure, focus setting, or both, either until you release the button or press it a second time.

✦ **Main command dial:** This dial is spun to change settings such as shutter speed, bracketing, or shooting mode, depending on what function button is being pressed at the same time.

Lower left

This is the D70's "hot corner," with a collection of the function buttons you'll use the most. They can have multiple functions, so you need to keep your camera's current mode (playback/shooting, and so on) in mind when you attempt to access a specific feature. A more complete description of each button's functions appears later in this chapter. The buttons include:

✦ **Playback button:** Enter picture review (playback) mode.

✦ **Menu button:** Access the D70's multilevel menu system.

✦ **Sensitivity (ISO)/thumbnail button:** In any shooting mode, hold this button and spin the main command dial to change ISO. In playback mode, use it to change the number of thumbnails displayed on the LCD.

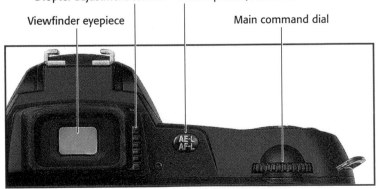

Diopter adjustment control Autoexposure/Autofocus lock

Viewfinder eyepiece Main command dial

1.11 Key components on the upper-right corner of the back panel of the D70.

✦ **White balance/help/protect button:** In any shooting mode, hold and spin the main command dial to change the white balance. When viewing the Custom Settings menu, press it to view the help screen. In playback mode, press it to lock the current image from accidental erasure.

✦ **Image quality/size (QUAL)/ playback zoom/enter button:** Press and spin the main command dial or sub-command dial to change the image quality or picture size. In playback mode, press it to zoom in and out of the reviewed image. When viewing menus, this button services as an OK key.

Lower right

A second cluster of controls and components is found in the lower-right corner of the back panel (see figure 1.13):

✦ **LCD:** The color LCD displays your images for review and provides access to the menu system.

✦ **Multi selector:** Used to navigate menus as well as scroll through photos being reviewed (by pressing the up/down keys), and to change the type of image information displayed (by pressing the left/right keys.)

✦ **Focus selector lock:** Enables/disables manual focus area selection.

✦ **Delete button:** Erases the currently viewed image during review.

✦ **Memory card access lamp:** Blinks when an image is being written to the Compact Flash card.

✦ **Compact Flash compartment:** Your memory card goes here.

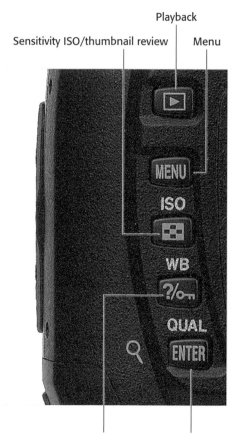

Playback

Sensitivity ISO/thumbnail review | Menu

White balance/ help/protect

Image quality/ size (QUAL)/ playback zoom/ enter

1.12 Key components on the lower left panel of the D70.

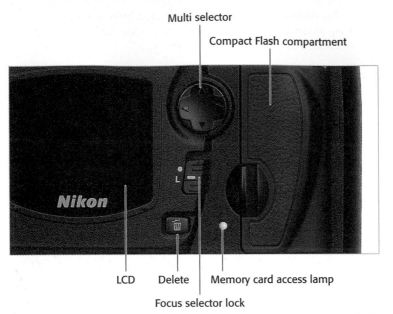

Multi selector

Compact Flash compartment

LCD Delete Memory card access lamp

Focus selector lock

1.13 Key components on the lower-right corner of the back panel of the D70.

Viewfinder Display

The D70 provides lots of status information in the viewfinder, although not all of it will be visible at one time. Here's the skinny:

✦ **Reference grid:** This optional set of reference lines can be used to align images.

✦ **Center-weighted metering reference circle:** Shows the 8mm circle that's the default area for center-weighted meter readings. The size of the circle used can be changed in the menu system.

✦ **Autofocus/spot metering zones:** Shows the areas used by the D70 to focus and measure exposure.

✦ **In-focus indicator:** Illuminates when an image is focused correctly.

✦ **Focus area/autofocus mode:** Shows the current focus area, and which autofocus mode is in use.

✦ **Autoexposure (AE)/autofocus (AF) lock indicator:** Shows that exposure and/or focus have been locked.

✦ **Battery status:** Current power level of the battery.

✦ **Shutter speed:** Selected shutter speed.

✦ **Aperture:** Selected lens opening.

✦ **Exposure display:** Shows the amount of over- or underexposure.

✦ **Flash compensation:** Shows added or subtracted flash exposure.

✦ **Exposure compensation:** Shows added or subtracted exposure.

✦ **Shots in buffer/other functions:** Multifunction display that shows the number of shots remaining in the buffer when the shutter release is pressed. Also shows white balance preset status, exposure/flash compensation values, and PC/USB connection status.

✦ **Flash ready:** Lights when the Speedlight is charged for an exposure.

✦ **ISO automatic indicator:** Shows that ISO is being set automatically.

✦ **Thousands of exposures indicator:** Shows that the number of remaining exposures indicated exceeds 1,000.

Center-weighted metering reference circle

Reference grid Autofocus/spot metering zones

In-focus indicator Aperture | Flash compensation Flash ready

Focus area/ Shutter speed ISO Automatic indicator Thousands of
Autofocus mode exposures indicator

Exposure display Exposure compensation

Battery status Autoexposure lock indicator Shots in buffer/White balance preset/
EV/Flash compensation/PC connection

1.14 Viewfinder readouts and indicators.

LCD Display

The top-panel monochrome LCD display shows a broad range of current status information. This display is a bit much to bite off in one chunk, so I've color-coded it for you.

✦ **ISO auto:** Indicates that ISO sensitivity is being set automatically by the camera.

✦ **Flash sync mode:** Shows the current flash synchronization setting.

✦ **Image quality:** Shows whether image files are being saved in RAW format, Fine (JPEG), Normal (JPEG), Basic (JPEG), or RAW+Basic.

✦ **Image size:** Indicates the current resolution being used, either 6 megapixels, 3.3 megapixels, or 1.5 megapixels, indicated by L (large), M (medium) or S (small) indicators.

✦ **Shutter speed:** Current shutter speed setting.

✦ **Aperture:** Current f-stop.

✦ **Flexible program:** Shows that program mode is in use and that

shutter speed/f-stop combinations can be changed to other equivalent exposures by rotating the main command dial.

✦ **EV/flash EV:** Indicates that exposure compensation or flash exposure compensation are being used. The amount of compensation (for example +0.7) is shown in the shutter speed readout area immediately above these indicators.

✦ **Clock battery:** Shows that the date/time should be set, or that the permanent built-in clock battery must be replaced by an authorized technician.

✦ **Bracketing:** When bracketing is being used, the BKT indicator will appear, the EV indicator on the LCD and viewfinder will flash, and the icons under the BKT indicator will disappear as each bracketed picture is taken.

✦ **Beep indicator:** Shows whether a beep will sound during certain camera functions, such as self-timer operation or when single autofocus is achieved.

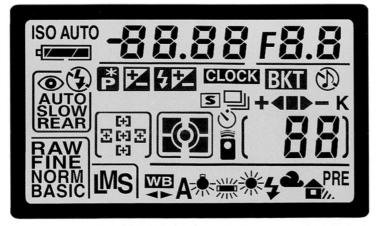

1.15 Top-panel LCD display readouts and indicators.

✦ **Thousands of exposures:** Appears to show that the number of remaining exposures exceeds 1,000.

✦ **Remaining Exposures:** Approximate number of pictures remaining on your memory card. (With RAW format, this estimate is often about half of the true number of pictures available.)

✦ **Focus Area/autofocus Mode:** Shows the currently selected focus area and type of autofocus operation in use.

✦ **Metering Mode:** Indicates current exposure metering mode.

✦ **White Balance Settings:** Shows whether white balance is being set automatically, to one of the built-in

settings, or to a manually preset value.

Viewing and Playing Back Images

The D70's playback mode lets you review your images, delete the bad ones, and decide on exposure or compositional tweaks to improve your following shots.

Follow these steps to review your images:

1. **Press the playback button to produce the most recently taken photo on the back panel LCD.**

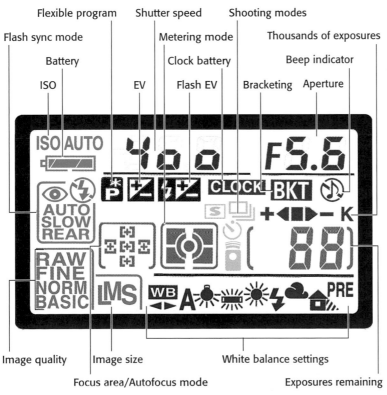

Flexible program Shutter speed Shooting modes
Flash sync mode Metering mode Thousands of exposures
Battery Clock battery Beep indicator
ISO EV Flash EV Bracketing Aperture

Image quality Image size White balance settings
 Focus area/Autofocus mode Exposures remaining

1.16 Monochrome LCD readouts.

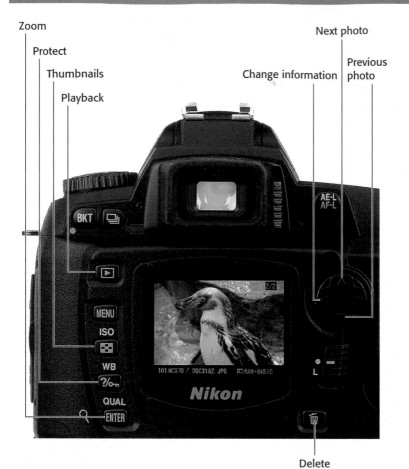

1.17 Review your photos using the color LCD.

2. **Press the thumbnail button repeatedly to cycle among single-picture display, or tiled views that show four or nine reduced-size thumbnails at one time.**

 - In single-picture display, the up and down keys on the multi selector move to the next or previous image.

 - When viewing four or nine thumbnails, the up and down keys navigate among the available images. Press the playback button to view a selected image on the LCD in full size.

3. **Press the playback zoom button to enlarge the viewed image on the screen.**

 - Use the multi selector's cursor keys to move the zoomed area around within the enlarged view.

 - Hold down the thumbnail key to view an inset area with a miniature view of the entire image, with the zoomed area highlighted. You can move this

1.18 Moving the zoomed area.

highlighted area around with the multi selector's cursor keys.

- Hold down the thumbnail key and spin the main command dial to change the size of the zoomed area.

4. **Press the left and right keys on the multi selector while viewing an image to change the type of information shown with your preview.** Your options include:

 - **File Information:** Shows the image, its filename, frame number, size, quality, folder name, and so on.

 - **Shooting Data 1:** Gives you a screen with more information, including the info in the basic File Information page, plus camera name, date, time, metering and exposure methods, shutter speed, aperture, lens focal length, flash information, and any EV adjustment you've made.

 - **Shooting Data 2:** Includes the File Information basics, plus ISO setting, white balance, sharpening, color mode, hue, saturation, and some other data.

- **Histogram:** Adds to the basics a histogram graph that displays the relationship between the dark and light tones in the image.

- **Highlights:** The brightest areas of an image are represented with a flashing border so you can easily see any portions that might lack detail because of overexposure.

5. **Press the protect button to keep the selected image from accidental erasure.** The photo can still be removed if the card is reformatted, however.

6. **Press the delete button to erase the selected image.**

Activating the Onboard Flash

In some scene modes, the built-in electronic flash can be set to pop up automatically when the D70 detects low light levels suitable for flash photography. Or you can manually pop up the flash by pressing the flash button on the left side of the camera. Once

the flash is in place, you have the following options:

 Cross-Reference *You'll find more on using flash in Chapter 4.*

✦ If you're using programmed, shutter priority, aperture priority, or manual modes, hold down the flash button and spin the main command dial to switch among:

- **Front curtain sync:** The flash fires as soon as the shutter opens. Set the shutter speed of your choice (generally up to 1/500 second), when using manual or shutter priority modes. In programmed and aperture priority mode, the D70 sets the shutter speed between 1/60 and 1/500 second.

- **Red-eye reduction:** Triggers the front-panel lamp (also used for focus assist) 1 second prior to exposure to reduce red-eye effect.

- **Slow sync:** Uses slow shutter speeds (as long as 30 seconds) to add background illumination to the flash exposure. Not available with shutter priority or manual modes.

- **Slow sync with red-eye:** Adds red-eye reduction to slow sync mode.

- **Rear-curtain sync:** The flash is delayed until just before the shutter closes. This puts any "ghost" images from the ambient light caused by moving objects to appear behind the flash image.

- **Slow rear-curtain sync:** Also delays flash until just before the

shutter closes, but adds long shutter speeds to add background illumination to the flash exposure. Not available with shutter priority or manual modes.

✦ If you're using auto, portrait, or close-up modes, hold down the flash button and spin the main command dial to switch among:

- **Auto front-curtain sync:** Similar to front-curtain sync, but the flash pops up automatically.

- **Auto with red-eye:** Same as auto front-curtain sync, with red-eye reduction.

- **Off:** Flash does not fire.

✦ If you're using the night portrait mode, hold down the flash button and spin the main command dial to choose.

- **Auto slow sync:** Similar to slow sync, but the flash pops up automatically.

- **Auto slow sync with red-eye:** Same as auto slow sync, but with red-eye reduction.

1.19 Flash options.

- **Off:** Flash does not fire.

Tip *In certain modes, such as Programmed mode, the camera's viewfinder will signal the user with an icon when flash is suggested so that the flash button can be used to raise the flash head.*

Metering Modes

The D70 can use any of three different exposure metering methods when set to any of the semi-automatic or manual exposure modes (which are discussed later in the chapter). Select the metering mode by holding down the metering mode button and spinning the main command dial until one of these metering modes appears in the monochrome LCD:

✦ **Matrix:** The camera examines 1,005 pixels in the frame and chooses the exposure based on that information (plus, with Type G and D lenses, distance range data).

✦ **Center-weighted:** The camera collects exposure information over the entire frame, but when making its calculations emphasizes the 8mm center circle (or other size chosen by you) shown in the viewfinder.

✦ **Spot:** Exposure is calculated entirely from an area approximating the currently selected focus area.

1.20 Metering modes.

ISO Sensitivity

The D70 can choose the sensitivity setting (ISO) for you automatically, or you can manually choose a setting. Just follow these steps:

1. **If the LCD monitor is on, tap the shutter-release button to cancel the display.**

2. **Hold down the ISO button on the back panel.**

3. **Rotate the main command dial to choose an ISO setting from ISO 200 to ISO 1600.**

Cross-Reference *ISO and white balance can alternatively be set using the menu system, which is discussed in Chapter 2. You can also find more information on ISO and white balance in Chapter 3.*

Setting White Balance

To more closely match the D70's color rendition to the color of the illumination used to expose an image, you can set the white balance. To use a preset value, follow these steps:

1. **If the LCD monitor is on, tap the shutter-release button to cancel the display.**

2. **Hold down the white balance button on the back panel.**

3. **Rotate the main command dial to choose a white balance from among auto, incandescent, fluorescent, direct sunlight, flash, cloudy, shade, and preset.**

White balance can also be set using the menu system, where you have additional options for fine-tuning or defining a preset value.

1.21 White balance options.

Programmed Exposure Modes

The D70 has seven Digital Vari-Program (DVP), or scene, modes that make some of the setting decisions for you. You can choose these modes from the mode dial. They include:

✦ **Full auto:** In this exposure mode, the D70's brains take care of most of the settings, based on what kind of shot you've framed in the viewfinder. For example, the camera knows how far away the subject is (from the automatic focus mechanism), the color of the light (which tells the camera whether you're indoors or outdoors), and it can make some pretty good guesses about what kind of subject matter (landscape, portrait, and so forth) from exposure data and other information. After comparing your shot to its 30,000-picture database, the D70 decides on the best settings to use when you press the shutter-release button. Auto is the mode to use when you want one of those fumble-fingered neophytes in your tour group to take your picture in front of the Eiffel Tower. Don't use this mode if you want every picture in a series to be exposed exactly the same. If you change shooting angles or reframe your image, the D70 might match your shot with a different image in its database and produce a slightly different (but still "optimized") look.

✦ **Portrait:** In this mode, the D70 assumes you're taking a portrait of a subject (or two) standing relatively close to the camera. So, it automatically focuses on the nearest subject and uses a wider lens opening (which can throw the background out of focus). The camera's built-in sharpening effects are not used, to produce less detailed, but smoother skin tones. Exposure is also set to create smoother tonal gradations that are flattering for your subjects. Flash (if used) is set to reduce red-eye effects. Don't use this mode if your portrait subject is *not* the closest object to the camera.

✦ **Landscape:** Scenic photos are usually taken of distant objects, but the D70 doesn't lock focus at infinity; it uses the "closest subject" setting, just as with portrait mode. However, it does assume that electronic flash won't be of much help in shooting your vistas, so it locks out the built-in Speedlight. The camera automatically boosts sharpness and color richness to help you capture distant details and the vivid colors of foliage. Don't use this mode if you need to use flash as a fill-in to illuminate shadows in subjects relatively close to the camera who are posing in front of your vistas.

✦ **Close up:** Your D70 makes some adjustments suitable for close-up photos when you choose this mode. For example, the automatic focusing mechanism will concentrate on the center of the frame (because that's where most close-up subjects are located), and not seek sharp focus until you partially depress the shutter-release button.

✦ **Sports:** The D70 switches into a continuous autofocus mode that tries to track moving subjects to keep them in focus. It also uses higher shutter speeds and turns the flash off. Because the D70 figures you don't want to miss a fast-moving shot, the shutter will trip even if focus hasn't been achieved.

✦ **Night landscape:** In this mode, the D70 uses shutter speeds as long as 17 seconds to allow dark backgrounds and shadows to be properly exposed. The flash is turned off.

✦ **Night portrait:** Similar to night landscape mode, this mode adds flash capability and tries to balance flash exposure with the background illumination using front-curtain slow synchronization.

Semiautomatic and Manual Exposure Modes

The Nikon D70 has three semiautomatic exposure modes that allow you to specify shutter speed, aperture, or combinations of the two; and a manual exposure mode that gives you the complete freedom to set

shutter speed and aperture. These four exposure modes are also set using the mode dial. Your choices include:

✦ **Program:** In this mode, the D70 automatically chooses an appropriate shutter speed and f-stop to provide the correct exposure. However, you can override these settings in several ways. In all cases, if your attempted adjustments result in an exposure beyond the range of the system (that is, you're asking for a shutter speed or f-stop that's not available), either HI or LO will appear in the viewfinder.

• Rotate the main command dial to the left to change to a slower shutter speed and smaller f-stop combination that provides the same overall exposure.

• Rotate the main command dial to the right to change to a higher shutter speed and larger f-stop combination that provides the same overall exposure.

• Hold down the EV button and rotate the main command dial to the left or right to add or subtract exposure from the metered exposure reading.

✦ **Shutter priority:** In this exposure mode, you specify the shutter speed with the main command dial, and the D70 will select an appropriate f-stop. The HI and LO warnings will appear if you exceed the range of available settings.

✦ **Aperture-priority:** In this exposure mode, you specify the f-stop to be used with the sub-command

dial, and the D70 will select the shutter speed for you, or display the HI and LO indicators if this isn't possible.

✦ **Manual:** You can select both the shutter speed and f-stop using the main and sub-command dials. The D70 will still let you know when proper exposure is achieved using the exposure readout in the viewfinder.

Tip

As you work with these exposure modes, keep in mind that each of them may lock you out of making the full range of adjustments of a particular type. For example, when using any DVP/scene mode, you won't be able to adjust the exposure manually using the EV settings. In portrait mode, electronic flash options can be set only to automatic, or red-eye reduction either on or off.

Setting Up Your D70

◆ ◆ ◆ ◆

In This Chapter

Shooting menu preferences

Setup menu Preferences

Custom settings menu preferences

◆ ◆ ◆ ◆

Most of the controls you learned in Chapter 1 were settings that you can make while shooting photos, usually to modify how the picture is taken when you want to improve the rendition or apply some creativity. The Nikon D70 also has a large number of other settings that you'll use less frequently. Tucked away in the menu system, these settings usually customize your camera's defaults so it uses the image size, white balance, focus modes, and other preferences you want to use most of the time.

This chapter details some of the most commonly changed setup parameters you can use to tailor your D70's operation. You'll find many of the more esoteric settings listed in the camera's manual. In addition, preferences for flash photography are discussed in the chapter on using electronic flash.

The D70 has four main menus — the playback menu, the shooting menu, the setup menu, and the custom settings menu. To access any menu choice, press the menu button on the left side of the back panel, then use the multi selector's cursor keys to select the individual menu you want, and the choices within it. Press the enter button on the left side of the back panel to activate your selection, and the menu button again to exit the menu system.

Firmware updates sometimes change the appearance of menus, so yours may not appear exactly like those shown in this chapter.

Shooting Menu Preferences

Picture-taking preferences are found within the shooting menu, shown in figure 2.1.

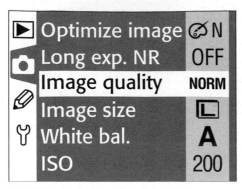

2.1 Nikon D70 Shooting menu.

The key choices are:

✦ **Image quality:** Choose NEF(Raw), one of three JPEG compression levels (Fine, Norm, or Basic), or NEF+JPEG Basic, which produces two image files, one saved in RAW format, and the other in JPEG Basic. You can also make these settings by holding down the QUAL button on the camera back panel, and rotating the main command dial.

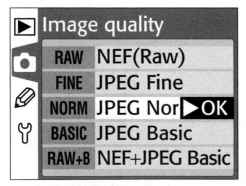

2.2 Set Image Quality.

✦ **Image size:** Choose L (3008 by 2000 pixels), which is 6 megapixels; M (2240 x 1488), which is 3.4 megapixels; or S (1504 x 1000), which is 1.5 megapixels. You can

also make these settings by holding down the QUAL button on the camera back panel, and rotating the sub command dial.

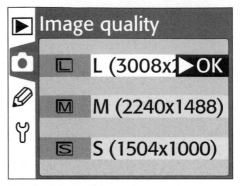

2.3 Set Image Size.

✦ **ISO:** Choose ISO 200, 250, 320, 400, 500, 640, 800, 1000, 1250, or 1600. These correspond to 1/3 stop increments. You can also have the D70 change ISO for you automatically as appropriate for the lighting conditions, as outlined in the custom settings menu (CSM) discussed later in this chapter. The basic ISO settings can also be adjusted by pressing the ISO button on the camera back panel and rotating the command dial.

2.4 Set ISO sensitivity.

✦ **Long exp. NR:** Turn long exposure noise reduction on when you'll be shooting exposures longer than 1 second (preferably with the camera mounted on a tripod) and you want the D70 to use its noise-reduction features to remove those multicolored random speckles that result, especially at higher ISO settings. You wouldn't want to leave this on all the time, because it effectively doubles the time required to take a photograph at a longer shutter speed. After each exposure is made, the D70 takes a second, blank picture for the same time interval, and then compares the two to identify noise artifacts that should be removed before storing the image on the memory card.

✦ **Optimize image:** This menu lets you tweak the camera's basic settings for color saturation, sharpness, printing, portraits, and landscapes. A custom selection can include your choices for sharpening, color mode, saturation, hue, and tone compensation. The latter may be specified using a custom tonal curve you upload from Nikon Capture (see Chapter 7).

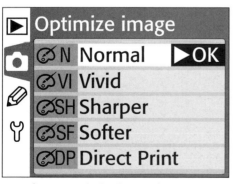

2.5 Choose optimization settings.

✦ **White bal.:** Choose auto (the camera chooses the white balance for you), incandescent, fluorescent, direct sunlight, flash, cloudy, shade, or preset. Setting a preset value is discussed later in this section. You can also make the basic selections by holding down the WB button on the camera back panel, and rotating the command dial.

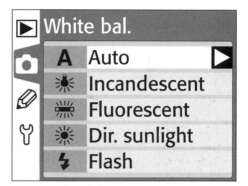

2.6 Set white balance.

Customizing white balance

To fine-tune white balance, choose preset from the white balance menu, while using P, S, A, or M modes. You're given a choice of using the last white balance you've used, or setting the white balance from an existing photo that you've already taken as a reference. You may also use an object, such as a neutral white or gray object, to preset white balance, or fine-tune an existing setting.

✦ If you select measure, white balance will be set to the last value you used as a preset white balance. If you haven't used a preset white balance, direct sunlight will be used instead.

✦ If you select use photo, a screen appears that lets you choose a folder on your memory card, and select an image from a thumbnail display. White balance will be set to the same value as the thumbnail you specify.

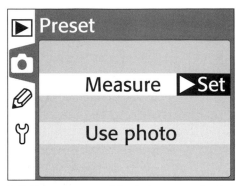

2.7 Select preset white balance method.

✦ When you select auto or any of the default white balance settings, a screen appears that you can use to set white balance warmer (press the up cursor key on the multi selector) or cooler (press the down cursor key on the multi selector.)

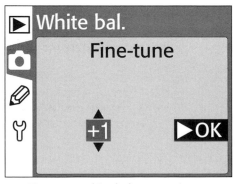

2.8 Fine-tune white balance settings.

Setting white balance manually

To use the white balance of your current environment, follow these steps:

1. **Hold the WB button on the camera back panel and spin the main command dial until the PRE white balance choice appears on the LCD control panel.**

2. **Release the WB button, and then press it again until a blinking PRE icon appears in the control panel space and viewfinder where the number of exposures normally are shown.**

3. **Point the camera to fill the frame with a plain, neutral surface or object and press the shutter-release button completely.** The camera will display Good in the LCD control panel (or Gd in the viewfinder) if it successfully measured the white balance of the object, or no Gd in both locations if the measurement was unsuccessful.

4. **If the measurement didn't work out (you do not see Good or Gd), repeat Steps 1 through 3.**

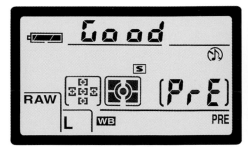

2.9 The word "good" indicates white balance has been preset.

Setup Menu Preferences

You can change some of your D70's default behaviors in the Setup menu. Here are a few of the key parameters:

✦ **LCD brightness:** The back panel monitor can be difficult to view under very bright lighting conditions. You can boost the brightness using this menu command. Press the multi selector up button to increase brightness or the down button to decrease it. Press the right button when finished.

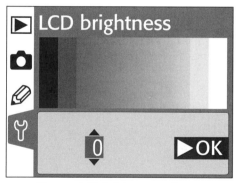

2.10 Change LCD brightness values.

✦ **Image comment:** The option lets you add text to the comment field included with each image, such as your location or even a copyright for the image (for example, "(c)2005 Kitchen Table International").

To add a comment, follow these steps:

1. **Select the image comment option from the menu.** An alphanumeric menu appears.

2. **Use the multi selector keys to navigate among the characters, and then press the WB button on the left back panel of the camera to select a character.**

3. **Hold down the ISO button on the left back panel of the camera and spin the main command dial to move the input cursor around within the comment you're adding.**

4. **Delete a highlighted character by pressing the Trash button on the camera back panel.**

5. **When you're finished entering up to 36 characters, press the enter button to return to the menu.**

Tip *If you have Nikon Capture (see Chapter 7) you can type your comment on your computer and upload it to the D70.*

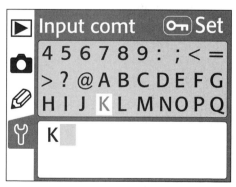

2.11 Enter a comment to accompany each photograph.

✦ **Image Rotation.** If you'd like vertically oriented images to be rotated to the correct angle when viewed, choose Automatic.

Custom Settings Menu Preferences

The CSM (custom settings menu) contains up to 26 choices, most commonly referred to by D70 users by their abbreviated names: CSM 1 through CSM 25, plus menu reset. The Setup menu has a CSM menu choice that allows you to choose simple (only the first 10 CSM entries) or detailed (all 26 entries) menu display. There's no reason why you shouldn't go ahead and set this preference to detailed.

2.12 Choose Detailed CSM from the Setup menu.

Many of the custom settings parameters affect how other menus or controls work. For example, CSM 14 is labeled command dial, and it reverses the functions of the main command dial and sub command dial. When set to yes, in manual mode you'd adjust the shutter speed using the sub command dial (instead of the main command dial) and the aperture using the main command dial (instead of the sub command dial.)

The CSM entries can be confusing, so you may find yourself consulting the D70's manual when it comes time to tweak one of the lesser-used settings. Here's an overview of a few of the more commonly used CSM settings:

✦ **CSM 1: Beep.** Turns the camera speaker on or off.

✦ **CSM 2: Autofocus.** This controls the D70's default autofocus mode. Choose AF-S to choose single-servo autofocus; the camera in AF mode locks focus when the shutter release is pressed down halfway, and the shutter will not release until focus has been achieved. Choose AF-C for continuous auto-focus if you prefer to have the camera continually refocus as the shutter release is partially depressed. Pressing the shutter release all the way takes a picture, even if sharp focus hasn't been achieved.

✦ **CSM 3: AF Area Mode.** This selects the default autofocus area mode. These include a single user-selectable area; a dynamic mode that uses multiple focus areas in addition to the one selected by the user; and closest subject, which focuses on the subject closest to the camera.

✦ **CSM 4: AF Assist.** Enables or disables the autofocus assist light on the front of the camera, or on the SB-600/SB-800 electronic flash or SC-29 flash connecting cable.

✦ **CSM 5: ISO Auto.** When enabled, lets the camera adjust ISO settings to achieve the best exposure with available light or flash. Many D70 users prefer to set ISO themselves and don't like the uncertainty of

having the camera set sensitivity, and so leave ISO Auto disabled.

✦ **CSM 6: No CF Card.** Locks/unlocks shutter release when no memory card is inserted.

✦ **CSM 7: Image Review.** Enables or disables display on the monitor of the image just shot.

✦ **CSM 8: Grid Display.** Activates optional lines in the viewfinder that may be helpful for aligning subject matter or making compositions.

✦ **CSM 9: EV Step.** Chooses 1/3 and 1/2 EV increments for exposure compensation, bracketing, and flash exposure compensation.

✦ **CSM 10: Exposure Comp.** Sets whether exposure compensation can be adjusted using the exposure compensation button, the sub-command dial, or the main command dial.

✦ **CSM 11: Center Wtd.** Changes size of center-weighted metering to 6, 8, 10, or 12mm.

✦ **CSM 12: BKT set.** Used to specify which settings are affected by bracketing, from among AE/Flash, AE only, Flash only, or white balance.

✦ **CSM 13: BKT order.** Determines the order in which bracketing settings are applied.

✦ **CSM 14: Command dial.** Swaps the main command dial function with the subcommand dial function.

✦ **CSM 15: AE-L/AF-L.** Controls how the autoexposure and autofocus lock button behaves. You can choose to enable the lock for both exposure and focus, or only one of the two, as well as whether the lock will remain until the button is released or pressed a second time.

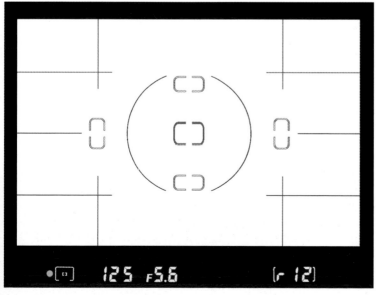

2.13 Display optional grid lines.

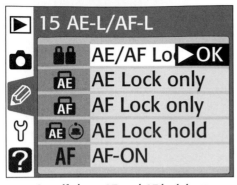

2.14 Specify how AE and AF lock button behaves.

✦ **CSM 16: AE Lock.** Choose the AE-L button to lock exposure only when the button is pressed, or the +Release button if you prefer to have exposure locked either when the AE-L button is pressed or the shutter release is pressed halfway.

✦ **CSM 17: Focus area.** Whether focus area is bounded by the four outer focus sensors, or whether the area wraps around when adjusted up, down, left, or right.

✦ **CSM 18: AF area illm.** Determines whether active focus area is highlighted in the viewfinder, or not.

✦ **CSM 19: Flash mode.** Chooses among TTL, Manual, or Commander flash modes.

✦ **CSM 20: Flash sign.** Determines whether the flash indicator is shown in the viewfinder when flash is recommended.

✦ **CSM 21: Shutter spd.** Sets the slowest shutter speed possible when mode dial is set to P or A.

✦ **CSM 22/23: Monitor Off/Meter Off.** Use to specify how long the monitor and exposure meter will remain active before automatically switching off. Monitor options range from 10 seconds to 10 minutes; the meter can remain active from 4 seconds to 30 minutes.

✦ **CSM 24: Self-timer.** Sets self-timer to 2, 5, or 10 seconds.

✦ **CSM 25: Remote.** Determines how long the camera stands by waiting for a remote control signal, from 1 minute to 15 minutes.

Creating Great Photos with the Nikon D70

Photography Basics

You're out in the field, see a perfect picture-in-the-making, and want to apply a little creativity to make it extra special. Then, you realize that you've relied on your D70's automated features so much that you're a little rusty on some of the basics you need to apply. Don't panic! In this chapter, you'll find a quick refresher of some photography basics. Spend a minute or two boning up on exposure, depth of field, and a few other topics, and then capture that award-winning shot!

Understanding Exposure

As a Nikon D70 user, you probably have a pretty good grasp of proper exposure already. You may understand f-stops, shutter speeds, and their relationship with ISO settings and have already used them effectively in your photography. However, the D70 does a good job of calculating exposure on its own, whether you're using one of the canned scene modes, programmed exposure, or even aperture- or shutter-preferred modes. The D70 doesn't leave you entirely on your own in manual shooting mode, either, because the indicators in the viewfinder show you when your manually selected f-stop and shutter speed are more or less correct.

Creative photography often calls for an even deeper understanding of how exposure works. Here's a quick recap to bring you up to speed.

What affects exposure?

Digital cameras, like film, react to light passing through the lens, and form an image when sufficient illumination reaches

the sensor. The amount of light received by the sensor varies, depending on how much light is reflected or transmitted by the subject, and how much actually makes it through the lens. Insufficient light results in an image that's too dark; too much light gives you an image that's too bright. The levels in between form your image.

Proper exposure results when just enough light reaches the sensor to provide detail in the darkest areas of your image, while avoiding excessive illumination in the brightest areas (which causes them to wash out). As you probably know, four things affect exposure:

✦ **Light reaching the lens:** Your subject may reflect light (say, a flower basking in the sunlight), transmit light (a backlit flower with light coming through its petals), or be a light source on its own (as, for example, a candle flame). To change the exposure, you simply increase or decrease the amount of illumination coming from the light source.

✦ **Light passing through the lens:** The amount of light that makes it through the lens is limited by a number of factors, the most important of which is the size of the lens opening. Except for a few specialized lenses (such as mirror lenses), the optics for your D70 all include a diaphragm that can be adjusted, usually through an arrangement of thin panels that shift to enlarge or reduce the size of the lens opening, as shown in the simplified image in figure 3-1. The relative size of the aperture is called the *f-stop.*

✦ **Light passing through the shutter:** The amount of light admitted

by the lens is further adjusted by the duration of the exposure, as determined by the shutter. With the D70, shutter speeds can be as brief as 1/8,000 second, or as long as 30 seconds automatically, or many seconds if you manually keep the shutter open with a Bulb exposure.

✦ **Sensitivity of the sensor:** The sensor, like film, has an inherent response to the light that reaches it. This sensitivity is measured using International Standards Organization (ISO) ratings, much like film is. When the D70 is adjusted to use a higher ISO setting, the signal produced is amplified, creating the same effect as a higher-sensitivity sensor.

3.1 The diaphragm controls the size of the lens opening.

All four factors work together to produce an exposure. Most importantly, they work together *proportionately and reciprocally* (with some exceptions involving very long

and very short exposure times), so that doubling the amount of light reaching the lens, making the lens opening twice as large, leaving the shutter open for twice as long, or boosting the ISO setting 2X all increase the exposure by the same amount.

Exposure adjustments

From an exposure standpoint, if you need more or less light falling on the sensor to produce a good exposure, it doesn't matter which of the four factors you change. In practice, however, that's seldom true, because each factor affects the picture in different ways, whether you're adjusting the exposure yourself or letting your D70 make the settings for you.

Adjusting the light reaching the lens

The lighting of your scene has an effect on both the artistic and technical aspects of your photograph. The quality of the light (soft, harsh), its color, and how it illuminates your subject determine its artistic characteristics. In exposure terms, both the quantity of the light and whether your subject is illuminated evenly have a bearing on the settings. You can do one of these things:

✦ **Increase or decrease the total amount of light in the scene.** Move your subject to an area that's better illuminated or that has less light. Add lights or an electronic flash or remove them. Bounce illumination onto your subject using a reflector.

✦ **Increase or decrease the amount of light in parts of your scene.** If there is a great deal of contrast between brightly lit areas and the shadows of your picture, your D70's sensor will have difficulty rendering the detail in both. Your best bet is usually to add light to the shadows with reflectors, fill flash, or other techniques, or move your subject to an area that has softer, more-even lighting. Figure 3.2 shows a close-up made with two lights, with the second one added to fill in inky shadows. In figure 3.3, the extra light has been switched off. The shadows are darker, but the overall image is more interesting.

Adjusting the aperture

Changing the f-stop adjusts the exposure by allowing more or less light to reach the lens. In manual or aperture priority modes, you can change the aperture independently by spinning the sub-command dial on the front of the camera. The f-stop you choose appears in the viewfinder and on the LCD status panel on top of the camera. There are several considerations to keep in mind when changing the lens opening:

✦ **Depth of field:** Larger openings (smaller numbers, such as f/2.8, f/3.5) provide less depth of field at a given focal length. Smaller openings (larger numbers, such as f/16 or f/22) offer more depth of field. When you change exposure using the aperture, you're also modifying the range of your image that is in sharp focus, which you can use creatively to isolate a subject (with shallow depth of field) or capture a broad subject area (with extensive depth of field).

✦ **Sharpness:** Most lenses produce their sharpest image approximately two stops less than wide open. For

3.2 Light has been added to the shadow areas, making for an even exposure . . .

3.3 . . . however, letting the shadows go dark often makes a more interesting, 3-D image.

example, if you're using a zoom lens with an f/4 maximum aperture, it will probably have its best resolution and least distortion at roughly f/8.

✦ **Diffraction:** Stopping down farther from the "optimum" aperture may create extra depth of field, but you'll also lose some sharpness due to a phenomenon known as *diffraction.* You'll want to avoid f-stops like f/22 unless you must have the extra depth of field, say, for macro shooting or need the smaller stop so you can use a preferred shutter speed.

✦ **Focal length:** The effective f-stop of a zoom lens can vary depending on the focal length used. That's why the D70's kit lens is described as an f/3.5-f/4.5 optic. At the 18mm position, the widest lens opening is equivalent to f/3.5; at 70mm, that same size opening passes one stop less light, producing an effective f/4.5 f-stop. At intermediate zoom settings, an intermediate effective f-value applies. Your D70's metering system compensates for these changes automatically, and, as a practical matter, this factor affects your photography *only* when you need that widest opening.

✦ **Focus distance:** The effective f-stop of a lens can also vary depending on the focus distance but is really a factor only when shooting close-ups. A close-focusing macro lens can lose a full effective f-stop when you double the magnification by moving the lens twice as far from the sensor. The selected f-stop then "looks" half as large to the sensor, which accounts for the light loss. Your D70's exposure meter will compensate for this, unless you're

using gadgets like extension tubes, bellows, or other add-ons that preclude autoexposure.

Tip *Teleconverter lenses, which fit between your prime or zoom lens and your camera to magnify an image, also can cost you from 0.4 to 2 f-stops, too. These include the Nikon autofocus teleconverters TC14E, TC17E, and TC20E.*

✦ **Rendition:** Some objects, such as points of light, in night photos or backlit photographs appear different at particular f-stops. For example, a streetlight, the setting sun, or other strong light source might take on a pointed star appearance at f/22, but is rendered as a normal globe of light at f/8. If you're aware of this, you can avoid surprises and use the effect creatively when you want.

Adjusting the shutter speed

Adjusting the shutter speed changes the exposure by reducing the amount of time the light is allowed to fall on the sensor. In manual and shutter priority modes, you can change the shutter speed by spinning the main command dial on the back of the camera. The speed chosen appears in the viewfinder and LCD status panel on top of the camera. You're probably familiar with most of the considerations involving altering shutter speed:

✦ **Action stopping:** Slow shutter speeds allow moving objects to blur and camera motion when the camera is panned during an exposure, or the photographer fails to hold the camera steady enough, to affect image sharpness. Higher shutter speeds freeze

3.4 At f/4, the setting sun looks undefined and globular.

action (see figure 3.6) and offer almost the same steadying effect as a tripod.

✦ **Reciprocity:** Shutter speeds that are very long may produce exposures that aren't equivalent, due to a phenomenon known as *reciprocity failure.* That is, a 30-second shot at f/2.8 could provide less light than one at 1/2 second and f/22, even though the exposure settings are equivalent. Reciprocity also applies to very short exposures, but the D70's 1/8,000 top speed is unlikely to generate much in the way of exposure "failure." However, an electronic flash's 1/50,000 second (or shorter) burst just might.

Changing ISO

You can produce the same effect on your exposure as opening up one f-stop, or doubling the length the the exposure, by bumping up the ISO setting from ISO 200 to 400. However, there is at least one side effect to boosting the D70's ISO setting. *Noise artifacts* — those multicolored speckles that are most noticeable in shadow areas but that can plague highlights, too — appear more numerous and denser as the ISO setting is increased.

Fortunately, the Nikon D70 performs very well in this regard. You probably won't notice much more noise at ISO 400, and ISO 800 can produce some very good images indeed. While ISO 1600 is still quite usable, you can expect noise to be visible.

3.5 At f/22, the same sun takes on a star-like effect.

3.6 A high shutter speed freezes all the action — except for the fast-moving softball.

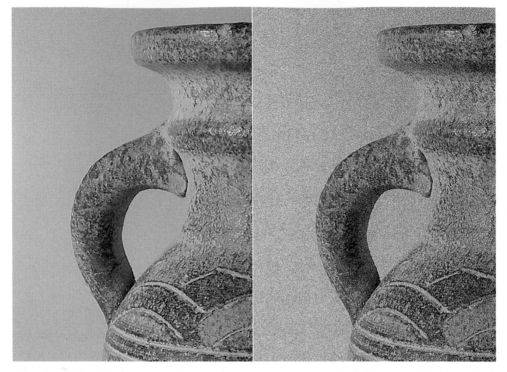

3.7 At ISO 200, (left) sensor noise is almost invisible. Boost the ISO to 1600 (right), and you'll be able to detect noise, particularly in the darker areas and when the image is enlarged this much.

You can change the ISO by holding down the ISO button on the back of the camera and spinning the main command dial. The ISO you've selected appears on the LCD status panel on top of the camera.

Getting the Right Exposure

You're probably no beginner to photography, so you understand that good exposure involves much more than keeping your picture from coming out "too dark" or "too light" (like the average point-and-shoot photographer). That's because no sensor can capture all the details possible in an image at every conceivable light level. Some details will be too dim to capture, and others will overload the photosites in the sensor and not register at all or, worse, will "overflow" into adjoining pixels and cause blooming or other effects.

Like film, digital sensors can't handle large variations between the darkest and lightest areas of an image, so the optimum exposure is likely to be one that preserves important detail at one end of the scale while sacrificing detail at the other. That's why you, the photographer, are often smarter than your D70's exposure meter. You know

3.8 Only you can decide whether the detail in the highlights or the detail in the shadows is most important for the image you're trying to take.

whether you want to preserve detail in the shadows at all costs, or you're willing to let them fade into blackness in order to preserve the lightest tones.

Left to its own devices, the D70 has a tendency to avoid allowing the highlights to be clipped (blown out) in order to preserve shadow detail. New users of the camera often think the D70 "underexposes" most pictures (until they begin making adjustments on their own), when, in fact, it's rescuing those parts of the image that are most easily corrected. You can often boost detail in areas that are underexposed, whereas not much can be done with blown highlights.

Understanding tonal range

The number of light and dark shades in your image is called its *tonal range,* and the D70 provides several tools to help you manipulate

that range. One of these is called *custom curves,* which you can create in Nikon Capture and upload to the D70. Unless you're using a "canned" custom curve prepared by others (using a search engine such as Google or Yahoo!, you can find tons of them created for the D70), this tool is beyond the scope of this field guide. However, if you understand how to use the Curves palette in Photoshop, you can probably improve the tonal range of your images right in your camera using custom curves.

 See Chapter 7 for more information on how to upload curves to the camera.

A more accessible tool for the average D70 user is the *histogram.* While histograms can be shown "live" in the preview image of point-and-shoot cameras, for digital SLR owners, they're generally an after-the-shot tool that is used to improve the *next* exposure.

You can view the histogram for any image you've taken by pressing the Review button on the back of the camera to display the image on the monitor LCD. Then press the multi selector button left or right to page through the various information display options until the histogram graph appears.

A histogram is a simplified display of the numbers of pixels at each of 256 brightness levels, producing an interesting mountain-range effect, as you can see in figure 3.9. Each vertical line in the graph represents the number of pixels in the image for each brightness value, from 0 (black) on the left and 255 (white) on the right. The vertical axis measures the number of pixels at each particular brightness level.

3.9 A histogram of an image with correct exposure and normal contrast will show a mountain-shaped curve of tones extending from the shadow areas (left) to the highlight areas (right).

This sample histogram shows that most of the pixels are concentrated roughly in the center, with relatively few very dark pixels (on the left) or very light pixels (on the right). Even without looking at the photo itself, you can tell that the exposure is good, because no tonal information is being clipped off at either end. The lighting of the image isn't perfect, however, because some of the sensor's ability to record information in the shadows and highlights is being wasted. A perfect histogram would have the toes of the curve up

snuggled comfortably with both the left and right ends of the scale.

Sometimes, your histogram will show that the exposure is less than optimal. For example, figure 3.10 shows an underexposed image; some of the dark tones that appeared on the graph in the original exposure are now off the scale to the left. The highlight tones have moved toward the center of the graph, and there's a vast area of unused tones at the right side of the histogram. Adding a little exposure will move the whole set of tones to the right, returning the image to the original, pretty-good exposure.

3.10 In an underexposed image, dark tones are lost at the left end of the scale.

An overexposed image is shown in figure 3.11, with highlight tones lost off the right side of the scale. Reducing exposure can correct this problem. As you work with histograms, you can use the information they contain to fine-tune your exposures.

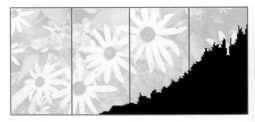

3.11 In an overexposed image, tones are lost at the right end of the scale.

Fine-tuning

There are several ways of fine-tuning your exposure and the tonal range of your images. Here's a quick checklist:

✦ **In manual mode:** Just adjust the aperture or shutter speed to add or subtract exposure.

✦ **In program, shutter-priority, or aperture priority modes:** Perhaps you feel that choosing a different metering mode will let your D70 choose an appropriate exposure more easily. Hold down the metering mode button on the top of the camera, and spin the main command dial to switch among matrix metering, center-weighted, or spot metering. Although matrix metering generally does a great job, sometimes you want to add emphasis to subject matter in the middle of the frame, using center weighting, or meter from one precise area in the frame, using the spot metering capability.

✦ **Use tone compensation:** You can actually tell the D70 what kind of image you have, so it will apply its own specialized tonal curves to the image as it is shot. Press the menu button, select the shooting menu, and scroll to Optimize Image ⇨ Custom ⇨ Tone Comp. There, you can choose Automatic, Normal, Low Contrast, Medium Low, Medium High, High Contrast, or Custom (which applies a tonal curve you've uploaded using Nikon Capture).

✦ **Apply EV settings:** Hold down the EV button, and spin the main command dial to apply up to plus or minus five stops worth of exposure in 1/2- or 1/3-stop increments (depending on how you've set up your D70 in the Custom Settings menu). EV actually adds or subtracts exposure from the D70's default meter reading using aperture or shutter speed changes, depending on what the current program mode specifies. The new shutter speed or f-stop appears in the viewfinder, so you'll know what your EV change has done.

✦ **Bracketing:** Hold down the BKT button on the back of the camera and spin the main command dial to activate bracketing for exposure, white balance, or flash, depending on how you've set up your D70 in the Custom Settings menu. Depending on which bracketing program you've selected, the D70 will vary the settings for the next two or three exposures, using your bracketing specifications. As demonstrated in figure 3.12, bracketing doesn't fine-tune an individual exposure but, rather, lets you take a series of pictures, one of which, you hope, is optimal.

Tip
When you're using Programmed mode, the D70 will select the correct exposure for you. However, if you decide you want to use a different shutter speed and f stop combination for that exposure, you can do that by spinning the main command dial. This feature lets you switch quickly from, say, 1/500 second at f/11 to 1/1,000 second at f/8 or 1/250 second at f/16, quickly and easily.

3.12 Bracketing lets you take a series of photos at different settings.

Understanding Depth of Field

The final basic aspect of photography that sometimes needs review is depth of field (DOF). While DOF is a familiar topic for those who have been using film SLR cameras, anyone who stepped up to the Nikon D70 from a point-and-shoot digital camera may be foundering in brand-new territory.

That's because digital snapshot cameras have much smaller sensors that require lenses with shorter focal lengths to achieve the same image size, and depth of field is determined by the focal length of the lens and the distance from the camera to the subject. So, that 7mm to 21mm 3X zoom lens on your point-and-shoot camera may have the same field of view as a 35mm to 105mm zoom on a full-frame film camera, but the depth of field will be much greater.

The telephoto position, for example, will have the same depth of field as a 21mm lens on a film camera.

The larger sensor on your D70 calls for somewhat longer lenses, but the extra depth of field still accrues, although to a lesser extent. The kit lens, for example, has the same field of view as a 27mm to 105mm lens on a film camera, but the depth of field at each zoom position is closer to what you'd expect from the 18mm–70mm lens it really is.

If depth of field is important to you because you want to maximize or minimize the range of your image that's in focus, the depth of field preview button is your best friend. Some lenses have DOF markers on their barrel that let you estimate depth of field at a particular f-stop.

What's depth of field?

It's difficult to talk about depth of field in concrete terms because it is, for the most part, a subjective measurement. By definition, *depth of field* is a distance range in a photograph in which all included portions of an image are at least acceptably sharp. What's acceptable to you might not be acceptable to someone else and can even vary depending on viewing distance and the amount the image has been enlarged.

Strictly speaking, only one plane of an image is in sharp focus at one time (see figure 3.13). That's the plane selected by your D70's autofocus mechanism, or by you (if you've manually focused). Everything else, technically, is out of focus. However, some of those out-of-focus portions of your image may still be acceptably sharp, and that's how we get depth of field ranges.

3.13 When you've focused on the pitcher in back, the cup in front will be out of focus.

As you probably know, the DOF range extends one third in front of the plane of sharpest focus, and two thirds behind it. So, assuming your depth of field at a particular aperture, focal length, and subject distance is 3 feet, everything 1 foot in front of the focus plane and objects 2 feet behind it will appear to be sharp.

If you plan on making a grab shot and don't want to risk losing it while your D70 autofocuses, you can switch to manual focus and set your lens at a point known as the *hyperfocal distance*. This distance is a point of focus where everything from half that distance to infinity appears to be acceptably sharp. For example, if your lens has a hyperfocal distance of 4 feet at a particular focal length, everything from 2 feet to infinity would be sharp. The hyperfocal distance varies by the lens focal length and the aperture in use. On the Internet, you can find charts that help you calculate hyperfocal distance.

Most of the time, DOF is described in terms of the size of the *circle of confusion* in an image. A portion of an image appears sharp to our eyes if fine details seem to be sharp points. As these sharp points are thrown out of

focus, they gradually become fuzzy discs rather than points, and when that happens we deem that part of the image unacceptably blurry. The closer we are to the image and the more it has been blown up, the larger its circles of confusion appear, so depth of field that looks acceptable on a computer display might be unacceptable when the same image is enlarged to poster-size, hung on the wall, and examined up close.

To make things even more interesting, some of these out-of-focus circles are more noticeable than others, and can vary from lens to lens. This particular quality is called *bokeh,* after *boke,* the Japanese word for "blur." (The *h* was added to help English speakers avoid rhyming the word with *broke.*) The bokeh qualities of a particular lens are determined by factors like the evenness of its illumination and the shape of the diaphragm. (In some cases, the out-of-focus circles can take on the shape of the lens iris!)

Lenses with good bokeh produce out-of-focus discs that fade at their edges, in some cases so smoothly that they don't produce circles at all, as in figure 3.14. Lenses with intermediate bokeh qualities generate discs that are evenly shaded, or perhaps have some fade to darkness at their edges. The worst lenses create discs that are darker in the center and lighter on their edges, as in figure 3.15. You've probably seen the "donut hole" bokeh that result from catadioptic or "mirror" lenses, which is either the most atrocious bokeh possible, or else a creative effect, depending on your viewpoint.

3.14 When the out-of-focus discs blend together smoothly, they're much less distracting.

3.15 Individual discs with dark centers and bright edges call attention to out-of-focus areas of your image.

Working with Light

As a photographer, light is one of your basic tools. The quantity and quality of the light you work with has an effect on every other aspect of your photography. The amount of light available controls whether you can make an exposure at all, how well you can stop action, whether you can slow down a shutter enough to use movement blur creatively, and how you apply selective focus. The distribution of light affects the tonal values and contrast of your photo. The color of the light determines the hues you see.

In many ways, photography (*light writing* in ancient Greek) depends as much on how you use light as it does on your selection of a composition or a lens. Great books have been written on working with lighting; for this field guide, I concentrate on some of the nuts and bolts of using the lighting tools available for the Nikon D70 digital SLR.

Light falls into two categories: continuous light sources, such as daylight, incandescent and fluorescent light; and electronic flash. Both forms are important.

D70 Flash Basics

Electronic flash illumination is produced by accumulating an electrical charge in a device such as a capacitor, and then directing that charge through a glass *flash tube* containing a gas that absorbs the electricity and emits a bright flash of photons. If the full charge is sent through the flash tube, the process takes about 1/1,000 second and produces enough light (with the D70's built-in flash in manual flash mode) to properly illuminate a subject 10 feet away at f/5.6 with an ISO 200 sensitivity setting.

Exposure is calculated in this way because light diminishes with the distance (actually, the *square* of the distance). An object that is 4 feet from the flash receives 16 times as much illumination as one that is twice as far at 8 feet. Photographers call this the *inverse square* law.

Through its exposure sensing system, the D70 is able to determine (via a preflash that you probably won't even notice) whether sufficient light is reflected from the subject and change the exposure accordingly. If the subject is more than 10 feet away, the camera could use a larger f-stop, such as f/4, or if the subject is closer, a smaller f-stop, such as f/8.

In practice, the D70's Speedlight will vary the *amount* of light issued by the flash tube to reduce the illumination reaching subjects that are closer to the camera. This is done by dumping some of the electrical energy before it reaches the flash tube, in effect making the duration of the flash shorter. The basic intensity is the same; the flash is just briefer (roughly 1/50,000 second when squelched the equivalent of seven f-stops, or 1/128 full power).

No matter what the duration of the flash, it generally occurs only when the D70's shutter is fully open. As with most SLR cameras, the D70's mechanical focal plane shutter consists of two curtains that follow each other across the sensor frame. First, the *front curtain* opens, exposing the leading edge of the sensor. When it reaches the other side of the sensor, the *rear curtain* begins its travel to begin covering up the sensor. The full sensor is exposed when the flash is tripped. If the flash went off sooner or later, you'd see a shadow of the front or rear curtains as they moved across the frame.

With the Nikon D70, the sensor is completely exposed for all shutter speeds from 30 seconds (or longer) to 1/500 second. The maximum top shutter speed that can be used with electronic flash is called the camera's *sync speed.* Under some circumstances, flash can be used at higher than the nominal sync speed, using electronic trickery to make the flash last longer than the shortest interval when the shutter is completely open. Such techniques reduce the effective power of the flash and are useful chiefly for close-up photography.

Note

> *Compared to most other digital SLRs, which may sync as slow as 1/180 second, the D70's sync speed is relatively high, which can be useful when you want to eliminate ghost images as described later in this chapter.*

What does all this mean in the field? These basics produce some corollaries that affect your shooting:

✦ Because the flash occurs for a brief time only when the shutter is completely open, the actual shutter speed has no effect on the flash's action-stopping power. A 1/1,000 second flash will freeze action at 1/2 second in exactly the same manner as at 1/500 second.

✦ If the shutter is open long enough to produce an image from the non-flash (available) light in a scene, you'll get a second exposure in addition to the flash exposure. If your subject is moving, this second exposure will appear as a blurry ghost image adjacent to the sharp flash image. You must always take into account the fact that you're taking two exposures, not one, when shooting with flash.

✦ Photos taken with the automatic flash squelching in operation have an effective exposure speed that's much shorter than 1/1000 second — as brief as about 1/50,000 second at the lowest power used for very close subjects. You can use this quality to stop very fast action.

4.1 The brief duration of an electronic flash can freeze the quickest action.

✦ After an exposure has been made, it takes a short time for the flash to recharge to full power, usually 1 to 2 seconds. If your photo didn't require the full capacity of the flash, you may be able to take another picture more quickly.

✦ Because of the effects of the inverse square law, electronic flash produces a correct exposure *only* at one distance. Objects that are farther away or closer to the flash will be under- or overexposed. For example, if you're shooting a person standing 8 feet away, someone positioned 4 feet behind your main subject will receive about one f-stop less exposure; a bystander 8 feet farther will receive two fewer f-stops' worth of light. Someone in the foreground 4 feet from the camera will be overexposed by two full stops. You can think of this phenomenon as *depth-of-light,* although the distribution is the opposite of depth of field: on a foot-by-foot basis, there's more *behind* the main subject than in front of it.

Flash Sync Modes

Flash exposure calculation works with any of the D70's *sync modes,* which control how and when the electronic flash is triggered. These include:

✦ **Front sync:** In this mode, which is the default, the flash fires at the beginning of the exposure when the first curtain has reached the opposite side of the sensor and the sensor is completely exposed. The sharp flash exposure is fixed at that instant. Then, if the shutter

speed's exposure is long enough to allow an image to register by existing light as well as the flash, and if your subject is moving, you'll end up with a streak that's in *front* of the subject, in the direction of the movement.

4.2 Front sync can produce ghosts that appear ahead of the direction of movement.

✦ **Rear sync:** In this optional mode, available only in S and M modes, the flash doesn't fire until the *end* of the exposure. The ghost image is registered first and terminates with a sharp image produced by the flash at your subject's end position, providing a ghost streak behind the subject, similar to the streaks you see in comic books and movies about superheroes. If you must have ghosts (or want them for creative effect), rear-curtain sync is more realistic.

✦ **Slow-sync:** This mode, available only when the D70 is set to P or A shooting modes, combines slow shutter speeds with flash to produce two different images (one from the flash, the other from the ambient light) so that your flash pictures have a background that isn't completely black. Using a tripod and avoiding moving subjects

when using slow sync is best, because the D70 can program exposures up to 30 seconds long, and you're likely to get ghost images otherwise. (Use slow rear-curtain sync instead, to place the ghosts behind the subject.)

4.3 Rear sync creates more realistic trailing ghost images.

✦ **Multi-modes:** Red-eye reduction uses a preflash of the focus-assist lamp to reduce the chances of red-eye effects. Supposedly, the preflash causes your subjects' pupils to contract and stifle some of the reflection. Red-eye reduction is available as an optional mode both for front-sync and slow-sync settings. In addition, in P and A modes, you can choose to combine slow sync with rear-curtain sync.

Flash Exposure Modes

Your D70 determines the correct exposure by emitting a preflash just prior to the actual exposure, and then measuring the amount of light reflected from the subject. The preflash occurs almost simultaneously

with the main flash, so you probably won't even notice it.

Several different flash exposure modes are available. They can be set using the menus on the camera, or, in the case of three optional modes with the SB-600 and SB-800 flash, on the flash itself.

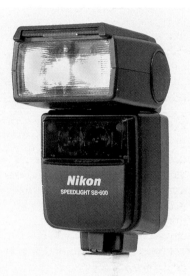

4.4 The Nikon Speedlight SB-600 supports all i-TTL features.

✦ **i-TTL:** Nikon calls its basic through-the-lens (TTL) flash exposure system *i-TTL.* At this writing, the full features of i-TTL are supported only by the Nikon D70's internal electronic flash, plus the Nikon SB-600 and SB-800 flash units. In use, the system uses information supplied by the lens's autofocus system (which tells the camera the focal length of the lens and the distance of the main subject) with the measured light reflected during the preflash, and attempts to balance the flash illumination with the

ambient light to produce the best exposure.

✦ **TTL:** A second mode, called simply TTL, is used when you select spot metering or manual exposure. This mode calculates only the exposure needed to properly expose the subject. The D70 does not try to balance the flash with ambient light.

✦ **AA (Auto Aperture):** This mode, available with the SB-600/SB-800 external flash (and a few older Nikon flash units), takes some of the control from the camera and calculates exposure in the flash itself. The camera tells the flash the ISO and aperture settings, and a sensor on the front of the flash measures light reflected by the subject.

✦ **A (Automatic):** This mode, similar to AA mode, may be all you have available with some non-Nikon flash units. The aperture and ISO setting must be entered into the flash manually, and the flash measures the amount of light reflected by the subject and shuts off at the appropriate time.

✦ **Manual:** You can set the power of the internal D70 flash manually using the menus, or set the power output of an external flash on the Speedlight itself. This mode is useful when you have a handheld electronic flash meter or want to set the flash level yourself for other reasons.

Flash Exposure Compensation

If you want to tweak the exposure set for you by your flash, you can use the D70's flash exposure compensation system. To make this adjustment, hold down the flash exposure compensation button on the left side of the top surface of the camera, and turn the main command dial until the setting you want (+ or − 2 EV) shows in the status LCD on top of the camera.

This feature is especially useful when you're trying to use fill flash to brighten up shadows and your D70 provides either too much or too little fill.

Using External Flash

As you work with your D70, you may find yourself constrained by the limitations of the built-in flash. There's a lot to like about the internal flash. It's always there when you need it, requires no extra batteries, and is well-integrated with the D70's exposure system. The built-in flash is more or less a no-brainer accessory.

Unfortunately, the internal flash is relatively limited in output, so your effective range may be 10 to 12 feet at ISO 200. Its location so close to the lens tends to exacerbate red-eye problems, even with the ineffectual red-eye pre-flash in use. The flash's position also means it's not very useful when shooting close-up photos or some wide-angle shots. The lens or its lens hood can cast a visible shadow on your subject. There's no way to re-aim the D70's internal flash to bounce it off the ceiling, walls, or reflectors. Finally, a lot of light is wasted by the internal flash, which keeps the same coverage area whether you're using a wide-angle or telephoto lens.

An external flash unit, particularly one designed especially for the D70, solves many of these problems. The maximum output of the SB-800 Speedlight, for example, allows

an exposure of about f/18 at 10 feet with an ISO setting of 200 — more than three stops more light than the D70's built-in flash. Even mounted in the camera's hot shoe, an external flash is much farther away from the lens, reducing red-eye problems. (It can also be swiveled up or down or from side to side to change its coverage while mounted on the hot shoe.) You can remove the flash from the camera (if you use a connecting cable or set it for wireless Commander mode) and point it any way you like for bounce flash or close-ups. The flash coverage can be adjusted narrower or wider to better suit the focal length of the lens being used. Your D70 can even tell the flash unit the focal-length setting so this adjustment is automatic.

Triggering external flash

You can connect an external flash by sliding it into the hot shoe, by connecting its cord to an Nikon AS-15 Sync Terminal Adapter, or Wein Safe Sync adapter, or by using an external cable, such as the Nikon SC-28 or SC-29. The chief difference between the two Nikon cables is that the SC-29 has a focus assist light built into the portion of it that slides into the hot shoe. That light supplants the light built into the flash unit, on the theory that a focus assist lamp on the camera will be better positioned than one on a flash that's not mounted on the camera.

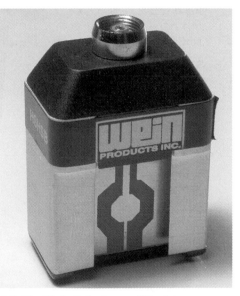

4.6 The Wein Safe Sync will isolate your strobe's triggering voltage.

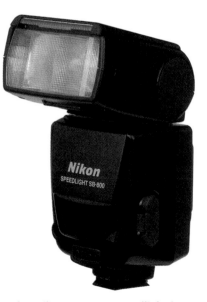

4.5 The Nikon SB-800 Speedlight is a more powerful external flash unit.

Many of the electronic flash's automated functions are available with non-Nikon external flash units, as well. A few even support the Nikon i-TTL exposure system. However, not all Nikon flashes support all the features of the SB-600/SB-800.

You can also trigger an external flash by equipping that flash with a light-sensing slave unit (some have them built-in) and using the D70's internal flash to trigger the external unit. Use the menus (Custom Settings menu #19) to set the internal flash to Manual mode and 1/16 power. The reduced power will minimize the effects of

the internal flash in your photo but will still be enough to trigger the remote unit.

If you're using a Nikon SB-600 or SB-800 flash unit (or multiple units), there's an even better way of achieving wireless operation. Use CSM #19 to set the internal flash to Commander mode. Then, press the Sel button on your external flash, change the flash's mode to Remote, and select Channel 3. Assign this setting to Group A, and you're ready to go. (Your flash's manual explains all these options in more detail.) You can actually use several different external flashes in this way.

Using multiple flash units

You'll find that using several flash units provides you with great flexibility in lighting your subjects. The only tricks to using several flash units involve triggering them and visualizing how the illumination from the flash will look when applied to your subject.

 Cross-Reference *Suggestions for using multiple flash units can be found in Chapter 6.*

Your D70 in Commander mode (the camera's wireless triggering mode) can control several specific external Nikon flashes, such as the Nikon SB-600 or SB-800. You can also use flash equipped with slave sensors, or attach add-on slave sensors to your flash. The light from one flash will automatically trigger the others.

Visualizing the effects of your flash is usually accomplished through the use of modeling lights. Studio flash units generally have incandescent lamps located concentrically with the flash tube so their light provides a very good approximation of the actual light you'll get from the flash. These modeling lamps can be set to act proportionately; that

is, they get brighter or dimmer as you adjust the output level of the studio flash.

Some of the latest Nikon external flash units simulate a modeling lamp by firing repeatedly at a lower power to supply an almost continuous light for a few seconds. You can use this light to judge how your flash will appear. This is a make-do approach at best; true modeling lights like those found in studio flash can remain on for hours at a time without consuming much power or overheating. Still, it's nice to have this capability available in a small battery-powered unit.

When using multiple flash units, you'll especially want to take advantage of options like the snap-on diffuser dome that comes with the SB-800, the built-in bounce-light cards, and wide-angle lenses that spread the illumination of your flash over a broader area. You can also add colored gels to change the hue of each individual flash.

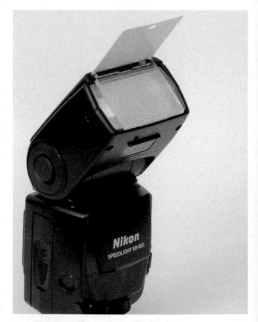

4.7 Some Nikon Speedlights come with slide-out wide-angle diffusers and bounce-light cards.

Repeating flash

Repeating flash is a feature of the Nikon SB-800 unit to fire off a series of brief flashes over a period of time to provide a succession of images in a single photo. For example, you might want to analyze your golf stroke. Set up the camera on a tripod in a dark room with a dark background, take a 1-second exposure, and execute your stroke during that span. The SB-800, set for repeating flash, will capture a sequence of shots of your stroke.

You can adjust the flash for 1/8 to 1/128 power, and choose from about 4 shots to 90 shots per second, depending on the power level you've chosen. Because reduced power is used to allow the multiple shots, this capability is most useful for close-up photography of things like water-drop splashes. Your golf-stroke shot would probably require using a higher ISO setting to provide enough light for a decent number of shots during your stroke.

Studio flash

The D70 can be connected to studio flash units if you want the ultimate amount of control and access to accessories such as soft boxes, umbrellas, radio controls, and other add-ons that are available in more limited variety for Nikon's own Speedlights. Such lights are available in inexpensive versions costing as little as $200 per light. The least expensive units, called *monolights*, have built-in power supplies so you don't have to fuss with bulky external power packs.

Studio lights generally attach to the camera using a PC connection, which the D70 lacks. You can purchase the Nikon AS-15 Sync Terminal Adapter, which fits in the hot shoe and allows connecting any flash using a PC cord. However, the triggering voltage of the external flash should be limited to 24 volts or less. Older flash units may have higher voltages. In that case, use a component such as the Wein Safe Sync, which performs the same function as the AS-15 adapter, but isolates your camera from the flash's voltage, eliminating the chance of frying your D70's internal circuitry.

Conquering Continuous Lighting

The other form of light you'll work with is continuous lighting, either in the form of available light that's already on the scene (including daylight, outdoors), or add-on lamps, lighting fixtures, or reflectors that you supply expressly for photographic purposes.

Continuous lighting has some advantages over electronic flash. You always know what lighting effect you're going to get. Daylight and lamps of all types are their own modeling lights. Any such light automatically shows how it affects your scene and how it interacts with other continuous lighting in use. It's easier to measure exposure with daylight/incandescent/fluorescent-style lighting. Daylight tends to fill a scene completely, but artificial lights suffer from the same light fall-off due to the inverse-square law characteristics as flash (as described earlier in this chapter) — but it's usually easier to increase your depth-of-light by providing broader, more diffuse lighting from multiple sources. Continuous lighting "syncs" with any shutter speed for any exposure.

On the other hand, continuous lighting doesn't have the built-in action-stopping capabilities of electronic flash, nor is it always as intense. In the studio, you might have to mount your D70 on a tripod to get

sufficient exposure, where an electronic flash allows hand-holding the camera under the same conditions — usually a better option when shooting people or pets, as long as the ambient light in the scene is not strong enough to record an image on the sensor.

Types of continuous lighting

Fortunately for photographers, continuous lighting is much less complicated and confusing than flash. The main thing you'll want to be concerned about is the color of the light, which is referred to by the terms color temperature and white balance. Both refer to the same thing: the tendency of various types of illumination to change the apparent overall color of the light used to make the exposure.

As I mentioned at the beginning of this section, there are three types of continuous lighting: daylight, incandescent/tungsten light, and fluorescent light. There are also some oddball light sources, such as sodium vapor illumination, that share some of the usual lighting renditions of fluorescent lighting, even though the process used to generate the light is different.

✦ **Daylight.** This is the light produced by the sun, even on cloudy days when the sun isn't visible. Sunlight can be harsh when it's direct, and softer when it's diffused by the clouds, filtered by shade, or illuminates a subject indirectly as it bounces off walls, other objects, or even reflectors you might use. Strictly speaking, moonlight is sunlight, too, but it's rarely intense enough for photography of anything other than the moon.

✦ **Incandescent/tungsten light.** This kind of continuous light is produced by a heated filament inside (usually) a glass bulb that contains a vacuum. The tungsten filament is, in a sense, burning, like the sun itself. Unlike the sun, the filament tends to burn out during our lifetimes and the bulb must be replaced. Incandescent illumination is often called tungsten light because tungsten filaments are used in the most common variety of bulb.

✦ **Fluorescent light.** Fluorescent light is produced through an electro-chemical process in a tube full of gas, rather than burning (which is why the bulbs don't get as hot.) The type of light produced varies depending on the phosphor coatings and type of gas in the tube. So, the illumination produced by fluorescent bulbs can vary widely in its characteristics, as you'll learn later in this chapter.

Color temperature

Continuous light sources that produce illumination from heat, such as daylight or incandescent/tungsten illumination produce illumination of a particular color, which can be characterized by its color temperature (or, in digital camera terminology, white balance.) Electronic flash, another type of light that is produced by a burst of heat, also has a characteristic color temperature. Fluorescent light doesn't have a true color temperature, but its white balance can be accounted for nonetheless.

The term color temperature comes from the way it is defined. Scientists derive color temperature from a mythical object called a black body, which is a substance that

absorbs all the radiant energy that strikes it, and reflects none at all. A black body not only absorbs light perfectly, it emits it perfectly when heated. At a particular physical temperature, this mythical body always emits light of the same wavelength or color. That makes it possible to define color temperature in terms of actual temperature in degrees on the Kelvin scale that scientists use. Incandescent light, for example, typically has a color temperature of 3200K to 3400K ("degrees" is not used). Daylight may be 5500K to 6000K.

Photographers refer to these color temperatures using terms like "warm/reddish" or "cold/bluish," but the actual physical temperatures being described are just the reverse. As the black body is heated, it first glows with a dull reddish light, as you might see in an iron ingot that is being heated. As the temperature increases, the light becomes yellowish, and then blue. Humans often associate reddish hues with warmth and blue with cold, so that's why you'll see indoor illumination called warm, and bright daylight cold, even though the color temperature of incandescent light (3400K) is lower than that of daylight (5500K.) If you can remember that "cold" lighting is called that because it reminds us of ice and snow, and not because of its actual temperature, you can keep the concept straight.

Coping with white balance

In the digital camera world, white balance adjustments are how we compensate for the different color temperatures of light. As I mentioned, all light sources, including electronic flash, can vary in the color balance of their illumination. Each individual source has its own particular color, popularly (but inaccurately) called white balance. This color can be partially — but only partially — specified using the scale called *color temperature* that was described in the previous section.

Digital camera sensors can't automatically adjust to the different colors of light the way our eyes do. So, you must tell the sensor what type of lighting it is looking at by specifying a color temperature. The D70's electronics can make some pretty good guesses at the type of lighting being used, and its color temperature, simply by examining and measuring the light in the scene. But when the camera's white balance setting is on Auto, you might not always get the results you want. That's why the D70 has an array of manual white balance settings, and the ability to measure and set white balance from a neutral area of your scene. You can select from daylight, incandescent light, and so forth as described in that chapter. You can also fine-tune the white balance to a little warmer or cooler, as needed for particular situations.

 Cross-Reference *For more information on setting your white balance manually, see Chapter 2.*

Things get a little complicated when we introduce fluorescent lights into the mix, because such lights don't produce illumination from heat but, rather, from a chemical/electrical reaction. So, fluorescent light can't be pegged precisely to the color temperature scale. Nor do such lights necessarily produce proportionate amounts of all the colors of light in the spectrum, and the color balance of fluorescents varies among different types and vendors.

That's why fluorescents and other alternative light technologies such as sodium-vapor illumination can produce ghastly-looking human skin tones. Their spectra can be lacking in the reddish tones we associate with

healthy skin and emphasize the blues and greens popular in horror movies and TV procedural investigation crime shows.

These light sources can also be graded using a system called *color rendering index*, or CRI, which measures how well a particular light source represents standard colors compared to another light source, using a scale from 0 (really bad) to 100 (perfect).

For example, daylight and incandescent lights are assigned a CRI of 100. Daylight fluorescents may have a CRI of about 79; not great, but acceptable compared to other sources such as white deluxe mercury vapor lights (CRI 45), or low-pressure sodium lamps (CRI 0-18). You won't generally use CRI in photography, except when checking, say, a fluorescent lamp you intend to use, to see how close its CRI is to ideal. (Warm

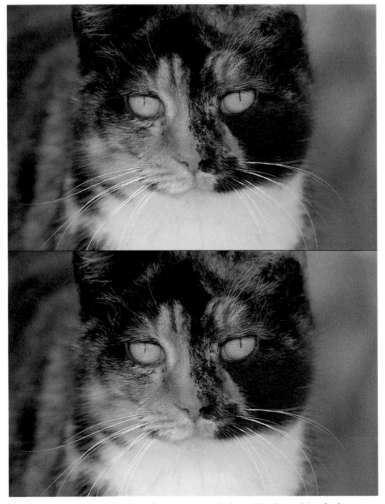

4.8 An image exposed under tungsten light with the white balance set to Daylight will appear to be too warm (top); an image exposed under daylight illumination with the white balance set to tungsten will seem too bluish.

white fluorescents may have a CRI of 55; a deluxe cool white fluorescent, a CRI of 86.)

The D70 does a fairly good job of compensating for the most common types of fluorescent tubes, but when colors are critical, it's best to use incandescent light, flash, or daylight.

If you shoot RAW, you can adjust the white balance when the image is imported into your image editor. If you're an old-school photographer, you can use color-correction filters on your lenses, including the special filters such as the FL-D created for particular types of fluorescent lights. Although electronic flash color balance can vary, depending on the flash exposure, advanced units like the Nikon SB-800 can report its current color balance to the D70 for automatic compensation.

If you're not satisfied with the automatic white balance settings you're getting, you can select a manual setting.

Cross-Reference *See Chapter 2 for instructions on setting a manual white balance.*

All About Lenses

Although the Nikon D70 is called a single lens reflex, that doesn't mean you're limited to a single lens! In fact, the ability to swap out one set of optics for another is one of the two or three top reasons for switching from a non-SLR digital shooter to a camera like the Nikon D70. Lenses give you extra flexibility and give your picture-taking possibilities a boost. Add-on lenses are arguably the number-one expansion option available for your camera.

This chapter tells you everything you need to know about choosing and using the best lens for the job.

Expanding Your Lens Options

If you didn't already own a Nikon SLR and lenses, you probably purchased your D70 with a lens. If so, the odds are good that you went ahead and bought the pre-packaged kit, which includes the 18–70mm f/3.5–4.5G ED-IF AF-S DX Zoom Nikkor (the "kit" lens). Some dealers substitute a different lens of similar zoom range built by a third-party lens vendor, such as Sigma.

For example, Sigma makes a popular 18mm–125mm zoom for digital cameras that is priced roughly the same as the kit lens but offers a little more telephoto reach. Or the dealer might have wanted to provide an extra-low kit price and packaged the D70 with Sigma's budget-priced 18mm–50mm zoom.

A third scenario might be that you had some definite ideas about what lens you wanted with your D70, so you chose something other than the kit lens from the Nikon line or from third-party vendors.

In any of these cases, if you have the D70 and just one lens, you're ripe for an add-on.

Kit lens advantages

If you bought your D70 with the kit lens, you have a lens that's extremely versatile and suitable for a wide variety of picture-taking situations. Here are some of the advantages of the kit lens:

✦ **Low cost:** For about $300, this lens is a very good value and is solidly constructed.

✦ **Nice 3.8X zoom range:** When you factor in the 1.5X lens multiplier factor (more on that later), this lens corresponds to a 27mm–105mm zoom on a full-frame film camera. At the wide end, that 27mm provides a moderately wide field of view, certainly enough for everyday shooting. The 105mm telephoto position falls smack into the range considered excellent for portraits and some types of close-in sports activities.

✦ **Adequate aperture speed:** The f/3.5 maximum aperture at the wide-angle position and f/4.5 at the telephoto end are about one-half to a full f-stop slower than what you'd expect from a prime (non-zoom) lens at the equivalent focal length. However, faster lenses cost a lot more, and the kit lens's speed is, at least, adequate.

✦ **Good image quality:** Even at its low price, the kit lens includes extra-low dispersion glass and aspherical elements that minimize distortion and chromatic aberration; it's sharp enough for most applications. If you read the user evaluations in the online photography forums, you know that owners of the kit lens have been very pleased with its image quality.

✦ **Compact size:** At less than 14 ounces and roughly 3 inches in diameter and length, this is a compact optic that makes a good "walking around" lens you can take with you when you plan to leave all your other gear at home.

✦ **Fast, relatively close focusing:** The autofocus mechanism of the 18–70mm lens is fast and quiet, and will get you down as close as 14 inches, so you can use it as a semi-macro lens in a pinch.

If you can afford only one lens for your D70, this is one to consider. Unless you shoot

5.1 The 18–70mm f/3.5–4.5G ED-IF AF-S DX Zoom Nikkor "kit" lens.

many ultra-wide-angle photos, or you need to reach out with a longer telephoto, the kit lens can handle most of the picture-taking situations you're likely to encounter.

Why switch?

After you've used your D70 for a while, you'll certainly discover that there are at least a few pictures you can't take with your existing set of lenses. It's time to consider buying an add-on lens. Here are some of the key reasons for making a switch:

✦ **Wider view:** When your back is against a wall — literally — you need a lens with a wider perspective. A lens with a shorter focal length will let you take interior photos without going outside to shoot through a window, or asking the owner of a 21st-century vegetable cart to move so you can photograph that 16th-century cathedral. You can emphasize the foreground in a landscape picture while embracing a much wider field of view. Move in close with a wide-angle lens to use the perspective distortion that results as a creative element. For the D70, wide-angle lenses generally fall into the 10mm to 24mm range, and include both fish-eye (distorted, curved view) and rectilinear (non-distorted, mostly) perspectives.

✦ **Longer view:** A longer telephoto lens can do several things for you that a shorter lens cannot. A telephoto lens reaches out and brings distant objects closer to the camera; it's especially valuable when "sneaker zoom" won't work. A long lens has less depth of field, so you can more easily throw a distracting background or foreground out of focus for a creative effect. Telephoto lenses have the opposite perspective distortion found in wide-angle lenses:

5.2 Get a broader view with a wide-angle lens.

Subjects, such as faces, appear to be broader and "flattened." So, the appearance of a narrow face might be improved simply by using a longer zoom setting. That same distortion is great when you want to reduce the apparent distance between distant objects — the same effect used in Hollywood to make it appear that the hero is darting in and out between oncoming cars that are actually separated by 30 feet or more. With the D70, a 50mm lens has something of a telephoto effect, and longer lenses extend out to 600mm or much more.

✦ **Macro focusing:** Macro lenses let you focus as close as an inch or two from the front of the lens, offering a different perspective on familiar objects. You'll find these lenses available both as prime lenses (such as the popular 60mm and 105mm Micro-Nikkors), and as macro-zoom lenses. The available

range of focal lengths is important, because sometimes you want to get as close as possible to capture a particular viewpoint (say, to emphasize the stamens in a delicate flower petal) or back off a few feet to avoid intimidating your subject (perhaps a hyperactive hummingbird).

5.4 Macro lenses provide extra magnification, as in this shot of a cocktail glass.

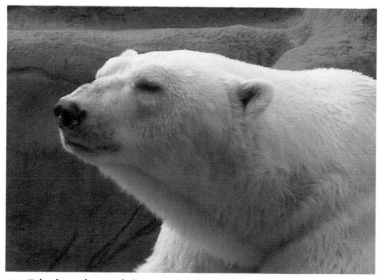

5.3 Telephoto lenses bring you up close.

✦ **Sharper image:** Some lenses, such as fixed-focal-length prime lenses, are sharper, overall, than others. Inexpensive zoom lenses are often noticeably less sharp than the discriminating photographer might prefer. In addition, lenses rarely have the same sharpness at all apertures and zoom settings. A wide-angle lens, for example, might have lots of barrel distortion and fuzzy corners at its widest setting, and if you shoot many photos at that focal length you might be better served with a different optic. Lenses also fall down in sharpness when they're asked to do things they weren't designed for, such as taking macro photos with a zoom that's best suited for sports photography, or shooting at maximum aperture under low-light conditions.

✦ **Faster aperture:** Your 300mm f/4.5 lens may be sharp enough and have the perfect focal length for the sports photography you're planning to do. But, you find that it's not fast enough to let you use a high enough shutter speed. What you may really need is a 300mm f/2.8 lens, optimized for shooting wide open. The difference between a shot grabbed at 1/500 second at f/2.8 and the same image captured at 1/180 second at f/4.5 can be significant in terms of action stopping. In addition, your f/2.8 lens might be sharpest when stopped down to f/5.6. You might have to use f/8 to get similar sharpness with the f/4.5 optic.

✦ **Special features:** Another reason to choose an add-on lens is to gain special features. Although the close-up capabilities of a macro lens are certainly a special feature, you have more exotic capabilities at your disposal. These include lenses with shifting elements that provide a certain amount of perspective control; and optics like the Nikon DC (defocus control) series that let you adjust how the out-of-focus portions of an image appear (especially useful in portraiture). Other special lenses include fisheye lenses, ultra-violet lenses for scientific applications, and vibration reduction lenses that compensate for camera shake and give you sharper results at slower shutter speeds. When you need or want an unusual feature, you'll be glad your D70 has interchangeable lenses and the ability to use older Nikon mount optics.

Choosing Between Zoom or Fixed-Focal-Length Lenses

It wasn't that long ago that serious photographers worked almost exclusively with fixed-focal-length/prime lenses rather than zooms. Many zoom lenses were big, heavy, and not very sharp. The most expensive zooms were sharp, but they were still big and heavy. For example, the Zoom-Nikkor 50mm–300mm f/4.5 optic that set the standard for such lenses, weighed five pounds and was almost a foot long! Today, you can buy a 28mm–300mm lens for the D70 that's about 3 inches long and weighs less than a pound.

Some of these early zoom lenses had a nasty habit of shifting focus as you zoomed in or out. They were used primarily for applications where it wasn't always practical to change lenses rapidly (such as sports or spot

news), or when the zoom capability itself was needed for a special look, such as the ever-popular "zoom during exposure" effect.

Today, optical science has made great strides, and there are lots of zoom lenses available that even the most snobbish photographer can endorse. They're smaller, lighter, faster, and sharper. For example, Nikon's 28–200mm f/3.5–5.6G ED-IF AF Zoom-Nikkor is a little gem that measures 2.7 by 2.8 inches, weighs just 13 ounces, and focuses down to 1.2 feet. Many D70 users favor this lens as a "walking around" optic when they expect that longer telephoto reach will be more valuable than extra-wide-angle perspective. The chief drawback of this lens is that it's slow (f/5.6) at the telephoto position.

Prime lens considerations

Use a prime lens when you must have the ultimate in sharpness or speed at a particular focal length. For example, Nikon offers f/1.4 lenses in fixed 28mm, 50mm, and 85mm focal lengths that are unmatched for speed and resolution. You can buy 300mm and 400mm Nikkor lenses with f/2.8 maximum apertures, and 500mm or 600mm f/4 super-telephotos. In contrast, even wide-angle and short telephoto zoom lenses from Nikon with f/2.8 maximum apertures tend to be very expensive.

Prime lenses are a good choice when you have freedom of movement and can get closer to your subject, or back up a little to fill the frame appropriately.

Zoom lens considerations

Size, speed, and sharpness tend to be the chief drawbacks of zoom lenses. Because of the additional elements required to zoom, these lenses tend to be quite a bit larger than their fixed-focal-length counterparts. The disparity can be huge if you take most of your photos at the short end of the zoom range; a 50mm f/1.8 prime lens, at 5 ounces, might be only 20 percent of the size and weight of a slower zoom lens that covers the same focal length.

The most affordable zoom lenses tend to change their maximum aperture as the focal length increases. An f/3.5 lens might become an f/5.6 lens when cranked all the way out. A smaller maximum f-stop brings with it a penalty in exposure flexibility, viewfinder brightness, and autofocus capabilities. (The D70's autofocus system won't function if the f-stop is smaller than f/5.6, which might be the case with a zoom mounted on a teleconverter or that has a maximum aperture of f/6.3 or smaller.) Lenses that don't change their maximum aperture as they zoom are more costly and, typically, much heavier, too.

Lens Compatibility

Among all digital cameras, Nikon lenses are, without a doubt, the most compatible. Indeed, most of the lenses produced for the first Nikon F in 1959 can be used (perhaps with some small modifications) on the latest digital SLRs offered by Nikon, Fuji, and Eastman Kodak Company. That's not the case with other brands. (Canon digital SLRs merely two years old can't use a few of the company's newest lenses.)

Of course, a few Nikkors, such as the earliest fish-eye lenses, extend too far into the camera to be used, or have parts that may intersect with components of the camera body. All Nikon lenses made prior to 1977 must have some simple machining done to

remove portions of the lens mount that interfere with tabs and levers added to later models for functions such as autofocus, including the D70.

> Tip *Technician John White can perform conversions for you for as little as $25 to $35 (www.aiconversions.com).*

Of course, older lenses can't provide all the features built into the latest optics. The automatic diaphragm works, but features like autofocus and autoexposure may not function. Many D70 users feel that the ability to recycle older lenses is worth the inconvenience of manual focusing and having to calculate and set exposure (just as in the old days).

5.5 Older lenses (bottom) don't have the electronic and mechanical linkages found on newer optics (top).

Decoding Nikon's Lens Code

Choosing the right lens from among the vast universe of new and used lenses that fit the Nikon D70 can be confusing, partially because of the system of letter codes used to indicate a lens's features. Here's a brief checklist that will clear up most of that confusion:

✦ **AI, AI-S:** Nikkor lenses produced after 1977 an automatic indexing feature that eliminated the need to manually align the aperture ring when the lens was mounted. The first lenses to include this feature had the AI or AI-S designation. However, all Nikon optics introduced after 1977 have automatic indexing (except for G Series lenses, because they have no aperture ring), whether that's included in the lens code or not.

✦ **E:** Nikon's Series E lenses are bargain-priced optics with great image quality, but less rugged mechanical innards suitable for use by non-professionals. They frequently include aluminum or plastic parts where brass is used in the most costly Nikkors. However, their lens mounts are all metal, so Series E lenses are more rugged than you might think.

✦ **D:** When a D is included in the lens name, the lens is capable of communicating focus distance information to the camera, which supposedly helps with 3-D matrix metering and flash photography.

✦ **G:** Lenses with this marking have no aperture ring. The aperture must be set by the camera, either

automatically or by spinning the sub-command dial (on the D70). The only caveat you should know is that these lenses cannot be used on older cameras that require an aperture ring.

✦ **AF, AF-D, AF-I, AF-S:** Various AF designations show that the lens is an autofocus lens. The secondary code letter provides additional information: D is a D-type lens; I focuses through an internal motor; S focuses or fine-tunes focus manually even with AF engaged.

✦ **DX:** All DX lenses are designed exclusively for use with digital cameras having the 1.5X crop factor. Their coverage circle isn't large enough to fill up a full 35mm frame. The digital-only design means that these lenses can be smaller and lighter than their full-frame counterparts.

✦ **VR:** These lenses have Nikon's vibration-reduction technology, which shifts lens elements to counteract camera shake or movement, and allow taking photos without a tripod at slower shutter speeds.

✦ **ED:** The ED designation indicates that the lens has elements made of extra-low dispersion glass, which tends to reduce chromatic aberration and other defects. Some lenses use a LD (low dispersion) or UD (ultra low dispersion) marking.

✦ **Micro:** The term *micro* is Nikon's designation for a macro lens.

✦ **IF:** This code means that the lens has internal focusing, so the length of the lens doesn't increase or decrease as the lens is focused.

✦ **IX:** Don't be fooled; the IX lenses can't be used on the D70. They

were produced for Nikon's Pronea APS film cameras. Although many standard Nikkor lenses could be used on the Pronea 6i and Pronea S, the reverse is not true.

✦ **DC:** The DC stands for *defocus control,* which is a way of changing the appearance of the out-of-focus portions of an image, especially useful for portraits or close-ups.

Applying the Lens Multiplier Factor to Your Pictures

Just a quick review: You know that because your D70's sensor is smaller than the 24 by 36mm standard film frame, lenses at a particular focal length produce what appears to be a magnified image, but that is, in fact, just a cropped version of the original image. The D70 provides a 1.5X crop factor.

It's important to recognize that the cropping factor is not a focal-length multiplier, because the true focal length of the lens (along with its depth of field) remains the same. Your 200mm f/3.5 lens isn't really converted to a 300mm f/3.5 optic. It's still a 200mm lens, but you're cropping out the center portion in the camera rather than in Photoshop.

As you've seen, although this multiplier factor can be very cool for those who need fast, cheap telephoto lenses, it makes getting a true wide-angle view that much more difficult.

Of course, because a smaller portion of the lens coverage area is used, the smaller sensor crops out the edges and corners of the

5.6 The Nikon D70's view is just a cropped version of the traditional 35mm film frame.

image, which, with some lens designs, is where aberrations and other defects reside. On the other hand, stretching an extremely short wide-angle lens (10–15mm) to fill the D70's sensor can reintroduce those very distortions that are reduced by the crop factor in longer lenses.

Using a Wide-Angle Lens

A wide-angle lens or wide-angle zoom setting is useful for several picture-taking situations, which were outlined briefly earlier in this chapter. Here's a concise listing of the top reasons for using a wide-angle lens:

✦ **In close quarters:** Frequently, you won't have much room to maneuver indoors if you want to shoot an entire room. Architectural photographers outdoors might find that the perfect position to photograph a building might unfortunately be inside the lobby of the building across the street. Perhaps you want to photograph a celebrity surrounded by a crowd, and backing up an extra 5 feet means you'll have a wall of bodies between your camera and your subject.

✦ **To increase the field of view for distant shots:** You're looking at a stunning panorama and want to capture as much of it as possible. Shoot with a wide-angle lens to grab the broadest possible view.

✦ **To increase depth of field:** Wide-angle lenses offer more depth of field at a given aperture than a telephoto lens. Of course, the fields of view and perspective differs

sharply, but if lots of depth of field is your goal, a wide-angle lens is your best bet.

✦ **To emphasize the foreground:** Using a wide angle on that landscape will also tend to emphasize the foreground details while moving the distant scenery farther back from the camera. You can crop out the foreground, or use it as a picture element. For example if you're photographing a vista that includes a lake, you might want to use the wide angle to emphasize the broad, unbroken expanse of water nearest the camera.

✦ **To provide an interesting angle:** Get down low and shoot up. Get up high and shoot down. Wide-angle lenses can emphasize the unusual perspective of either angle, providing additional creative opportunities.

✦ **To distort the foreground:** Wide-angle lenses provide a special kind of perspective distortion to objects that are closest to the camera, and you can use this look to create unique photos.

When working with a wide-angle lens, there are a couple things to keep in mind:

✦ **Watch your horizontal and vertical lines.** Because things like the horizon or the lines of buildings in your photograph are emphasized, you'll want to keep the plane of the camera parallel to the plane of your subject, and avoid tilting or rotating the camera if you want those lines to be appear straight in your photo. Architecture can be especially problematic, because tilting the camera back to take in the top of a building invariably produces that peculiar "tipping over" look. Your Nikon D70's optional

5.7 Wide-angle lenses emphasize the foreground.

5.8 Wide-angle perspective distortion can provide an interesting effect.

viewfinder reference grid can help you keep your lines straight.

✦ **Avoid unwanted perspective distortion.** Wide-angle lenses exaggerate the relative size of objects that are close to the camera. Although you might want to use this effect for creative purposes, you may also want to avoid it when shooting subjects, like people, that don't benefit from the distortion.

✦ **Be aware of lens defects.** Many lenses produce barrel or pincushion distortion, and perhaps have other problems, such as chromatic aberration or even vignetting, at the edges. You'll want to keep this in mind when composing your photos so that important picture information doesn't reside in areas that will have problems.

✦ **Watch flash coverage.** Electronic flash units might not cover the full wide-angle frame in their default modes. You may need to use a diffuser or wide-angle accessory over your flash, or set the flash unit for its wide-angle mode to avoid dark corners. The lens hood on some lenses may cause a shadow in flash pictures when used with the D70's built-in speedlight at the wide-angle positions of the kit lens and other lenses. Sometimes, simply removing the lens hood or zooming in slightly will solve the problem.

5.9 If you tilt the camera back, the structure will appear to be tipping over.

✦ **Don't forget sneaker-zoom.** If the widest zoom setting isn't wide enough, look behind you. Unless you're standing at the edge of a cliff, you just might be able to back up a few steps and take in the entire view. Zoom lenses are so common these days, it's easy to forget that your feet can be brought into play.

✦ **Slower shutter speeds are possible.** You know that telephoto lenses require higher shutter speeds because their longer focal lengths tend to magnify camera shake. You'll find wide-angle lenses more forgiving, because of their wider field of view. You may be

able to hand-hold your D70 at 1/30 second or slower when shooting with a wide-angle lens. That can be a special boon when taking photos in low-light conditions indoors.

Using a Telephoto Lens

Many D70 shooters fall into one of two camps: the wide-angle people and the telephoto folks. Although these photographers are smart enough to use a full range of focal lengths creatively, they tend to favor the odd viewpoints that wide-angle lenses produce, or treasure the up-close, in-your-face perspective of telephoto lenses. If you're an innate telephoto shooter, you'll especially want to explore one of these creative avenues:

✦ **To isolate your subject:** Telephoto lenses reduce the amount of depth of field and make it easy to apply selective focus to isolate your subjects.

✦ **Sports:** Except for a few indoor sports like basketball, it's often difficult to get close to the action in other kinds of contests. A telephoto lens will bring you right into the huddle, into the middle of the action around the goal, or up to the edge of the scrum.

✦ **Wildlife photography:** Whether you're photographing a humming-bird hovering 12 feet from your camera, or trying to capture a timid fawn 50 yards away, a telephoto lens can bring you closer without scaring off your photographic prey.

5.10 Get close without alarming your wild subject.

✦ **Portraits:** Human beings tend to photograph in a more flattering way with a telephoto lens. A wide-angle might make noses look huge and ears tiny when you fill the frame with a face, but that same magnification will look more natural with a 50–85mm lens or zoom setting on a D70.

✦ **Macro photography:** An ordinary 60mm macro lens will get you up close to that tiny object you want to photograph — perhaps even too close so that the camera or lens itself casts a shadow on your subject. A longer telephoto macro lens, such as the 105mm f/2.8 or 200mm f/4 Micro-Nikkors, lets you back up and still shoot close-ups.

✦ **Decrease distance:** Sometimes you simply can't get any closer. That erupting volcano makes a tempting target, but you'd rather stay where you are. Perhaps you want to capture craters on the moon, or photograph a house on the other side of the river. Slip a

long lens on your D70, and you're in business.

Telephoto lenses involve some special considerations of their own; some of them are the flip side of the concerns pertinent to using wide-angle lenses. Here's a summary:

✦ **Shutter speeds:** Longer lenses tend to magnify camera/photographer shakiness. The rule of thumb of using the reciprocal of the focal length (for example, 1/500 second with a 500mm lens) is a good starting point, but it doesn't take into account the actual steadiness of the photographer, the weight distribution of the camera/lens combination, and how much the image will be enlarged. When sharpness is very important, use a higher shutter speed, a tripod, or a monopod.

✦ **Depth of field:** Telephoto and zoom lenses have less depth of field at a given aperture as you increase focal length. That might be a good thing or a bad thing, depending on whether you're using selective focus as a creative element in your photo. Use your depth of field preview button, if necessary, and be prepared to use a smaller f-stop to provide the depth of field you need.

✦ **Haze/fog:** When you're photographing distant objects, a long lens will be shooting through a lot more atmosphere, which generally is muddied up with extra haze and fog. That dirt or moisture in the atmosphere can reduce contrast and mute colors, so you should be

prepared to boost contrast and color saturation if necessary.

✦ **Flare:** Both wide-angle and telephoto lenses are furnished with lens hoods for a good reason: to reduce flare from bright light sources at the periphery of the picture area, or completely outside it. Because telephoto lenses often create images that are lower in contrast in the first place, you'll want to be especially careful to use a lens hood to prevent further effects on your image (or shade the front of the lens with your hand).

✦ **Flash coverage:** Edge-to-edge flash coverage isn't the problem with telephoto lenses; distance is. A long lens may make a subject that's 50 feet away look as if it's right next to you, but your camera's flash isn't fooled. You'll need extra power of distant flash shots; probably more than is provided by your D70's built-in flash. Sports photography, in particular, often calls for a more muscular flash unit like the Nikon SB-800.

✦ **Compression:** Telephoto lenses have their own kind of perspective distortion. They tend to compress the apparent distance between objects. Fence posts that extend down the west side of your spread's lower 40 might look as if they're only a few feet apart through a 1000mm lens. Similarly, human faces can look flatter (but not flattered) when photographed

5.11 Towers separated by 40 feet appear to be right next to each other in a telephoto shot.

with a very long lens. You can use this effect creatively if you like, but you should always be aware of it when using a telephoto lens.

Using a Normal Lens

So-called "normal" lenses (which would be about a 32mm zoom setting or 35mm prime lens on a D70) are disdained by many because they are too . . . well . . . *normal.* Not wide enough to provide a wide-angle perspective, and not long enough to pull in distant details or serve as a portrait lens, the normal lens is seen as bland and not very creative.

Of course, if you're using a zoom lens that includes the normal position in its range, it's unlikely you'll give this much thought. The normal lens setting is just another position on the zoom scale, one that you choose because it provides the framing and look you prefer.

If you're working with prime lenses, however, there's a lot to be said for fixed-focal-length lenses in this range. Here are a few things to think about:

✦ **Speed:** Prime lenses in the normal range can be quite a bit faster than zoom lenses at the same setting. Nikon offers a 28mm f/1.4 and a 35mm f/2 lens that are perfect for indoor available-light photography. If you stretch the definition slightly to include 50mm lenses, Nikon's 50mm f/1.4 and 50mm f/1.8 lenses are other speed demons to consider.

✦ **Low cost:** Okay, Nikon's 28mm f/1.4 costs more than $1,000. But the vendor's 35mm f/2 and 50mm f/1.4 lenses can be purchased for less than $300, and the 50mm f/1.8 is a positive steal at less than $100. A low-cost "normal" lens may be a great way to add to your lens arsenal without emptying your wallet.

✦ **Sharpness:** Prime lenses tend to be simpler in design and much sharper than zoom lenses in the same coverage and price range. Millimeter for millimeter, the Nikon 50mm f/1.8 has to be one of the sharpest lenses on the market, and the other lenses in the Nikon "normal" range aren't slouches in terms of resolution, either.

✦ **Size:** If you want to travel light, a normal prime lens is compact and light in weight. Use one as a walking-around lens, and you may even learn more about photography as you work with and around the lens's advantages and limitations.

Using a Macro Lens

Macro lenses — "micro" lenses in Nikon's nomenclature — are used to take what are called *close-ups,* although the term may be a misnomer. What you're really looking for when you shoot with a macro lens is not to get close, but to magnify the apparent size of the subject in the final image. The distance doesn't matter as much as the magnification.

When using a macro lens, there are two things to keep in mind:

✦ **Magnification offered:** With conventional lenses, the specification

touted is the close-focusing distance; that is, can you get down to 12 inches, 6 inches, or 2 inches from the subject. With macro lenses, the magnification is more important, because these optics are offered in a variety of focal lengths and, even, as zoom lenses by vendors other than Nikon. You'll want a lens that provides at least a half-life-size image (1:2 magnification), and preferably one with life size (1:1) magnification.

✦ **Minimum aperture and depth of field:** Depth of field is at a premium in macro photography, and you'll want to be able to stop down as far as possible (at least to f/32) to avoid a focused area that's too shallow. Of course, at such small apertures you'll certainly be losing sharpness to diffraction effects, but that's often an acceptable tradeoff.

in response to the motion of the lens during handheld photography, countering the shakiness produced by camera and photographer, and magnified by telephoto lenses. However, vibration reduction, or VR, is not limited to long lenses; the feature works like a champ at the 24mm zoom position of Nikon's 24mm–120mm VR lens.

VR provides you with camera steadiness that's the equivalent of at least two stops, which can be invaluable under dim lighting conditions, or when hand-holding a long lens for, say wildlife photography. Perhaps that shot of an elusive polka-dotted field snipe calls for a shutter speed of 1/1000 second at f/5.6 with your 80mm–400mm zoom lens. If you're using the 80–400mm f/4.5–5.6D ED VR AF Zoom-Nikkor, you can go ahead and use 1/250 second at f/11 and get virtually the same results.

5.12 Depth of field is at a premium in macro photographs.

Reducing Vibration

Nikon has introduced an expanding line of lenses that include a vibration-reduction/ image-stabilization feature. This capability uses lens elements that are shifted internally

5.13 Vibration reduction technology lets you shoot handheld in much lower light levels.

Or, maybe you're shooting a high school play without a tripod or monopod, and you'd really, really like to use 1/15 second at f/4. Assuming the actors aren't flitting around the stage at high speed, your 24–120mm f/3.5–5.6G ED-IF AF-S VR Zoom-Nikkor just might do the job.

Here are some things to keep in mind when using a VR lens:

✦ **VR doesn't stop action.** Unfortunately, no VR lens is a panacea to replace the action-stopping capabilities of a higher shutter speed. Vibration reduction applies only to camera shake. You'll still need a fast shutter speed to freeze action. VR works great in low light, when using long lenses, and for macro photography. It's not so great for action photography.

✦ **Choose your battles.** Some VR lenses produce worse results if used while you're panning. The lens may confuse the motion with camera shake and overcompensate. Optical designers are working to fix this problem by designing two different anti-shake systems into the same lens. However, you might want to switch off VR when panning to be on the safe side. VR also may not work the way it's supposed to when the camera is mounted on a tripod.

✦ **VR slows you down.** The process of adjusting the lens elements takes time, just as autofocus does, so you might find that VR adds to the lag between when you press the shutter and when the picture is actually taken. That's one reason why vibration reduction may not be a good choice for sports.

✦ **Save your money.** Remember that an inexpensive monopod may be able to provide the same additional steadiness as a VR lens, at much lower cost. If you're out in the field shooting wild animals or flowers and think a tripod isn't practical, try a monopod first.

Extending the Range of Any Lens with a Teleconverter

Nikon, as well as third parties such as Kenko and Tamron, offer teleconverter attachments, which fit between your prime or zoom lens and your D70's camera body and provide additional magnification to boost the lens's effective focal length. These are generally available in 1.4X, 1.7X, and 2X (from Nikon), as well as those magnifications plus 3X from the third-party vendors.

For about $100 to $400, you can transform your 200mm lens into a 280mm telephoto (with a 1.4X converter) or into a 600mm monster (with a 3X module). Remember that with the D70's 1.5 crop factor, your "new" 280mm lens has an actual field of view equivalent of a 420mm lens on a 35mm camera, and the 600mm "monster" is the equivalent of a 900mm lens. However, there is no free lunch. Here are some things to consider:

✦ **You lose an f-stop — or three.** Teleconverters all cost you some light as they work their magic. It may be as little as half an f-stop with Nikon's 1.4X converter, to three full stops with a 3X converter. Transforming your 400mm f/6.3

lens into a 1200mm f/18 optic might not seem like such a great idea when you view the dim image in your finder and realize that you can use this lens only outdoors at ISO 1600. This light loss is one reason why the more moderate 1.4X and 1.7X converters are the most popular.

✦ **You may lose autofocus capabilities.** The D70's autofocus system functions only when there is f/5.6's worth of light, or better. Most teleconverter vendors call this to your attention by recommending use of their higher magnification converters (especially the 3X models) for autofocus use only with lenses having a maximum aperture of at least f/2.8. That requirement excludes a lot of zoom lenses, unless you're willing to focus manually. In addition, some teleconverters don't provide autofocus or autoexposure, or don't allow access to special features like VR at all.

✦ **You'll lose sharpness.** In the best of circumstances, you'll lose a little sharpness when working with a teleconverter. Part of that loss of sharpness comes from the additional optics in the light path, and part of it might be due to the tendency to use a larger, less-sharp f-stop to compensate for the light loss. In the worst case, you might find that simply shooting with no converter at all and enlarging the resulting image might provide results that are equal or better. A converter with moderate magnification, especially one of the pricey Nikon models, produces the best results. The latest Nikon 1.4X converter, for example, has five lens elements in five groups and special coatings to reduce flare.

Working with Autofocus

For Nikon, the autofocus era began in 1983, hit its stride a few years later, and, today, many veteran Nikon SLR photographers have never used anything else. Manual focus has become something you use when you want to refine your camera's auto focus, when you're photographing a subject that defies automatic focusing, when you're doing macro photography, or, perhaps, when you're working with an older lens.

Still, automatic focus has continued to develop in the last 20-plus years, so that the system available in the Nikon D70 is light years beyond the initial efforts. The next section provides a quick review of the focusing features you'll be using when you're out in the field.

Autofocus basics

To use autofocus, you must be using a Nikkor autofocus lens (or an equivalent lens from third-party vendors), designated with an AF in its product name. Older lenses as well as some current inexpensive and specialized lenses being sold today by Nikon (such as those with the AI-S designation) are manual focus only.

To get the most from your D70, you'll probably use AF lenses most of the time, so you'll want to know that the camera body has a lever next to the lens mount (shown in figure 5.14) that can be set to M (for manual focus) or AF (for autofocus.) In addition, some lenses, including the kit lens, have their own levers, as shown in figure 5.15. In this case, set the camera body lever to AF, and use the lens control to adjust focus mode. The M/A designation on the lens is used to remind you that focus can be

manually overridden (by turning the outer-most ring on the lens barrel) or left alone for the D70 to provide focus. The M position on the lens barrel means that focus will be set manually at all times.

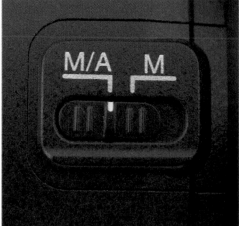

5.15 Some lenses have their own autofocus/manual switches.

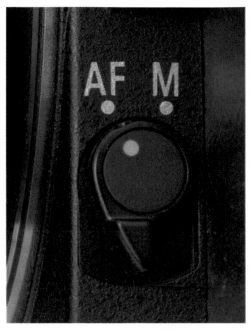

5.14 Switch from autofocus (AF) to manual focus (M) using the switch on the camera body.

To focus manually, twist the focus ring on the lens. It can be the innermost or outer-most ring, depending on the lens you have mounted. (With the kit lens, the focus ring is the innermost ring.) As you rotate the ring back and forth, you'll see the image pop in and out of focus. When the part of the image you're focusing on looks its sharpest, the image is in focus. With AF lenses in man-ual both AF and manual modes, and most manual focus Nikkor lenses, a green light in the lower-left corner of the viewfinder, called the *electronic rangefinder*, glows to indicate focus has been achieved.

To set focus automatically, partially depress the shutter-release button. If the D70 is set on automatic focus, it will lock into sharp focus. Brackets in the viewfinder that repre-sent the area used to calculate focus will flash red, and that green light in viewfinder, shown in figure 5.16, will glow, as long as the lens has a maximum aperture of f/5.6 or larger (for example, f/5.6 to f/1.4) The other elements in your viewfinder may look different from those in the illustration, depending on what picture-taking mode you've selected.

There are a variety of options for fine-tuning focus, such as the ability to choose whether the camera continuously focuses as you frame your subject after depressing the shutter release halfway; or whether the camera locks in focus once as soon as you partially depress the shutter button. The D70's factory default setting is for the latter behavior, and that will work fine for your first pictures. (The other mode may be use-ful for some kinds of action photography. However, changing the default requires a trip to the D70's menu system.)

Selected focus area

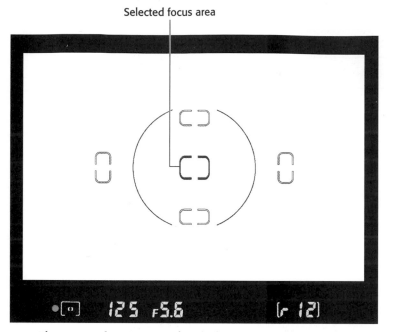

5.16 The current focus area and an in-focus LED appear in the viewfinder.

Focus is best achieved when you're shooting well-lit subjects with a lot of contrast between the subject and the background. If lighting is insufficient, the D70's focus assist lamp will come on (unless you've disabled it in the setup menus) and provide additional light to help the focus system. The autofocus system may become confused if there are objects at different distances within the focus zone (say, the subject is being viewed through a chain-link fence), or the subject contains patterns or very fine details that mask the contrast between different areas.

Understanding the focus zones

If you've chosen one of the DVP/scene modes (except close-up), the D70 always chooses the focus area for you, using the closest subject method, which selects the focus zone based on the object closest to your camera. It's not possible to change the zone, but the camera will indicate the area being used by highlighting in red one of the five brackets located around the center of the viewfinder area. You'll know you're in closest subject mode by the indicator in the viewfinder to the immediate right of the in-focus indicator light. As you can see in figure 5.17, the icon (next to the in-focus LED at lower left) has five plus signs (+) arranged in its center.

Choosing the focus zone manually

If you've selected P, A, S, or M, or if you've chosen the close-up DVP/scene mode, focus mode defaults to single area (unless you've changed to a different preference in the menus), and you can change the area

Closest subject focus icon

Focus area selected by camera

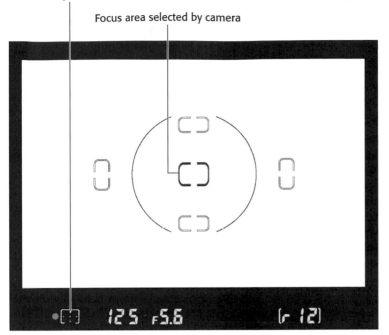

5.17 When using any of the scene modes except close-up, closest subject focus is selected automatically.

used as the focus zone. The single area focus icon appears in the viewfinder, as shown in figure 5.18.

To choose the focus area manually, follow these steps:

1. **Make sure the focus selector lock (see figure 5.19) is not set to L (lock).**

2. **Use the multi selector (four-way cursor pad) to move among the five focus zones (see figure 5.19).** The selected area is highlighted in red.

3. **If you want to use the same focus area for a succession of shots, move the focus selector lock back to the L position.**

Locking focus/exposure

As mentioned earlier, when you partially depress the shutter-release button, the automatic focus (and exposure) mechanisms are activated, and the informational display of the current settings appears at the bottom of the viewfinder screen. The viewfinder info display and exposure system remain active when you release the shutter button, but then go to sleep after a few seconds (or a longer time you can specify using the setup menus). To wake them up again, tap the button or depress it slightly if you want to refocus.

If you want the focus and exposure to be locked at the current values (so you can change the composition or take several photographs with the same settings) hold down the AE-L/AF-L button, shown in figure 5.20.

Single area focus icon Selected focus zone

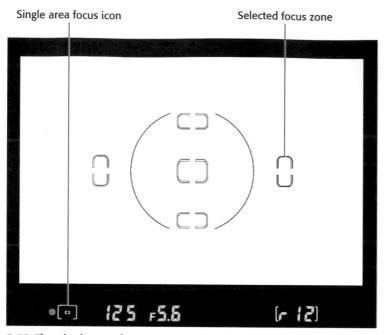

5.18 The single area focus zone can be set manually.

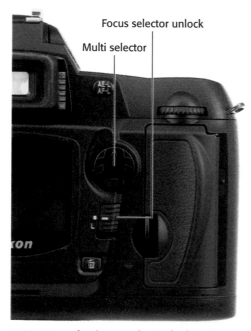

Focus selector unlock

Multi selector

5.19 Move the focus selector lock to the unlock position and use the multi selector pad to change the focus zone.

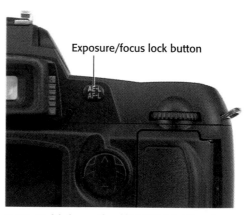

Exposure/focus lock button

5.20 Hold down the AE-L/AF-L button to lock exposure and focus.

Focus modes

The D-70 lets you choose how autofocusing is applied:

✦ **Single-servo:** In this mode (AF-S), the D70 tries to focus the image

as soon as you partially depress the shutter-release button. When focus is achieved, the in-focus indicator light illuminates, and focus is locked at that point. If you don't release the shutter button completely between shots and instead keep it depressed while continuous shots are taken, the focus will remain at the locked point for all the shots. You can also

push the AE-L/AF-L button to lock focus.

✦ **Continuous-servo:** In this mode (AF-C), the D70 attempts to focus the image when you partially depress the shutter-release button, and then continues to refocus until you take the picture. If you want to lock the focus at any point, you'll need to use the AE-L/AF-L button.

Photo Subjects

As you use your Nikon D70 to create pictures, you'll discover two things:

✦ **The more you shoot, the better you become as a photographer.** Although some of your end results may be pleasing, and others may be less successful, all of them help you learn how to improve your results and enhance your skills.

✦ **You'll constantly find new types of photography that excite you.** Perhaps photography became a serious pursuit for you when you decided to learn how to take great portraits or candid pictures of your kids or grandchildren. Then, the first time one of these youngsters stepped onto a soccer field or Little League diamond, you discovered how much fun sports photography can be. During quiet moments at home, you found out that close-up photography of flowers can be engaging and rewarding. There are dozens of different photographic arenas where your growing skills can be applied.

Of course, the first time you try a different kind of photography, you may find the new subject matter intimidating. You may want to have an "old hand" at your side who can point out the pitfalls and help spark your creativity. That's where this chapter comes into play. Each section provides a consistent formula for exploring one of the most common shooting situations. You'll find tips for choosing a lens, selecting the right ISO setting, and composing the picture. You can turn to any photo subject, and follow the guidelines to get good pictures right off the bat.

The Basics of Composition

The very best photos are carefully planned and executed. Good execution means more than proper exposure and sharp images, especially because some very good pictures are deliberately under- or overexposed and include an element of blur in their design. Beyond the technical aspects, good images have good composition (that is, the selection and arrangement of the photo's subject matter within the frame).

Here are some questions to ask yourself as you compose your picture:

✦ **What do I want to say?** Will this photo make a statement? Should it tell something about the subject? Is the intent to create a mood? Know what kind of message you want to convey and who your audience is.

✦ **What's my main subject?** A picture of six cute puppies may not be as effective as one that focuses on a single puppy surrounded by its littermates. Even if the picture is packed with interesting things, select one as the subject of the photo.

6.1 There's no mistake about what's the center of interest in this photograph.

✦ **Where's the center of interest?** Find one place in the picture that naturally draws the eye and becomes a starting place for the exploration of the rest of the image. Da Vinci's *The Last Supper* included several groupings of diners, but viewers always look first at the gentleman seated in the center.

✦ **Would this picture look better with a vertical or horizontal orientation?** Trees may look best in vertical compositions; landscapes often lend themselves to horizontal layouts. Choose the right orientation now, and avoid having to waste pixels when you crop later on.

6.2 Choose a vertical or horizontal orientation appropriate for your subject matter.

✦ **What's the right shooting distance and angle?** Where you stand and your perspective may form an important element of your composition. For example, getting down on the floor with a crawling baby provides a much more interesting viewpoint than a shot taken 10 feet away from eye level.

✦ **Where will my subject be when I *take* the picture?** Action photography, especially, may force you to think quickly. Your composition can be affected not just by where your main subject is now, but where it will be at the time the picture is taken.

✦ **How will the background affect the photo?** Objects in the background may become part of the composition — even if you don't want them to. Play close attention to what's visible behind your subjects.

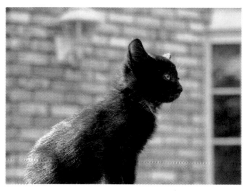

6.3 Cute kitten — but the background, even out of focus, is too distracting.

✦ **How should the subjects in the photo be arranged?** This is the essence of composition: arranging the elements of the photograph in a pleasing way. Sometimes you can move picture elements, or ask them to relocate. Other times you'll need to change position to arrive at the best composition.

✦ **How should the eye move within the composition?** Viewers don't stare at a photograph; their eyes wander around the frame to explore other objects in the picture. You can use lines and curves to draw the eye from one part of the picture to another, and balance the number and size of elements to lead the viewer on an interesting visual journey.

The rule of thirds

Photographers often consciously or unconsciously follow a guideline called the Rule of Thirds, which is a way of dividing a picture horizontally and vertically into thirds, as shown in figure 6-4. The best place to position important subject matter is often at one of the points located one-third of the way from the top, bottom, and sides of the frame.

Other times, you'll want to break the Rule of Thirds, which, despite its name, is actually just a guideline. For example, you can ignore it when your main subject matter is too large to fit comfortably at one of the imaginary intersection points. Or you may decide that centering the subject would help illustrate a concept, such as being "surrounded," or that placing the subject at one side of the picture implies motion, either into or out of the frame. Perhaps you want to show symmetry in a photograph that uses the subject matter in a geometric pattern. Following the Rule of Thirds usually places emphasis on one intersection over another; breaking the rule can create a more neutral (although static!) composition.

6.4 The "horizon" formed by the far shore of the lake is located one-third of the way down from the top of the image, while the center of interest — the boat — is placed one third of the way from the bottom and right side of the frame.

Other compositional tips

Here are some more compositional rules of thumb you can use to improve your pictures:

✦ **If subjects aren't facing the camera, try to arrange it so they're looking into the frame rather than out of it.** This rule doesn't apply only to people or animals. An automobile, a tree swaying in the wind, or a bouncing ball all look more natural if they're oriented toward the frame.

✦ **Use curves, lines, and shapes to guide the viewer.** Fences, a gracefully curving seashore, meandering roads, railroad tracks, a receding line of trees, all can lead the eye through the composition. Curved lines are gentle; straight lines and rigid geometric shapes are more forceful.

✦ **Look for patterns that add interest.** A group portrait of three people will be more interesting if the subjects are posed in a triangular or diamond shape, rather than in a straight line.

✦ **Balance your compositions by placing something of interest on each half (left and right, top and bottom).** For example, if you have a group of people on one side of the frame, you'll need a tree or building or some other balancing subject matter on the other to keep the picture from looking lopsided.

6.5 Lines and curves lead the eye through the composition.

✦ **Frame your images by using doorways, windows, arches, the space between buildings, or the enveloping branches of trees as a "border" for your compositions.** Usually, these frames will be in the foreground, which creates a feeling of depth, but if you're creative you can find ways to use background objects to frame a composition.

✦ **Avoid mergers — those unintentional combinations of unrelated portions of an image, such as the classic tree-growing-out-of-the-top-of-the-subject's-head shot.**

Abstract Photography

Abstract photography is your chance to make — rather than take — a picture. When shooting abstract images, your goal is not to present a realistic representation of a person or object but, rather, to find interest in shapes, colors, and textures. One definition of abstract art says that the artistic content of such images depends on the internal form rather than the pictorial representation. That's another way of saying that the subject of the photo is no longer the subject!

6.6 A drop of water splashing in a wine glass creates an abstract composition that can be frozen in time with a high enough shutter speed.

You can let your imagination run wild when you're experimenting with abstract photography. An image doesn't have to "look" like anything familiar. Some people will tell you that if it's possible to tell what an abstract subject really is then the image isn't abstract enough. A droplet of splashing water can become an oddly malleable shape; a cluster of clouds in the sky can represent fantasy creatures as easily as random patterns. When you choose to photograph an abstract shape, you're giving your vision a tangible form.

Inspiration

French photographer Arnaud Claass once said, "In painting, the curve is a hill; in photography, the hill is a curve." In other words, while painters attempt to use abstraction to create an imaginative image of a subject, photographers use abstract techniques to deconstruct an existing image down to its component parts. Both approaches create art that doesn't look precisely like the original subject, but that evokes feelings related to the subject matter in some way.

6.7 Abstract images can be found in nature.

You can find abstract images in nature by isolating or enhancing parts of natural objects such as plants, clouds, rocks, and bodies of water. Many wonderful abstracts

have been created by photographing the interiors of minerals that have been sliced open, or capturing the surfaces of rocks polished over eons by ocean waves.

You can also create abstract compositions by arranging objects in interesting ways, and then photographing them in non-representational ways. A collection of seashells that you've stacked, lit from behind, and then photographed from a few inches away can be the basis for interesting abstract images that resemble the original shells only superficially and on close examination of the picture. Familiar objects photographed in unfamiliar ways can become high art.

Abstract photography practice

6.8 An unusual angle turns this box of crayons into an abstract image.

Table 6.1
Taking Abstract Pictures

Setup	**Practice Picture:** For figure 6.8, I took a tray of unused Crayola crayons and set it on a tabletop with a high-intensity desk lamp on either side. I mounted the D70 on a sturdy tripod, and cranked up the center column so I could shoot down on the points of the crayons.

Continued

Table 6.1 *(continued)*

Setup *(continued)*	**On Your Own:** Some of the best abstract images can be obtained from close-up views of everyday objects. A tripod lets you experiment with different angles, then "lock down" the camera when you find a view you like. Desk lamps make it simple to play with various lighting effects that can add to the abstract quality of your image.
Lighting	**Practice Picture:** I wanted the high-contrast lighting the direct illumination of the desk lamps provided, in order to enhance the texture of the crayons, which were already slightly pitted and cracked even though they'd never been used. Moving the lights created interesting highlights and shadows.
	On Your Own: While hard light accentuates texture, you can also bounce light from reflectors to diffuse it and create a softer look. Experiment with colored reflectors or colored pieces of plastic held in front of the light source to add interesting color casts.
Lens	**Practice Picture:** 60mm f/2.8D AF Micro-Nikkor. A macro lens is essential for getting close enough to capture detail without distortion. You could also use a macro-zoom lens that focuses close enough or even the 50mm f/1.8D AF Nikkor with an extension tube or close-up lens attachment that would let you focus closer than that lens's minimum 18-inch focus distance.
	On Your Own: Although close-focusing is a must for this kind of picture, a focal length of 50–60mm or perhaps a little wider is just as important. A longer lens, even if it can produce the same magnification, tends to flatten the image, reducing the three-dimensional quality.
Camera Settings	**Practice Picture:** RAW capture. Aperture-priority AE with white balance set to Tungsten, saturation set to Enhanced, and both sharpness and contrast set to High.
	On Your Own: Aperture-priority AE mode lets you choose a small aperture and let the camera select a slow shutter speed. Extra saturation, sharpness, and contrast increase the abstract appearance at the expense of realism. You can also boost these values when converting the RAW image and processing it in your image editor.
Exposure	**Practice Picture:** ISO 200, f/32, 1/8 second.
	On Your Own: A small lens aperture increases the depth-of-field so that the entire image is sharp. The long exposure means that the D70's best-quality ISO 200 sensitivity is sufficient.
Accessories	A tripod lets you lock down the camera after you've found an angle you like; it also makes it possible to stop down to a small f-stop without worrying that the long shutter speeds that result will cause image blur. A Nikon ML-L3 wireless remote control is faster for releasing the shutter without jiggling the tripod, but you can also use the self-timer.

Abstract photography tips

✦ **Go abstract in post-processing.** Many mundane conventional photographs can be transformed into abstract prize-winners by skillful manipulation in an image editor. Filter plug-ins can enhance edges, add textures, change color values, and perform other magic after-the-fact.

✦ **Freezing and blending time.** A high shutter speed can freeze a moment that isn't ordinarily easy to view, such as when a rock strikes the surface of a pond to produce concentric waves. Slow shutter speeds can merge a series of moments into one abstract image.

✦ **Use color and form to create abstract looks.** Exaggerated colors and shapes produce a nonrealistic look that has an abstract quality. Colored gels over your light sources can create an otherworldly look. An unusual angle can change a familiar shape into an abstract one.

✦ **Crop and rotate!** Try flipping an image vertically to create an unfamiliar look. When the light source seems to come from below, rather than above as we expect, our eyes see a subject in a new way. Or rotate the image to produce a new perspective. Then crop tightly to zoom in on a particular part of the image that has abstract qualities of its own.

Architectural Photography

Professional architectural photography is specialized and involves complex guidelines and sophisticated equipment. There are no such strictures on the kind of informal amateur architecture you can do just for fun with your D70 and a few lenses. Whether you're taking some snapshots of existing homes you'd like to offer as suggestions to your

6.9 Choose an angle that shows a building in its surroundings.

architect, or looking to document historic structures, taking photos of interior and exterior architecture is fun and easy.

Architectural photos can be used for documentation, too, to provide a record of construction progress, or show how a building has changed through the years. Some of the most dramatic architectural photos are taken at night, using long time exposures or techniques such as *painting with light* (using a light source such as a flash to illuminate a subject multiple times during a long exposure).

Inspiration

The best architectural photographs involve a bit of planning, even if that's nothing more than walking around the site to choose the best location for the shot. Or you might want to take some test shots and come back at a specific time, say, to photograph an urban building on Sunday morning when automobile and foot traffic is light. A particular structure might look best at sunset.

However, the biggest challenge you'll need to plan for will be illumination. The existing lighting can be dim, uneven, or harsh. You may encounter mixed illumination with daylight streaming in windows to blend with incandescent room illumination, or lighting that is tinted. Some of these problems can be countered by mounting your D70 on a

tripod and using a long exposure. Perhaps you can add lighting, supplementing existing light with reflectors, or lights mounted on stands. "Painting with light," by manually tripping an electronic flash aimed at different areas of an outdoor structure several times during a long exposure can work, too.

6.10 Large interiors make challenging subjects because the available illumination may be less than perfect.

Architectural photography practice

6.11 Because power lines were visible behind the house when shot from the front, this side view proved the best.

<table>
<tr><td colspan="2" align="center">Table 6.2
Taking Architectural Exteriors</td></tr>
<tr><td>**Setup**</td><td>**Practice Picture:** Walking all around this house-of-many-angles shown in figure 6.11 produced the best perspective for a simple photo destined for a holiday card.

On Your Own: Find a shooting spot that shows a building at its best, with a clean background and uncluttered foreground. Look for surrounding trees or other structures that can serve as a frame. You can look at articles in "home" magazines for ideas for the most flattering way to shoot a particular type of building.</td></tr>
<tr><td>**Lighting**</td><td>**Practice Picture:** Unadorned daylight during mid-afternoon provided the perfect lighting for this home portrait.

On Your Own: To avoid harsh shadows that can obscure important details, you may want to wait for slight cloud cover to soften the harsh daylight. If you've found a particular spot that's ideal and you have the luxury of time, you can choose the time of day that provides the best lighting.</td></tr>
<tr><td>**Lens**</td><td>**Practice Picture:** 28–200mm f/3.5–5.6G ED-IF AF Zoom-Nikkor set to 70mm. In tighter quarters, a lens with more wide-angle reach, such as the 18–70mm f/3.5–4.5G ED-IF AF-S DX Zoom Nikkor kit lens may be more suitable.</td></tr>
</table>

Continued

Table 6.2 *(continued)*

Lens *(continued)*	**On Your Own:** Your lens choice depends on whether you can get far enough away to avoid tilting the camera to take in the top of the structure. In extreme cases, a wide-angle prime lens like the 14mm f/2.8D ED AF Nikkor or wide zoom like the 12–24mm f/4G ED-IF AF-S DX Zoom-Nikkor may be necessary. As a last resort, you can use a semi-fisheye lens like the 10.5mm f/2.8G ED AF DX Fisheye-Nikkor and straighten out the curves in Nikon Capture.
Camera Settings	**Practice Picture:** RAW capture. Shutter-priority AE with a custom curve, saturation Enhanced, and sharpening Medium High.
	On Your Own: Outdoors in bright sun, you can usually use shutter-priority to specify a speed that will nullify camera shake, and let the camera choose the appropriate aperture.
Exposure	**Practice Picture:** ISO 200, f/13, 1/500 second.
	On Your Own: Use center-weighted or spot metering to ensure that the exposure will be made for the building itself and not any bright surroundings such as sky or snow. Using the D70's automatic bracketing feature will let you take several consecutive pictures at slightly different exposures, so you can choose the one that most accurately portrays the building.
Accessories	A tripod can be helpful to allow a repeatable perspective, in case you'll be returning from time to time to take additional shots from the sample angle. Record where you placed the tripod legs by removing the camera after the shot and taking a picture of the tripod and its position. Flash can sometimes be used to fill in shadows — but be careful of reflections off windows.

Architectural photography tips

✦ **Shoot wide.** Exterior architecture often requires a wide-angle lens, while interiors almost always call for a wide setting to capture most rooms or spaces. Unless you're shooting inside a domed stadium, cathedral, or other large open space, you'll find yourself with a back to the wall sooner or later. Wide angles also help you include foreground details, such as landscaping, that are frequently an important part of an architectural shot.

✦ **Watch out for lens distortion.** Some lenses produce lines that are slightly curved when they're supposed to be straight. Although you may not notice this distortion most of the time, architectural design often depends on straight lines and any warps introduced by your lens become readily apparent.

✦ **Avoid perspective distortion.** To avoid that "tipping over" look that results when the camera is tilted

back, locate a viewpoint that's about half the height of the structure you want to photograph. It might be a neighboring building or a bluff overlooking the site, or some other elevation. Shoot the picture from that position, using the widest lens setting you have available, keeping the back of the camera parallel with the structure.

✦ **Ask permission.** The laws of most states don't require getting permission to shoot and use photographs of buildings that are clearly visible from public areas. However, many property owners will become nervous as soon as you set up a tripod and start shooting, so it's always a good idea to ask first, and, perhaps offer them a free print if they seem reluctant.

Action and Sports Photography

The Nikon D70's fast response and rapid-fire continuous shooting mode capabilities make it a popular tool for capturing sports shots at football or baseball games, soccer and tennis matches, and those sometimes-violent pastimes they call hockey and rugby. But action photography isn't limited to sports, of course. You'll encounter fast-moving action at amusement parks, while swimming at the beach, or while struggling to climb a mountain.

Everything from skydiving to golf to motoring all lend themselves to action photography.

The dual challenges facing action photographers are knowing the right subject and knowing the right time. The other aspects are just technical details that are easy to master. However, you'll always need to understand enough about what is going on to anticipate where the most exciting action will take place and be ready to photograph that subject. Then you need to have the instincts to pull the trigger at exactly the right instant to capture that decisive moment.

6.12 All soccer moms — and soccer dads — will want to capture the exploits of their offspring on the field.

Inspiration

Action photography is exciting because it freezes a moment in time. The goal is to find exactly the right moment to capture. Your Nikon D70 simplifies the process in several ways. You can leave it switched on and ready to go at all times, so you'll never lose a shot waiting for your camera to "warm up." Moreover, after the camera is up to your eye and you see a picture you want to take, the autofocus and autoexposure systems work so quickly that you can depress the shutter-release button and take a picture in an instant, without the interminable shutter lag that plagues so many point-and-shoot digital cameras. Finally, the D70's continuous shooting mode can fire off bursts of shots as quickly as 3 frames per second, so even if your timing is slightly off, you can still improve your chances of grabbing the precise instant.

6.13 The peak moment is always the most exciting instant, and there may even be a pause where a fast shutter speed isn't needed to freeze the action.

Action and sports photography practice

6.14 A long lens, a good choice of location, perfect timing, and a little help from the D70's continuous shooting mode combined to produce this shot of a winning home run in the making.

Table 6.3
Taking Action and Sports Pictures

Setup	**Practice Picture:** My seat next to the visitors' dugout for the professional baseball game shown in figure 6.14 provided the perfect vantage point for coverage of both home plate and first base.
	On Your Own: Know where to stand or sit for the best action-shooting opportunities. At football games, that may be on the sidelines 10 yards in front of or behind the line of scrimmage. Soccer games can be shot from behind or next to the net. Basketball games look best from near the bench or behind the backboard. You may not have easy access to these positions at pro or college contests, but you'll find high school games considerably more photographer-friendly. Until you find a favorite location or two, roam around and scout out the best shooting sites.
Lighting	**Practice Picture:** Daylight was just fine at this mid-afternoon baseball game.
	On Your Own: Even outdoors, you may find the illumination is less than perfect, particularly on gloomy days or at dusk. When the outdoor light is really scarce, you can't do a lot except use a flash to fill in murky areas. Indoors, the light may be okay as is if you boost the ISO setting to ISO 800 or ISO 1600. More-ambitious sports photographers may want to experiment with multiple flash units to provide broad illumination over larger areas.
Lens	**Practice Picture:** Sigma 170–500mm f/5-6.3 APO Aspherical AutoFocus Telephoto Zoom Lens at 400mm. When you're far from the action, the longer the focal length you can muster, the better.
	On Your Own: Your lens choice depends on the type of action you're shooting. Indoor sports may call for wide-angle or normal focal lengths. Outdoors, if you can get close to the action, a 70–200mm zoom lens may cover all the bases. If you're up in the stands or you want to capture an outfielder snaring a fly ball, a prime lens or zoom in the 300mm to 500mm range may be required. You'll need a lens that's fairly fast if you want the D70's autofocus features to focus for you. A wide aperture also makes it easier to focus manually. However, most of your shots will be taken with the lens stopped down to produce sufficient depth-of-field.
Camera Settings	**Practice Picture:** JPEG Fine. Shutter-priority AE and continuous shooting mode.
	On Your Own: The D70 can usually store JPEG Fine images more quickly than RAW format, so when you're shooting quickly and continuously, you'll gain some speed with very little quality loss by choosing Fine. Select shutter-priority mode so you can choose the highest appropriate shutter speed when you want to stop action. Under reduced light levels, you'll want to drop down to a slower shutter speed or boost the ISO setting.

Continued

Table 6.3 *(continued)*

Exposure	**Practice Picture:** ISO 400, f/11, 1/1,000 second.
	On Your Own: At 400mm, the f/11 aperture allowed the people in the stands to blur, and 1/1,000 second was plenty fast enough to freeze all the action except for the ball and the end of the bat. Image noise isn't a problem with the D70 at ISO 400, but good results are possible at ISO 800 if you need a smaller aperture or faster shutter speed.
Accessories	Even with high shutter speeds, a tripod or monopod can help steady a long lens and produce sharper results. Compact tripods and monopods made of carbon fiber or magnesium are light in weight and easy to tote to sports events. Indoors, a flash may be useful.

Action and sports photography tips

✦ **Anticipate action.** Become sensitive to the rhythm of a sport and learn exactly when to be ready to press the shutter-release button to capture the peak moment.

✦ **Be ready to use manual focus or focus lock.** Autofocus works great, particularly the D70's predictive-autofocus feature that tries to anticipate where your subject will be at the time the picture is taken. However, don't be afraid to turn off the autofocus feature, manually focus or lock focus on a position where you think action will be taking place, and then snap the picture when your subjects are in position. You may be able to get more accurate focus this way.

✦ **Take advantage of peak action.** Many sports involve action peaks that coincide with the most decisive moment. A pole-vaulter pauses at the top of a leap for a fraction of a second before tumbling over to the other side. A quarterback may pump-fake a pass, and then hesitate before unleashing the ball. A tennis player poised at the net for a smash is another moment of peak action. These moments all make great pictures.

✦ **Shoot oncoming action.** Movement that's headed directly toward the camera can be frozen at a slower shutter speed than movement that's across the field of view. If you don't have enough light to use the D70's highest 1/8000 second shutter speed, try photographing oncoming action to freeze the motion.

Business Photography

Good photographs can spice up PowerPoint presentations overladen with bullet points and graphs. Pictures can help sell a viewpoint in reports, document progress in an ongoing project, illustrate business e-mail messages, and add credibility to correspondence. In today's visually-oriented world, the ability to communicate with photographs is a definite business advantage.

Miller Elementary School

3322 Royal Road
Wiston, OH 44444
(330) 555-4833

Staff Newsletter

As your principal, I wanted to thank you all on another successful academic year. Our professional staff was certified by the State Department of Education for the sixth consecutive year, and we were rated as AA-1 based on our students' results on the standard battery of tests administered this Spring.

6.15 Photos can enhance letterheads, newsletters, and other printed pieces.

Professional photographers hired by an organization will create illustrations needed for advertising, annual reports, and most brochures. But other kinds of business communication benefit from well-crafted photographic images.

Inspiration

There are dozens of formal and informal opportunities for business-oriented photos. More-formal photos would include most communications intended for customers, including external newsletters, new business proposals, training manuals, Web sites, and sales promotions. A more informal approach can be taken for internal communications, such as employee anniversaries or retirements, internal newsletters, and corporate communications.

Both kinds of pictures call for well-organized and cleanly composed images that highlight the main subject, whether it's a person or a product. If an image is intended for sales, training, or promotional use, it should accurately represent the subject matter and not mislead in any way.

Backgrounds should never detract from the message. Photograph people and larger products against a plain background, such as a neutral-colored wall located at least a half-dozen feet behind the subject to minimize shadows from available light or the D70's built-in flash. Smaller objects can be photographed on a seamless paper roll (available at any photo store) or a piece of poster board.

6.16 A simple product shot can enhance a text-heavy PowerPoint presentation with color and shape.

Business photography practice

6.17 Even mundane electronic components can be glamorized with simple product photography.

Table 6.4 Taking Business Pictures	
Setup	**Practice Picture:** I used a white poster board, gently curved to provide a seamless backdrop, as the background for the image in figure 6.17 of an AV cable I sell on eBay to connect laptop computers to a big-screen television.
	On Your Own: Fancy backgrounds and complex arrangements of objects make business images confusing. White, black, or gray poster boards make perfect uncluttered backgrounds. Mount the camera on a tripod to allow for a long exposure.
Lighting	**Practice Picture:** After curling the cable into a shape that clearly showed the connectors on both ends, I used a pair of tungsten-halogen high-intensity desk lamps bounced off pieces of white cardboard mounted on light stands at the left and right sides. This created a soft light. Additional pieces of black cardboard were used to shield the back part of the poster board backdrop so the illumination faded away to a muted gray.
	On Your Own: If you plan to do a lot of this kind of photography, you may want a set of umbrellas to bounce light off; simple photoflood lights; or external, off-camera electronic flash units to give you the most control over your illumination. You'll need a light for the background, one or two for your subject, and some reflectors to cast light into the shadows.

Lens	**Practice Picture:** The 60mm f/2.8D AF Micro-Nikkor is perfect for this kind of product photography, especially small objects. However, the 18–70mm f/3.5–4.5G ED-IF AF-S DX Zoom Nikkor is suitable at 50–70mm if you can fill the frame.

On Your Own: You don't need a special macro lens if you take photos of larger products and don't need to shoot extreme close-ups. A normal lens or zoom set to the normal range (about 30–40mm) works well for small objects. A longer lens or zoom setting will enable you to blur the background. If your product is best displayed on models, you'll need a medium wide-angle lens for group portraits. Head-and-shoulder portraits call for a short telephoto in the 60–90mm range. |
| **Camera Settings** | **Practice Picture:** RAW capture. Aperture-priority AE with a tungsten white balance.

On Your Own: RAW gives you the best sharpness, while using aperture-priority makes it possible to choose an f-stop that provides the amount of depth-of-field you need. Set white balance manually to the tungsten setting |
| **Exposure** | **Practice Picture:** ISO 200, f/11, 1/8 second.

On Your Own: A moderately small aperture, between f/8 and f/16, provides the depth-of-field required. Use a wider f/stop, such as f/5.6, to throw the background out of focus. An ISO setting of 200 will give you the best image quality. A higher sensitivity isn't needed, because mounting the camera on a tripod allows a sufficiently long exposure time. |
| **Accessories** | White cardboard sheets to soften the light. White umbrellas provide more control. For slightly more contrasty lighting to emphasize details in a subject, silver umbrellas or reflectors can be used to provide an indirect, but still vivid light source. A tripod is an essential accessory for exposure times longer than about 1/125 second. |

Business photography tips

✦ **Avoid direct flash in business headshots.** If you can't shoot with existing light, bounce the light off the ceiling. With portraits, use a silver reflector to cast light into the shadows that will form under the eyes, nose, and chin. With product shots, use white cardboard reflectors to illuminate those shadows.

✦ **Keep backgrounds simple.** If you're not using a poster board or wall as a background, pay attention to what's behind your subject to make sure it doesn't interfere.

✦ **Use consistent lighting and setups for photographs that will**

be used as a series. If you're photographing a number of products, or creating a series of portraits, either take as many of the pictures as you can in a single session, or use the same lighting, background, shooting angle, exposure and other setup details each time you take that sort of picture. Then you'll be able to use all the photos in a single print layout, presentation, or Web site while retaining a professional, consistent look.

◆ **Look at the colors as a group.** As you set up a photo, consider all the colors in the image. If they don't work well together, change backgrounds or locations to find a better background color scheme for the subject, or, failing that, use a neutral-color background such as a white wall or a poster board.

Candid Photography

Using your D70 as a candid camera is a great opportunity to, as the tagline of the television show of the same name says, "catch people in the act of being themselves." Unlike formally posed photos, which must be set up very carefully to avoid a stiff, "posed" look, candid pictures require nothing of the photographer other than to frame an interesting, technically good image when the subject is relaxed and natural.

The craze for candids first hit the professional portrait and wedding realms more than 40 years ago. The true arbiters of commercial photography success — the paying customers — decided that candids should augment (or entirely replace) studio portraits and wedding pictures. Today, even carefully crafted portraiture is likely to involve natural, candid-style backgrounds and less-formal poses.

6.18 Formal wedding portraits are now augmented by informal candid shots, like this snap of a groom at a wedding reception.

Inspiration

6.19 The character in this gentleman's face becomes an important part of the photograph as he sits lost in thought.

The goal of candid photography is not to grab pictures surreptitiously, with your subjects completely unaware that their picture is being taken. The best candid pictures result when the subjects know exactly what is going on — and don't care. With relaxed and comfortable subjects, the photographer can take her time, waiting for the right moment or the right look to capture on film. The result is a more natural photograph that tells something about the people being photographed: who they are, what they care about, or, even, what they think of the photographer!

So, the key to good candid photography is to keep your subject at ease. You'll always want to let them know that you'll be taking their picture. Don't interrupt what's going on. Saying "Smile!", "Say 'Cheese'!", or "Look at the camera!" is definitely self-defeating. Blend in, become part of the group. If appropriate, you can join in the conversation. Then any photograph you take will truly be candid and honest.

Candid photography practice

6.20 Lunch at a fast-food restaurant turned into a candid-photo opportunity as this young man refreshes himself after a day at the park.

Table 6.5
Taking Candid Pictures

Setup	**Practice Picture:** I was seated across the table from my nephew at a fast-food restaurant when I noticed how absorbed he was with his kids' meal. He never even noticed when I snapped off the photo shown in figure 6.20. **On Your Own:** Some of the best candid pictures result from experiences that you're participating in, rather than simply observing from a short distance. That's why it's a good idea to have your camera with you at all times, to better capture candid moments as they arise.
Lighting	**Practice Picture:** Light from the windows behind and in front of the youngster provided all the illumination necessary. A placemat, reversed and held up by a helpful aunt, reflected soft light onto the side of his face turned toward the camera. **On Your Own:** Candid photos taken by available light usually retain their informal quality better than those using a flash.
Lens	**Practice Picture:** 18–70mm f/3.5–4.5G ED-IF AF-S DX Zoom Nikkor at 25mm. **On Your Own:** Many candid photos zero in on one or two people, and the photographer is free to choose a suitable shooting distance. So, a prime or zoom lens of about 25mm to 50mm will provide the same flattering look that a short telephoto/portrait lens or moderate wide-angle will produce. A wide-angle lens should be used for candid pictures only if you must have the wider perspective and are willing to risk perspective distortion (or want to use it as a creative element).
Camera Settings	**Practice Picture:** JPEG Fine. Aperture-priority AE with white balance set for Daylight. **On Your Own:** Indoor pictures that are illuminated entirely by daylight coming through nearby windows may call for setting white balance manually. Using aperture-priority AE mode lets you choose the f-stop as appropriate.
Exposure	**Practice Picture:** ISO 400, f/5.6, 1/125 second. **On Your Own:** If you want to isolate the subject from a cluttered background, use a relatively wide aperture such as f/5.6. If you need more front-to-back sharpness, choose a smaller f/stop. ISO can be set to 200 to 400, depending on the amount of light available.
Accessories	Avoid bulky accessories that turn your candid opportunity into a formal photo shoot. Instead of reflectors, look for any reflective object — even a shirt that you or a bystander is wearing — to bounce light into shadows. Similarly, avoid breaking out the tripod, if you can. Instead, if you must use a slower shutter speed, rest the camera on a handy object and press down with your left hand to steady it as you trip the shutter with your right index finger.

Candid photography tips

✦ **Blend in as much as you can.**
Remember, a candid photo should be unposed and natural. That can't happen if your subjects are preoccupied with having a photographer around. Instead of standing around stiffly waiting for something interesting to happen, do what everyone else is doing and become part of the activity.

✦ **Be selective.** Snapping away wildly at every moment will unnerve most people and destroy those unguarded moments you're hoping to capture. Wait until someone is doing something interesting — instead of just standing or sitting around idly — then take your photo. After you've taken a photo, resume what you were doing and wait for the next moment.

✦ **Don't obsess over technical issues.** You'll find that if your candid photo captures an interesting moment, viewers won't care if the exposure or focus isn't absolutely perfect — a few imperfections may even make the photo appear more natural.

✦ **Don't expose your subject to embarrassment or ridicule.**
From time to time we all do something stupid or succumb to an accident — we'll even laugh about it if the moment was captured in a photograph. But as a photographer, you don't want to be seen as deliberately seeking out embarrassing moments to photograph solely for their own sake — unless you're a paparazzo and fleet of foot!

Child Photography

Everybody loves photographs of their own children. Pictures of kids are one type of image that looks better and is more treasured as time passes and the children grow older. The first, and best, advice for child photography is to take *lots* of pictures, many more than you think you'll need, and as often as possible. Years later, you'll find that a casual shot you didn't think much of at the time will be one of your favorites.

Photography of your own children and grandchildren is a joy, but taking pictures of these same kids that other people — people who don't have that personal connection to your kids — will enjoy is more of a challenge. You'll need a combination of careful planning, a cooperative child, and some luck to get the best kid photos yet.

Inspiration

6.21 Older kids are good sports enough to go along with corny-but-classic poses like this one.

6.22 When shooting more than one child at once, the challenge is getting all of them to smile at the same time!

Working with Kids

You don't need to be a parent to work with children — although it helps. Some techniques can make children more comfortable:

✦ Many kids are natural hams, while others are painfully shy. Your best bet for capturing warm images of either type of child is to carefully plan ahead so the photo session can be efficient and go off without a hitch.

✦ Have the parent dress the child in a favorite outfit that's clean and attractive, but not so new that the youngster feels uncomfortable or confined wearing it. If the photos are to be semiformal, a recent (but not brand-new) haircut accompanied by good combing or brushing and well-scrubbed face will help the child look his best. Mom, Dad, or grandparents should be spiffed up, too, because you'll want to include them in a few shots.

✦ Having one parent and perhaps a friend and a sibling or two along can help relax the child. The home environment can make a good background if you clean up all the stray toys, but a nearby park may make an even better backdrop. Children love parks — and they're usually better maintained than the typical parent's backyard!

✦ Have some props available for the child to hold for a few pictures. The bigger the better — a large teddy bear or soccer ball works better in many cases than a small action figure, doll, or baseball.

Child photography practice

6.23 Pose a child with a favorite toy to help the child relax.

Table 6.6
Taking Pictures of Children

Setup	
	Practice Picture: After a romp through the hiking trails of a state park, I convinced my 5-year-old nephew to park himself on a picnic bench for an outdoor portrait, as seen in figure 6.23.

On Your Own: Outdoor setups are great for kids because there's lots of room to choose different settings, and natural backgrounds are always interesting. Find a comfortable place for a fidgety child to sit while you take a few photos, whether it's a park bench, rock, or tree stump. Very small children who are old enough to sit up unaided can be plopped down on a blanket, or even the grass. You'll want to make sure Mom or Dad is next to the youngster, although out of the picture area, to avoid panicky feelings of abandonment — or the tendency to just crawl away!

Lighting

Practice Picture: I chose a bench under a tall tree that provided open shade. Then I popped up the built-in-flash and used it to fill in the shadows and provide a little catch light in each of the lads' eyes.

On Your Own: If you are outside, you'll usually be able to find a shaded area for your picture, but if you're shooting on the beach or in snow, it's a good idea to pose the child so she isn't staring into the sun. Then use reflectors to fill in the shadows, or pop up the D70's built-in flash unit for fill. The Flash EV setting lets you dial back the power of the flash to provide a pleasing amount of fill light. You can use reflectors and multiple lights indoors, too.

Lens

Practice Picture: 18–70mm f/3.5–4.5G ED-IF AF-S DX Zoom Nikkor at 70mm.

On Your Own: A lens in the 60–70mm range serves the dual purpose of providing a flattering perspective for your subject, plus reducing the amount of depth-of-field so the background is out of focus. If you prefer a sharp background, you can use a wider lens (avoid anything wider than about 40mm when shooting this close) and a smaller f-stop. Use lenses wider than 40mm when you're shooting a full-length or group photo.

Camera Settings

Practice Picture: RAW capture. Aperture-priority AE with a custom white balance.

On Your Own: You'll want to control the depth of field, so choose aperture-priority AE mode and set the white balance to the type of light in the scene.

Exposure

Practice Picture: ISO 200, f/5.6, 1/200 second.

On Your Own: To ensure front-to-back sharpness, set a narrow aperture such as f/8 or f/16. If the background is distracting, use a wider aperture such as f/5.6 or f/4.5. Set the ISO to 200 or 400, depending on the amount of light available.

Accessories

White or silver reflectors are useful outdoors to fill in shadows and avoid harsh light when photographing kids.

Child photography tips

✦ **Get down!** Get down on the floor with a young child and shoot from the child's viewpoint. The new perspective may surprise you.

✦ **Use soft light.** Choose a slightly overcast day or open shade for flattering lighting. Youths generally have great skin, but they also manage to collect nicks and scratches from just being a child. Soft light will minimize these "defects."

✦ **Fill in those shadows.** The difference between an amateur snapshot of a child and a good-looking candid portrait is often whether the shadows are inky-dark, or bright and full of detail. You need soft shadows to model the contours of the face, but you don't want dark pits under the eyes, nose, or chin. Reflectors or fill flash are your friends.

✦ **Let the child shoot you.** If the child is 5 or older, you can help her relax and participate in the shoot more readily if you let the youngster become a co-conspirator. Have a point-and-shoot digital camera ready, or even allow the child to use your D70 to snap off a few pictures of you. Show off the results. Then it's *your* turn to take a few.

✦ **Get close.** Use a 40–70mm lens setting and fill the frame with the child's head and shoulders. For most children, a close-up will show their personalities best. Plus, your shots will be different and more interesting than the typical full-length shot most parents take of their children ad infinitum.

✦ **Include the parents or grandparents — especially if you're one of them.** Too many children look through their family albums years later and ask, "Where were you, Dad (or Mom)?" You may enjoy looking at photos of your child or grandchild more than pictures of yourself, but the time will come when everyone involved will want to see the youngsters and parents or grandparents pictured together.

Environmental Portraits

Environmental portraits have been around for as long as we've had an environment, which is to say, dating back to the 1960s. (Actually, the environment has been around longer than that, but it didn't gain its current place in the public consciousness until Rachel Carson's book *Silent Spring*.)

Before the 1960s, most formal portraits were taken in the studio or, if outdoors, under rigidly controlled conditions. The renewed love for the environment and nature made environmental portraits a favorite type for both professional photographers and serious amateurs. The goal is to produce an image that looks like a portrait, rather than a snapshot, but which includes the more casual and informal elements of the great outdoors.

Some professional photographers have suitable environmental setups right next to their studios. They solve the bad-weather problem by using large backdrops with pictures of leafy trees, along with foreground props like logs or fence posts to get an environmental look indoors.

You'll want to scout appropriate locations in advance, or simply pack up your camera and portrait subject in a car and drive around looking for good sites. Find spots with attractive natural features and enough shady areas that you won't be shooting in direct sunlight all the time.

6.24 Senior portraits for yearbook use are often environmental portraits shot in casual clothing outdoors.

Strictly speaking, environmental portraits don't have to be outdoors. A painter in a studio, a horticulturalist in a greenhouse, or a basketball player at the foul line are all shown in their respective environments. However, most environmental portraits are taken outdoors, using the same basic concepts of portraiture as their more formal counterparts.

Inspiration

Environmental portraits are a great opportunity to work the creative muscles. You may not always be able to choose your portrait models, but you certainly can choose your environment! Just about any attractive outdoor setting is fodder for your shots. You can choose public parks, a nearby woods, a scenic overlook, or a handy urban location.

6.25 Diffusion is a great tool for softening images of women, whether the diffusion is achieved in the camera or, as in this photo, added later in an image editor.

Environmental portrait photography practice

6.26 A chilly day but a warm portrait resulted from this outing in the park, with a husband seated on a picnic table while his wife rests on the table's bench.

Table 6.7
Taking Environmental Portraits

Setup	**Practice Picture:** When my brother- and sister-in-law came up from Texas for a visit, I wanted to show off the Midwest fall colors, so we toured some scenic areas, pausing long enough for the portrait shown in figure 6.26. My brother rested comfortably on a picnic table while his spouse nestled next to him on the table's bench. **On Your Own:** Choose a background that is simple and not distracting, such as trees, flowers, or a scenic vista. It will help if the background colors aren't gaudy, and are, preferably, darker than your portrait subjects. If you need ideas for locations, check the online tourist Web sites for your area. You may unearth some local scenic gems that you'd forgotten about!
Lighting	**Practice Picture:** Outdoors, simple lighting is best, so I worked with the open shade that was already there, with the skylight to the left of my subjects providing the brightest highlights. No reflectors or fill flash were required. **On Your Own:** Look for shady areas with lots of illumination bouncing off the surroundings, so your images will be well-lit with soft light and not murky. Reflectors can help fill the shadows.
Lens	**Practice Picture:** 18–70mm f/3.5–4.5G ED-IF AF-S DX Zoom Nikkor at 70mm. **On Your Own:** Less-than-full-length portraits of people always look better if you get in close and frame with a short telephoto lens in the 50–70mm range. Longer lenses tend to "flatten" the features of your subjects a bit, widening faces almost imperceptibly.
Camera Settings	**Practice Picture:** RAW capture. Aperture-priority AE. **On Your Own:** Aperture-priority should always be your choice for portraits, when controlling the depth of field is important. Use RAW capture so you can adjust the white balance later if the camera doesn't pick up on the shady light, which can tend to be bluish when much of the illumination comes from sky light bouncing into the scene. RAW is a better choice than the D70's shade white balance, which might not be spot-on in all cases.

Continued

Table 6.7 *(continued)*

Exposure	**Practice Picture:** ISO 200, f/5.6, 1/200 second. **On Your Own:** To blur the background, use a wider aperture such as f/5.6 or f/4.5. To really throw the background out of focus, use a prime lens with an f/1.4 or f/1.8 aperture. If you want to show more of the background in sharp focus, use f/11 or f/16. Set the ISO to 200 or 320, depending on the amount of light available.
Accessories	Keep some reflectors around whenever you shoot portraits. A tripod will hold your camera steady and let you get in the photo, too, if you activate the self-timer.

Environmental portrait photography tips

✦ **A little environment goes a long way.** Unless you want the subject's surroundings to become a major part of the composition, frame tightly and let only enough of the environment show that's required to make the setting obvious.

✦ **Try late-afternoon and dusk shoots.** Humans look their best in the warm light of late afternoon, compared to the stark, bluish tones found at midday. As sunset approaches, you may find the color of the light too reddish for your tastes, but if you go with the flow you can get romantic images with an almost candle-lit quality. You'll find early-evening sunlight much different from what you'd get simply applying a warming tone using your camera's or image editor's controls.

✦ **Indoor rules apply, too.** Check out the posing tips in the group-portraits and indoor-portraits sections of this chapter. You can use the same guidelines to arrange pleasing portraits in environmental settings.

✦ **Watch that background!** What photographers sometimes forget is that the background in an environmental portrait outdoors can *change* dramatically while they're shooting. A cable-TV service truck may suddenly park in front of that nice stand of trees you were using as a background. Lighting may change behind your subject, even if the illumination where you're set up in the shade remains fairly constant. That nice cloud-filled sky can change into a stark, overexposed sky. Monitor your backgrounds as you shoot to make sure they're still as suitable as they were when you started.

Event Photography

Events are activities of limited duration where there are a lot of people and lots of things going on. They include county fairs, parades, festivals such as Mardi Gras, musical concerts, as well as weddings and other celebrations. They may last a few hours, a full day, or as much as a week. Your company's annual picnic at a local amusement park, a traveling art exhibit, a building dedication, or a tailgate party before a big football game all qualify as interesting events.

You'll find lots of photo opportunities at these events, usually with a lot of color, and all involving groups and individuals having fun. If you want your creativity sparked by a variety of situations, attending an event as a spectator or participant is a good place to start.

> **Note** *Many of the photo specialties in this chapter have some overlap. For example, figure 6.27 is* also an action photograph, or one that shows patterns. Figure 6.28 commemorates a special moment at an event, but it's also a candid photograph.

It sometimes helps to think of an event as an unfolding story that you can capture in photographs. You'll want to take photos that embody the theme of the event, including overall photographs that show the venue and its setting. Grab shots of the broad scope, the number of people in attendance, and the environment where the event takes place. Then zero in on little details, such as individuals enjoying moments, booths at an amusement part, a dignitary giving a speech, or an awards ceremony. Tell a story that transports the viewer to the event itself.

Planning can help you get the best shots. You can scout parade routes in advance, or recall what sort of lighting was used at the last rock concert you attended at a particular site. Events such as Renaissance

6.27 Look beyond the action and look for the interplay of shapes and colors to add interest to your event photographs.

fairs or festivals usually have a schedule of events you can work from (although you may need to request one in advance or visit the organizer's Web site). A program will let you spot scheduling conflicts, and separate the "must-see" events from those you'll catch if you have time.

Inspiration

Public events not only serve as photo opportunities but give you a chance to document your life and time in a way that will be interesting in years to come. For example, popular-music concerts today are quite different from those staged during the hippie years in the late 1960s. Customs at weddings change over the years. Clothing, such as the outfits that were common in discos 25 years ago, can seem exotic or retro today. You'll want to give some consideration to photos that will be interesting today, as well as those you'll take for posterity.

You'll want to pack light to increase your mobility, but be sure to take along a wide-angle lens to capture overall scenes and medium shots in close quarters, and at least a short telephoto for more-intimate photos. At concerts, you'll want a longer telephoto to shoot the action onstage and probably a monopod to steady your hand for longer exposures in low light. If flash is permitted, you might want a higher powered unit like

6.28 The reception following a wedding ceremony is a joyous, sometimes raucous event that deserves to be captured in photographs. Here, a young couple has a first dance as husband and wife.

the Nikon SB-600 or SB-800 to extend your shooting range.

Event photography practice

6.29 A rock musician concentrates on his solo in this live concert shot.

Table 6.8 Taking Event Pictures	
Setup	**Practice Picture:** The concert shown in figure 6.29 took place in a club that held about 400 people, all tightly packed around the stage or boogying on the dance floor. I got permission to climb past the barriers at the front of the stage so I could shoot the band from about 10 feet away.
	On Your Own: Shooting low at a concert provides an interesting perspective and usually gives you a plain background so you can isolate one musician. However, up front and below the band at a concert is not always the best place to shoot, especially if you want to include more than one band member in the shot. See if you can't get onstage in the wings or shoot from a few rows back where the angle won't be quite so drastic.
Lighting	**Practice Picture:** This picture was taken using only the stage lighting provided at the concert — in this case a spotlight with a reddish cast. Usually, the existing light will provide illumination that suits the mood of the performance. However, it's likely to be very contrasty with not much fill-in illumination in the murky shadows. I actually brightened the guitar-player's head and frizzy hair in an image-editing program.

Continued

Table 6.8 *(continued)*

Lighting *(continued)*	**On Your Own:** Lighting at concerts can vary dramatically during the course of the performance. There may be big, bright lights used for energetic portions, and more subdued illumination, often with a blue or other hue color cast. If flash is allowed and dozens of delirious fans are snapping away, you can use the D70's built-in Speedlight at a lower power setting to fill in some shadows. Using the flash at the full setting will overpower the existing light and give your photo a harsh, snapshot-like look.
Lens	**Practice Picture:** 85mm f/1.8D AF Nikkor at f/5.6. **On Your Own:** Although zoom lenses are great for events with bright lighting so you can change the focal length quickly, at concerts you'll want to use fast prime lenses for their low-light capabilities. Vibration-reduction lenses like the 24–120mm f/3.5–5.6G ED-IF AF-S VR Zoom-Nikkor are also a good choice.
Camera Settings	**Practice Picture:** Aperture-priority AE mode. The white balance was set to Tungsten. By controlling the aperture, I was able to control the depth of field so that the guitarist's face is in sharp focus, while his arm, hands, and the lights are blurred. **On Your Own:** You'll want to control the depth of field, so switch to aperture-priority AE mode and set the white balance to the type of light in the scene. If the light is low, switch to shutter-priority AE mode.
Exposure	**Practice Picture:** ISO 800, f/5.6 1/125 second. **On Your Own:** Concerts usually call for higher ISO ratings, and the D70 provides decent results at ISO 800. You might need ISO 1600 in very low light or when you're using a longer lens and want a higher shutter speed. Don't fear using lower shutter speeds to allow musicians' hands to blur slightly. Experiment with different shutter speeds to get different looks. For other kinds of events, particularly those taking place outdoors in bright sunlight, choose ISO 200 for the best results.
Accessories	A monopod is almost a must to steady your camera for exposures that are longer than 1/200 second — or even for faster shutter speeds with longer lenses.

Event photography tips

✦ **Get there early.** Although security is tight at major rock concerts (even if you have a backstage pass), shows at smaller venues with less-well-known bands can be more photographer-friendly, particularly if you arrive early and are able to chat as equipment is unloaded and being set up. (Don't get in the way!) At other kinds of events, getting there early lets you scout the area and capture some interesting photos of floats or exhibits as they're prepped.

✦ **Concerts and other events look best photographed from a variety of angles.** Don't spend the whole concert performance planted in front of the stage, right at street-level for a parade, or around the barbeque grill at a tailgate party. Roam around. Shoot from higher vantage points and from down low. Use both wide-angle and telephoto lenses.

✦ **Ask for permission before photographing adults or children who aren't performing.** Sometimes a gesture or a nod will be all you need to do to gain the confidence of an adult. It's always best to explicitly ask for permission from a parent or guardian before photographing a child.

✦ **For outdoor events, plan for changing light conditions.** Bright sunlight at high noon calls for positioning yourself to avoid glare and squinting visitors. Late afternoon through sunset is a great time for more-dramatic photos. Night pictures can be interesting, too, if you've brought along a tripod or monopod, or if you can use a flash.

Flower and Plant Photography

For many, flowers and plant-life are the only living things that are as much fun to photograph as people. Like people, each blossom has its own personality. Flowers come in endless varieties, and their infinite variety of textures and shapes can be photographed from any number of angles. If you like colors, flowers and fruits provide

6.30 The translucent petals of flowers seem to glow with their own light when backlit.

hues that are so unique that many of our colors — from rose to lilac to peach to orange — are named for them.

Best of all, flowers and plants are the most patient subjects imaginable. They'll sit for hours without flinching or moving, other than to follow the track of the sun across the sky. You adjust them into "poses," change their backgrounds, and even trim off a few stray fronds without hearing a single complaint. You can photograph them in any season, including indoors in the dead of winter. Floral photographs are universal, too, as flowers are loved in every country of the world.

Because of their popularity, you won't have to look far for subject matter. Your own garden may provide fodder, but if you're looking for more-exotic plants, there are bound to be public gardens, greenhouses, and herbariums you can visit for your photo shoots.

Photography is so likely to be part of the experience at some venues that you'll find maps leading you to the most popular exhibits, along with tips on the best vantage points for taking pictures. Take a few overall photos to show the garden's environment, and then get closer for floral "portraits" of your favorites.

Inspiration

Flower photography is an excellent opportunity to apply your creative and compositional skills. Use color, shape, lines, and texture to create both abstract and concrete images. Experiment with selective focus and lighting (just move to another angle, and the lighting changes!). It's always fun to find plants and flowers that look like people or other objects when you want to add a little mystery or humor to your photographs.

6.31 Careful choice of lighting and angle isolates this bloom.

When shooting flowers, you can capture individual blossoms, or photograph groups of them together. As every professional or amateur flower arranger knows, floral groups of different types of plant-life can be put together creatively in bouquets to form one-of-a-kind compositions.

If you have a macro lens, you can isolate an individual part of a flower to explore the mysteries of how these small-scale miracles are constructed. It's possible to spend an entire career doing nothing but photographing flowers, and many photographers do. Surely, you'll find many hours of enjoyment tackling this most interesting subject on your own.

Flower and plant photography practice

6.32 Break a few rules — shoot from the side and allow the blooms in the foreground to go out of focus — to create an unusual image.

Table 6.9
Taking Flower and Plant Pictures

Setup	**Practice Picture:** I wanted to show a bug's-eye view of some flowers, rather than the usual human viewpoint from above. So, I moved the camera down to shoot *through* the stems and blooms to get the photo shown in figure 6.32.
	On Your Own: It's tempting to shoot down on flowers, to better capture those sumptuous blooms. That's why you may enjoy the unusual results you'll get from looking at the plant's world from its own level. Or shoot up to include the contrasting blue sky in the photo. You can shoot single blossoms, bouquets, or an entire field full of wildflowers.
Lighting	**Practice Picture:** This shot was made in full midday bright sunlight, producing vivid colors and high contrast.
	On Your Own: Although overcast conditions can be suitable for floral photos, this soft lighting tends to mask the color and texture of flowers. Full sunlight brings out the brightest colors and most detail, but it also leads to dark shadows. Use reflectors or fill flash to more brightly illuminate individual blossoms and make the color pop out.
Lens	**Practice Picture:** 105mm f/2.8D AF Micro-Nikkor.
	On Your Own: Macro lenses are ideal for flower photography. Shorter macros like the 60mm f/2.8D AF Micro-Nikkor exaggerate the proportions of parts of the flower that are closest to the lens. A longer macro, like the 105mm Micro-Nikkor, lets you step back from the blossoms and helps throw the background or (in this case) the foreground out of focus. If you don't own a macro lens, a close-focusing telephoto in the 100mm range will also work. To photograph large groups of plants or an entire field of blossoms, use a 24 to 25mm lens or zoom setting.
Camera Settings	**Practice Picture:** Aperture-priority AE. The white balance was set to Auto, color saturation to Enhanced, and manual focus used to prevent the camera from locking in on foreground flowers.
	On Your Own: Usually you'll want to control the aperture yourself, either to limit depth of field for selective focus effects, or to increase the depth of field to allow several flowers to remain in sharp focus.

Exposure	**Practice Picture:** ISO 200, f/4, 1/3200 second.
	On Your Own: An ISO 200 is ideal for most outdoor lighting conditions. To blur the background, start with an f/5.6 aperture. For more generous depth of field, use an f/8 or f/11 aperture.
Accessories	Contemplative shots such as macro photos of flowers are often best made with a tripod, which will let you position the camera precisely and fine-tune focus manually if you need to.

Flower and plant photography tips

✦ **Try natural backlighting.** Get behind the flower with the sun shining through to capture details of the back-illuminated blossom. The translucent petals and leaves will seem to glow with a life of their own.

✦ **Use manual focus.** Play with manual focus and large apertures to throw various parts of the flower in and out of focus, creating a dramatic and romantic look.

✦ **Boost saturation.** Pump up the richness of the colors by setting saturation to Enhanced. A polarizing filter can be used to create even greater saturation in the flowers and sky.

✦ **Experiment with time-lapse photography.** If you have Nikon Capture, you can connect the D70 to a computer and instruct the software to snap off a photograph automatically at intervals. You can grab shots of the flower turning to face the sun, or shoot a sequence that shows a bud opening to its full floral glory.

Group Portrait Photography

A group portrait can involve two people, or a mob of them, each presenting very different challenges. Perhaps you're photographing a father and son, a family of four, or everyone in your department at work. As the most experienced photographer in your high school class, you may be asked to set up a group photo with several hundred people in

it. Each of these groups presents different opportunities and calls for a very broad range of skills. You'll need to direct and pose several (or several dozen) people, keep them all patiently attentive and focused, then make sure no one blinks, turns his head, or frowns at the decisive moment.

Although the specific challenges in group photography vary depending on the size of the group, you'll find the tips in the following sections helpful when photographing collections of any number of people.

6.33 Mother-child groupings provide an interesting look at the contrasts and similarities between generations.

Location and lighting

Group photographs in which everyone is lined up in a row or two are deadly dull, so you'll want to select your location carefully so individuals can be posed with their heads at slightly different heights. You'll want a site that lends itself to having some members standing and some seated. For small groups, a few stools may do the job. For larger groups, stairs, risers, a hillside with some interesting rocks, or a combination of picnic tables and benches may serve as your stage. Outdoors, daylight may serve as your illumination, particularly if you can find a shady spot that's facing a reflective structure

(such as a building) that can cast light into the shadows. On-camera flash will rarely work with groups larger than five or six people, because there often is not enough light to cover the full area of the group, and those in the back will receive significantly less exposure than those in the front. If you have a pair of flash units that can be used off-camera, such as the Nikon SB-800 or SB-600 flash, you can place them to either side of the camera to get full coverage of groups of up to 20.

Find a people wrangler

For any group larger than four or five people, it's a good idea to have an assistant to help you arrange your group. It's easier to tell your helper, "Have Uncle Joe move closer to Aunt Mary, and ask the twins to switch places with their parents" than to shout these instructions to your group. Your assistant can assemble the group around the main subject, then help you group the remaining folks into classic diamond arrangements that provide the most interesting compositions. Make sure you and your helper are communicating with the group at all times, however. If your subjects feel they're on their own while you fiddle with the posing and camera, their attention will wander.

Catch the blinkers, nodders, and turners

The more people you have in a group photo, the more likely it is that someone will blink during the exposure, or turn her

Posing Tips

The goal of portraiture is to make subjects look the best they can look. You can use a few techniques to achieve this goal:

✦ **Avoid having all the heads in the same horizontal plane.** Arrange members of your group so their faces are at different heights. Then ask them to pose with their bodies at a slight angle from vertical so their faces aren't ramrod straight, either.

✦ **Pose your group in geometric shapes.** The diamond formation is a classic arrangement, with one person at top, one at bottom, and two at either side (at slightly different heights.) You can arrange even large groups into diamonds and subdiamonds to create an interesting composition.

✦ **Have your subjects hold their hands in their laps, or perhaps resting on the shoulder of another member of the group.** The edges of hands are more attractive than the back or palms of the hands. Keep the hands away from faces.

✦ **Use an upright hand to show how you want your individual subjects to move their heads, rather than just telling them to "turn" this way or that.** Your hand can rotate around your wrist to indicate you'd like them to turn at the neck, tilt to indicate movement toward or away from a particular shoulder, or pivot forward and back tomahawk-style, to show when you need them to lean toward or away from the camera.

✦ **Make sure your subjects' eyes are looking in the same direction their noses are pointed.**

✦ **Use the fewest number of rows to make the most of your depth of field.**

✦ **If you shoot groups frequently, develop some patter to keep your group engaged and attentive while you set up and shoot.** Humor can help, too, in defusing impatience during multiple shots.

head at the worst possible moment. It's almost impossible to detect these problems on a tiny LCD review image. When you're ready to shoot, ask your group if everyone can see the camera clearly. That request will alert them *not* to look away. It's always a good idea to take at least as many pictures as there are people in the group, up to about eight or ten shots. Multiple photos increase your chances of getting one in which everyone is looking at the camera and smiling acceptably.

If you're using flash, ask the group to watch for the color of the flash when it goes off. After you take the picture, ask if anyone saw a red flash instead of white. If they saw red, they saw the flash through their closed eyelids and you'll need to shoot at least one more. Finally, although you should warn your group when you're about to take a picture, don't use a countdown or some precise tip-off. Many folks will flinch or blink at the exact moment they think a photo is about to be taken.

Inspiration

The group photos you take today may be of interest for much longer than you think, possibly 30 to 40 years in the future, even though your digital files will probably have to be copied from CD or DVD to whatever media replaces them in a dozen years (or less!). So, write down the names of everyone in the photo for posterity, even if each person is a close friend or family member. Can you name every single person in your kindergarten class photo today — even though you might have attended school with those kids for several years? Can you

6.34 Couples are an easy grouping to pose, because they fit together so naturally.

guarantee your group photo won't fall into the hands of some family or company archivist in the future who doesn't personally know each individual but would like to have their names anyway? Jot down the names now, and help out your descendants.

Group portrait photography practice

6.35 I arranged this group consisting of a pair of grandparents, their daughter, and her two children in a classic diamond pose, which keeps all the heads from lining up on the same level. That's always more interesting than faces all in a row.

Table 6.10
Taking Group Portraits

Setup	**Practice Picture:** I hadn't seen my niece since she was her son's age, so I made sure she posed with her kids and parents during a visit. I grouped the five-some in a casual arrangement to produce the photo shown in figure 6.35.
	On Your Own: Small groups can be posed anywhere you'd shoot an individual portrait. For larger groups, find an area that's large enough to accommodate everyone, and includes some surfaces you can use to provide seats or resting places. A stool or rock can elevate you, the photographer, slightly so you're not shooting up at the group.
Lighting	**Practice Picture:** Open shade, outdoors.
	On Your Own: Outdoors, you can work with existing light, preferable in open shade. But if your group moves indoors, you'll need more meticulous planning. One or two off-camera flashes, perhaps bounced from a wall or ceiling will help illuminate a large group. You'll need to watch for flash bouncing off glasses, too, when using flash. Ask your subjects to tilt their heads back slightly to avoid bouncing the flash back into the camera lens.
Lens	**Practice Picture:** 28–200mm f/3.5–5.6G ED-IF AF Zoom-Nikkor set to 50mm.
	On Your Own: For groups of two to three people, choose 60mm zoom setting. For five to ten people, a normal lens of 35–40mm works well. Larger groups require a wide-angle lens to take everyone in, but if you find yourself shooting with a lens at less than 20mm, try stepping back first, to avoid the distortion you sometimes get with more-extreme wide-angle lenses.
Camera Settings	**Practice Picture:** RAW exposure. Aperture-priority AE mode with white balance set to auto.
	On Your Own: You'll want to control depth of field in group photos, so use aperture-priority AE mode to choose the aperture and let the camera select a shutter speed.
Exposure	**Practice Picture:** ISO 200, f/5.6, 1/200 second.
	On Your Own: For small groups, a wider f-stop lets you throw the background out of focus. For larger groups arranged in more than one row, use f/8 to f/11 to increase the depth of field.
Accessories	A tripod is a good idea for group photos. You can compose your image, then step away and rearrange people as you compose the picture without the need to reframe when you're ready to shoot.

Group portrait photography tips

✦ **Check for subjects in disarray.** Even photos of large groups are still pictures of individuals, and each person in your shot will want to look his best. So, you or your assistant should take the time to review your posing, looking for unfortunate expressions, wrinkled or gappy clothing, mussed hair, and so forth, for each person in the group.

✦ **Check for any lighting errors.** Look carefully for shadows cast on people's faces (particularly if you're using an off-camera flash), glare off glasses or jewelry, and other lighting faux pas.

✦ **Take many more photos than you think you'll need.** Even if a group gets together regularly, reassembling them for a reshoot can still be a lot of trouble. As long as you have everyone in front of your camera, take the time to shoot lots of photos. After all, as a digital photographer, you don't have to pay extra for film, processing, and proofs.

Indoor Portraits

Indoor portraits are often what we think of as slightly-more-formal photos of individuals or small groups, using carefully-crafted lighting, posing, and backgrounds. However, portraits taken indoors can also be candid photos, like the one shown in figure 6-36. Today, most people have a definite preference for relaxed, comfortable portraits, whether they're taken indoors or out.

You'll find that indoor portraits are a perfect opportunity to experiment with lighting, because you'll usually have complete command of the illumination and can, if you like, set up lights or electronic flash units under more controlled conditions. A mini studio set up at home lets you adjust poses, backgrounds, and lighting in dozens of ways, all in the space of a few minutes.

6.36 Window lighting, augmented by light reflected from the window in the rest of the room, can be the basis for soft, flattering portrait lighting indoors. Most of the time, the subject will be posed facing the window, but breaking the "rule" can yield interesting shots like this one.

Inspiration

You can use several off-camera electronic flash or incandescent lights to create professional-looking indoor portraits.

6.37 Two lights — one on the background and one bouncing off a reflector to the left of the camera — were all that was needed for this glamour portrait.

Lighting Tips

Lighting should present your subject in a flattering way and can even be used to improve the looks of faces that are less-than-perfect. You can use a few techniques to achieve this goal:

✦ Work with two or three (or more) lights. A *main light* provides the principal illumination for the scene. The *fill light,* usually placed near the camera on the side opposite the main light, brightens shadows. Increasing or decreasing the intensity of the fill makes the shadows less or more dramatic. If necessary, you can use a third, *background light* to provide separation between your subject and a similarly-toned background. Many photographers add a *hair light* to add sparkle to the hair and create additional separation from the background.

✦ *Broad lighting* places the main light so it illuminates the side of the face turned toward the camera, as in figure 6-38. This type of lighting tends to widen narrow faces.

✦ *Short lighting* moves the main light behind the subject so it illuminates the side of the face turned away from the camera. This type of lighting narrows wide faces.

✦ *Side lighting,* as shown in figure 6-37, is used to illuminate profiles.

✦ *Back lighting* produces silhouette-type photos.

Indoor portrait practice

6.38 Three lights and a stool were all the tools needed for this semiformal home portrait.

Table 6.11
Taking Indoor Portraits

Setup	**Practice Picture:** I draped a length of fabric over a curtain as a background, set up three off-camera electronic flash units, and posed my model on a stool to bring her up to camera-eye-level for the photo in figure 6.38.
	On Your Own: You'll find that fabric, at a few dollars a yard, makes a great background for indoor portraits. Purchase two or three yards of solid or textured fabrics in blues, neutral browns, or grays. A transparent piece of plastic placed over your background line can turn a gray background into any color of the rainbow.

Continued

Table 6.11 *(continued)*

Lighting	**Practice Picture:** A low-power electronic flash with built-in slave unit was placed on the ground behind the model and pointed up at the background. An off-camera Nikon SB-800 Speedlight linked to the D70 through a Nikon SC-28 cable, was positioned to the right of the camera and bounced off a 40-inch white umbrella. A second SB-800 flash, triggered by the camera-linked unit, was bounced off a white reflector positioned to the left of the model, and slightly behind her. **On Your Own:** Some photographers also add a low-powered hair light, placed above and behind the model to illuminate the top of the head/hair and provide additional separation from the background. Be careful that the hair light does not spill over onto the face!
Lens	**Practice Picture:** 50mm f/1.8D AF Nikkor. **On Your Own:** At less than $100, Nikon's 50mm f/1.8 lens is likely to be one of the sharpest optics in your bag of tricks, and it makes a great portrait lens. It's sharp wide open, so you can opt for really shallow depth of field if you like, and it focuses as close as 1.5 feet — much closer than you'll want to get for most portraits. However, you can choose any lens or zoom setting in the 50–70mm range for most individual portraits.
Camera Settings	**Practice Picture:** RAW capture. Aperture-priority AE. **On Your Own:** If you're using flash, the shutter speed isn't crucial, so you'll want to use aperture-priority AE mode to let you specify the f/stop and control the amount of depth of field.
Exposure	**Practice Picture:** ISO 200, f/11, 1/500 second. **On Your Own:** For most portraits, you'll want enough depth-of-field to ensure your model's entire face is in sharp focus (especially the eyes!), but is shallow enough to throw the background partially out of focus. So, f/11 is a good place to start, but you can use f/8 or f/5.6 if you want more selective focus.
Accessories	White or silver reflectors or umbrellas are essential for providing indirect lighting that is softer and more flattering. Use soft white for women and teenagers who want their skin to look creamy-soft. Silver might be a better choice for men or older folks who are proud of their character lines. Gold reflectors add a warmer look that is beneficial for glamour shots. You'll want to eschew a tripod if you're using flash, because people pictures work best when the photographer is free to move around and change angles to capture the best pose or expression.

Indoor portrait photography tips

✦ Although a bald head has become a fashion statement these days, if your subject is sensitive about a bare pate, elevate your victim's chin and lower your camera slightly to minimize the top of the head. And *don't* use a hair light!

✦ If your subject has a long, large, or angular nose, have him face directly into the camera.

✦ To minimize prominent ears, shoot your model in profile, or use short lighting so the ear nearest the camera is in shadow.

✦ As mentioned earlier, wide faces can be narrowed by using short lighting; narrow faces can be widened using broad lighting.

✦ To minimize wrinkles or facial defects such as scars or a bad complexion, use softer, more diffuse lighting using a white umbrella or an even more flattering add-on light modifier called a *soft box*. (You can search online, with a search engine such as Google, to find vendors of these products.) Make sure the main light is at eye level to avoid wrinkle-emphasizing shadows.

✦ People wearing glasses are a perennial problem for portrait photographers. Watch for reflections and ask your model to raise or lower her chin slightly so the light will bounce off the lenses at an angle, rather than right back at the camera.

Landscape and Nature Photography

Like floral photography, landscape and nature photography provides you with a universe of photo subjects, there for the taking, courtesy of Mother Nature. This kind of photography provides a dual joy: the thrill of the hunt as you track down suitable scenic locations to shoot — whether remote or close to home — and then the challenge of using your creativity to capture the scene in a new and interesting way.

6.39 Rock formations carved out by glacier-fed streams created this interesting natural wonder.

Landscapes are an ever-changing subject, too. The same scene can be photographed in summer, winter, fall, or spring, and look different each time. Indeed, a series of these photos of a favorite vista in different seasons makes an interesting and rewarding project.

Inspiration

Nature photography can take many forms. You can photograph a landscape as it really is, capturing a view exactly as you saw it in a moment in time. Or you can look for an unusual view or perspective that adds a fantasy-world quality. The three basic styles

of landscape photography actually have names: *representational* (realistic scenery with no manipulation), *impressionistic* (using photographic techniques such as filters or special exposures that provide a less realistic impression of the landscape), and *abstract* (with the landscape reduced to its essential components so the photo may not resemble the original scene at all).

Look for wildlife to populate your landscape, or shoot a scene with only the trees, plants, rocks, sky, and bodies of water to fill the view. Choose the time of day or season of the year. You may be working with the raw materials nature provides you, but your options are almost endless.

Scouting Locations

As you enjoy landscape and nature photography, you'll discover some tricks for finding good scenes to shoot.

✦ If you're in an unfamiliar area, check with the staff of a camping or sporting goods store or a fishing tackle shop. Stop in and buy a map or make another small purchase, and then quiz these local experts to discover where the best hiking trails or fishing spots are.

✦ Buy a local newspaper and find out what time the sun or moon rises or sets. Dusk or dawn make particularly good times for landscape photography because the light is warm and the lower angle of the sun brings out the texture of the scenery.

✦ Don't get lost! Carry a compass so you'll always know where you are when scouting locations. Plus, you can use the compass with subposition tables you can find locally to determine exactly where the sun or moon will be at sunset or sunrise. If the sun will set behind a particular mountain, you can use that information to choose your position.

✦ Include weather in your plans. Rainy or cloudy weather may put a damper on your photography, or it can form the basis for some interesting, moody shots. The National Weather Service or local weather forecasters can let you know in advance whether to expect clear skies, clouds, wind, or other conditions.

6.40 During the summer, this particular lakeshore is a popular recreational boat-launching site. In winter, it's a deserted and lonely scene that lends itself to this backlit silhouetted image.

Landscape and nature photography practice

6.41 Dusk at a lake during late fall is a time of solitude and vivid colors that makes for beautiful scenic landscapes.

Table 6.12
Taking Landscapes and Nature Pictures

Setup	**Practice Picture:** This lake is full of water-skiers, swimmers, and boaters during the summer, but in the fall it becomes a perfect backdrop for striking scenic shots. I captured this solitary Great Blue Heron in figure 6.41 just a few yards from a now-deserted beach. A tripod steadied the camera.
	On Your Own: You don't need to find a remote location to find unspoiled wilderness. Even sites close to home can make attractive scenic photos if you're careful to crop out the signs of civilization.
Lighting	**Practice Picture:** I began my trek in search of photo locations in late afternoon, and it was almost dusk by the time I found this site. The sun, low in the sky, provided all the ruddy illumination needed to accentuate the rich color of the changing foliage.
	On Your Own: You won't have much control over the available illumination when shooting scenics; tools like reflectors or fill flash are little help when photographing vistas that may extend miles from your camera. Your best bet is to choose your time and place, and take your shots when the light is best for the kind of photographs you want to take.
Lens	**Practice Picture:** Sigma 170–500mm f/5-6.3 APO Aspherical AutoFocus Telephoto Zoom Lens at 400mm.
	On Your Own: Use a wide-angle lens to take in a broad view, but keep in mind that the foreground will be emphasized. If you're far enough from your chosen scene, a telephoto lens will capture more of the distant landscape, and less of the foreground. Use a long telephoto to reach out and grab scenes containing easily spooked wildlife.
Camera Settings	**Practice Picture:** RAW capture. Shutter-priority AE, with saturation set to Enhanced. Although I could have boosted saturation during conversion from RAW, it's easier to make your basic settings at the time you shoot.
	On Your Own: Shutter-priority mode lets you set a high enough shutter speed to freeze your landscape and counteract any camera or photographer shake if you're not using a tripod.
Exposure	**Practice Picture:** ISO 400, f/11, 1/500 second. Slight underexposure produced a slightly silhouetted effect and helped make the colors richer.
	On Your Own: This late in the day, an ISO setting of 400 allowed a higher shutter speed. Any extra noise caused by the ISO boost shows up only in the distant trees and in shadow areas.
Accessories	A tripod may help you steady the camera and make it easy to fine-tune your composition. Use a quick-release plate so you can experiment with various angles and views and then lock down the camera on the tripod only when you've decided on a basic composition. A circular polarizer and an umbrella and raincoat might be handy, too.

Landscape and nature photography tips

✦ **Use a circular polarizer with caution.** A polarizer can remove reflections from water, cut through haze when photographing distant scenes, and boost color saturation. However, a polarizer may cause vignetting with extra-wide-angle lenses, will reduce the amount of light reaching your sensor (increasing exposure times), and may be unpredictable when applied to images with a great deal of sky area.

✦ **Bracket your exposures.** The same scene can look dramatically different when photographed with a half-stop to a full-stop (or more) extra exposure, or with a similar amount of underexposure. An ordinary dusk scene can turn into a dramatic silhouette.

✦ **Take along protective gear for inclement weather.** A sudden shower can drench you and your D70. An unexpected gust of wind can spoil an exposure, or even tip over a tripod-mounted camera. An umbrella can protect you from precipitation or shield your camera from a stiff wind.

Light Trail Photography

Every type of photography requires light to make an exposure, but did you know that it's easy to make *light itself* your subject? You probably know that if your camera moves during a long exposure (which can range from 1/30 second to several seconds or minutes), everything in the photo will become streaky — especially any light sources within the frame.

If the points of light are the only thing bright enough to register, what you end up with is a photo that captures light trails. These trails show the "path" the light takes as the camera shakes or, in the case of non-stationary illumination, the movement of the light itself. Figure 6-42 shows an example of a fixed light source and a moving camera.

Alternatively, you can lock down the camera on a tripod and leave the shutter open long enough to capture moving lights at night, such as the headlights or taillights of moving automobiles, a rotating Ferris wheel, or fireworks displays.

6.42 I pointed the camera at some parallel light bulbs outdoors, and then jiggled the camera at random during a 1-second exposure to produce these abstract light trails.

Inspiration

Use your imagination to come up with different ways of recording light trails. Here are a few ideas to get you started:

✦ Outdoors on a very dark night, set up the camera on a tripod and open the shutter for a 30-second time exposure. A helper positioned within the camera's field of view can use a penlight pointed at the camera to write or draw an image with light. As long as no light spills over onto the person wielding the penlight, only the light trail will show up in the picture. Place a transparent piece of colored plastic in front of the penlight to change the color of the light trail, even during the exposure.

> **Tip** If your confederate wants to inscribe actual words in midair, remember to use script letters and write backward!

✦ Tie the penlight on a piece of long cord, suspend it from an overhead tree branch, and place the D70 on the ground, pointing upward. Start the penlight swinging back and forth, pendulum-fashion in a figure-8 or other pattern. Then open the shutter for a few seconds. You'll record a regular pattern. Carefully pass pieces of colored plastic in front of the lens to create multicolored streaks.

✦ Mount the camera on a tripod, point it at a busy street, and shoot long exposures to capture the streaking headlights and taillights of the automobiles. Experiment with various exposures, starting with about 1 second to 20 seconds to create different effects.

6.43 The camera was mounted on a tripod and the shutter opened for several seconds to produce the light trails left by this rotating Ferris wheel.

Light trails photography practice

6.44 A long exposure captured the multi-bursts that erupted during the finale of a Fourth of July fireworks extravaganza.

Table 6.13
Taking Pictures of Fireworks

Setup	**Practice Picture:** I got to the fireworks show in figure 6.44 early so I could pick out a prime location on a small hill slightly elevated above the crowd and at the edge of a stand of trees where I could set up a tripod without obstructing the view of the crowds seated in the vicinity.
	On Your Own: A position close to where the fireworks are set off will let you point the camera up at the sky's canopy and capture all the streaks and flares with ease. On the other hand, a more distant location will let you photograph fireworks against a city's skyline. Both positions are excellent, but you won't have time to use both for one fireworks show. Choose one for a particular display, and then try out the other strategy at the next show.

Continued

Table 6.13 *(continued)*

Lighting	**Practice Picture:** The fireworks provide all the light you need.
	On Your Own: This is one type of photography that doesn't require making many lighting decisions.
Lens	**Practice Picture:** 28–200mm f/3.5–5.6G ED-IF AF Zoom-Nikkor set to 28mm.
	On Your Own: A wide-angle lens is usually required to catch the area of the sky that's exploding with light and color. Even a fish-eye lens can be used to interesting effect. If you're farther away from the display, you may need a telephoto lens to capture only the fireworks.
Camera Settings	**Practice Picture:** RAW capture. Manual exposure, with both shutter speed and aperture set by hand. Saturation set to Enhanced.
	On Your Own: Depth of field and action stopping are not considerations. Don't be tempted to use noise reduction to decrease noise in the long exposures; the extra time the reduction step takes will cause you to miss some shots.
Exposure	**Practice Picture:** ISO 200, f/11, 30 seconds.
	On Your Own: Don't try to rely on any autoexposure mode. Your best bet is to try a few manual-exposure settings and adjust as necessary.
Accessories	A steady tripod is a must. You also should have a penlight, so you can locate the control buttons in the dark! Carry an umbrella so your camera won't be drenched if it rains unexpectedly. The infrared remote control can be used to trip the shutter or to produce a bulb-type exposure that continues until you press the remote-control button a second time.

Fireworks photography tips

✦ **You must use a tripod.** Fireworks exposures usually require a second or two to make, and nobody can handhold a camera completely still for that long. Set up the tripod and point the camera at the part of the sky where you expect the fireworks to unfold, and be ready to trip the shutter.

✦ **Review the first couple of shots you take on your LCD to see if the fireworks are being captured as you like.** Decrease the f/stop if the colored streaks appear to be too washed out, or increase the exposure if the display appears too dark. Experiment with different exposure times to capture more or fewer streaks in one picture.

✦ **Track the skyrockets in flight so you can time the start of your exposure for the moment just before they reach the top of**

their arc and explode, and then trip the shutter. An exposure of 1 to 4 seconds will capture single displays. You can use longer exposures if you want to image a series of bursts in one shot.

✦ **Don't worry about digital noise.** It's almost unavoidable at longer exposures and won't be evident after you start playing with the brightness and contrast of your shots in your image editor.

Macro Photography

Close-up, or *macro*, photography is another chance for you to cut loose and let your imagination run free. This type of picture taking is closely related to floral photography and still-life photography, which also can involve shooting up close and personal. However, the emphasis here is on getting really, *really* close.

Although you can have lots of fun shooting close-ups out in the field, macro photography is one of those rainy-day activities that you can do at home. You don't need to travel by plane to find something out of the ordinary to shoot. That weird crystal saltshaker you unearthed at a garage sale might be the perfect fodder for an imaginative close-up that captures its brilliance and texture. Grains of sand, spider webs, the interior workings of a finely crafted Swiss watch, and many other objects can make fascinating macro subjects. Or you can photograph something as important to you, such as your coin or stamp collection.

Inspiration

Explore the world around you by discovering interesting subjects in common objects. When you've found subject matter that will give your imagination a workout, the next step is to make it big.

Indeed, the name of the game in macro photography is magnification, not focusing distance. If you want to fill the frame with a

6.45 One of the most common applications for macro photography is to capture pictures of hobby collections, such as coins, stamps, or miniature figurines.

6.46 A close-up photo can help you discover new worlds in everyday objects. This exotic alien artifact is nothing more than a tripod mounting screw.

postage stamp, it matters little whether you're using a 60mm or 105mm macro prime lens, or a close-focusing zoom lens. Any of these should be able to fill that frame with the stamp, and for a relatively flat object of that sort, you probably won't be able to tell which lens or focal length was used to take the picture.

Your choice of lens, then, will depend on how far away you want to be when you fill that frame. To shoot a postage stamp, you might like a 60mm lens; a 105mm lens might be better when you're photographing a flower and want enough room to play with some lighting effects. If your passion is photographing poisonous spiders or skittish critters, perhaps a 200mm macro lens would be more suitable.

You don't have to purchase an expensive macro lens to enjoy close-up photography. A lens you already own may focus close enough for some kinds of macro work. Or if you own

Nikon's excellent 50mm f/1.8 AF lens (or are willing to spend less than $100 for one), you can couple that optic with an inexpensive extension tube to extend its focus range down to a few inches from your subject.

Automatic extension tubes that preserve your D70's autofocus and exposure features can be purchased individually for as little as $50, in sizes ranging from about 12mm to 36mm in length, or in sets of three. You can combine tubes to get longer extensions. A good, sharp lens and some extension tubes can get you in the macro game quickly.

Less ideal are close-up attachments that screw onto the front of a lens similarly to a filter, and provide additional magnification. Unless you buy one of the more expensive models ($50 or more, depending on the filter size your lens requires), you'll lose a little sharpness. Several close-up attachments can be used at once to produce additional magnification at the cost of a little more resolution.

Macro photography practice

6.47 This experimental close-up was made using a novel painting-with-light illumination scheme. A flashlight was shined on the micrometer and key subjects from a variety of angles during exposure.

Table 6.14
Taking Macro Photos

Setup	**Practice Picture:** I didn't even move from my desk to take the photo in figure 6.47. While writing this chapter, I grabbed a sheet of paper from my printer to use as a backdrop, mounted my D70 on a tabletop tripod I keep on my desk, and grabbed a flashlight for illumination.
	On Your Own: Use poster board, fabric, or other backgrounds to isolate your macro subjects, and pose them on a tabletop or other flat surface.
Lighting	**Practice Picture:** I turned off all the lights in the room. Then, during a 30-second exposure, I "painted" my subject from a variety of angles, providing a kind of omni directional light that still produced some smooth shadows.
	On Your Own: You can use desk lamps to light small setups, with reflectors to fill in the shadows.
Lens	**Practice Picture:** 105mm f/2.8D AF Micro-Nikkor.
	On Your Own: Use a macro lens or close-focusing prime or zoom lens to provide the magnification you need. Or fit a 50mm f/1.8 or other prime lens with extension tubes to get you in close.
Camera Settings	**Practice Picture:** RAW capture. Manual exposure. I could have converted the white balance to a tungsten setting when working with the RAW file in my image editor, but I loved the rich golden color of the flashlight illumination, so I left it alone.
	On Your Own: Unless you're going for a special effect, you'll want to control the depth of field, so choose aperture-priority AE mode and set the white balance to the type of light in the scene.
Exposure	**Practice Picture:** ISO 200, f/32, 30 seconds.
	On Your Own: For maximum front-to-back sharpness, set a narrow aperture such as f/16 to f/22. To blur the background, choose a wider aperture such as f/8 to f/11. Use ISO 200 for maximum sharpness and the least amount of noise. You won't need higher ISOs when your camera is mounted on a tripod.
Accessories	Use a tripod for macro photography. The Nikon ML-L3 infrared remote control is a good tool to help you avoid camera shake when tripping the shutter.

Macro photography tips

✦ **Use the focus-lock control to freeze focus.** You can also set your camera/lens to manual focus and zero in on the exact plane you want to appear sharpest.

✦ **If you don't have a Nikon ML-L3 remote control, use the self-timer to trip the shutter.** Even if you press the shutter-release button carefully, you'll probably still jostle the camera a little.

✦ **Remember that long exposures take some time.** Just because you heard a click doesn't mean the picture is finished. Wait until the shutter closes again, or you can see the review image on the LCD, before touching the camera.

✦ **Use the D70's LCD to review your close-up photos right away so you can double-check for bad reflections or other defects.** It takes a long time to set up a close-up photo, so you want to get it right now, rather than have to set up everything again later.

Night and Evening Photography

Photography during the evening and after dusk is a challenge because, after the sun goes down, there is much less light available to take the photo. Add-on light sources, such as electronic flash, can be used only as a last resort, because as soon as you add an auxiliary light, the scene immediately loses its nighttime charm. Unless you're looking for a retro–Speed Graphic look reminiscent of the 1930s to 1950s photojournalist Weegee (Arthur Fellig), flash at night is a less-than-perfect solution.

Instead, the goal of most night and evening photography is to reproduce a scene much as it appears to the unaided eye, or, alternatively, with blur, streaking lights, or other effects added that enhance the mood or create an effect.

6.48 This 12-foot-high illuminated skull greeted visitors at the entrance arch of a haunted park last Halloween. A fast f/1.8 prime lens and a tripod-mounted D70 captured the scariness.

Because night photography is so challenging technically, you'll find it an excellent test of your skills, and an opportunity to create some arresting images.

Inspiration

Correct exposure at night means boosting the amount of light that reaches your sensor. That can be accomplished in several different ways, often in combinations. Here are some guidelines:

✦ **Use the widest possible aperture.** A fast prime lens, with a maximum aperture of f1.8 to f1.4, will let you shoot some brightly lit night scenes handheld using reasonably short shutter speeds. Nikon makes such autofocus lenses in 28mm, 50mm, and

6.49 The Moon is one nighttime photo subject that can be shot at the same exposure as daylight subjects, so I was able to snap this picture at 1/1600 second at f/8 using an ISO setting of 400.

85mm focal lengths. Older-style (AI-S) manual focus lenses are available in 35mm f1.4, 50mm f1.2, and 85mm f1.4 configurations.

✦ **Use the longest exposure time you can handhold.** For most people, 1/30 second is about the longest exposure that can be used without a tripod with a wide-angle or normal lens. Short telephotos require 1/60 to 1/125 second, making them less suitable for night photography without a tripod. However, lenses with vibration reduction built in, such as the 24–120mm f/3.5–f/5.6 VR Zoom-Nikkor can be handheld for exposures of 1/15 second or longer.

✦ **Use a tripod, monopod, or other handy support.** Brace your camera or fix it tight and you can take shake-free photos of several seconds to 30 seconds or longer.

✦ **Boost the ISO.** Increase the sensor's sensitivity to magnify the available light. Unfortunately, raising the ISO setting above 400 also magnifies the grainy effect known as *noise.* If you're not in a hurry, the D70's noise-reduction option takes a second, blank frame for the same interval as your original exposure, and then subtracts the noise found in this dark frame from the equivalent pixels in your original shot. This step effectively doubles the time needed to take a picture, meaning you'll have a 30-second wait following a 30-second exposure before you can take the next picture.

Night and evening photography practice

6.50 Early evening officially begins when the sun goes down, and that can be the best time to capture some moody night scenes, such as this murky but detailed rural vista.

<table>
<tr><td colspan="2" align="center">Table 6.15
Taking Night and Evening Pictures</td></tr>
<tr><td>Setup</td><td>**Practice Picture:** I spotted the scene in figure 6.50 just after dusk on my way to an appointment and didn't even get out of the car. I pulled over, rolled down the window halfway, and rested the lens on the edge to snap off a series of shots.</td></tr>
<tr><td></td><td>**On Your Own:** If you carry your camera with you at all times, you can constantly be on the lookout for grab shots. You don't necessarily need a tripod for night scenes. Rest your camera on an available object to steady it. If your scene is relatively unmoving, use the self-timer to trigger the shot and avoid shaking the camera with your trigger finger.</td></tr>
<tr><td>Lighting</td><td>**Practice Picture:** The waning sunlight was enough for this exposure, as reflected skylight illuminated the field in the foreground.</td></tr>
<tr><td></td><td>**On Your Own:** Try to work with the light that is available. If you must use supplementary light, bounce it off reflectors or other objects and don't let it become strong enough to overpower the existing light. At most, you'd just want to fill in some of the darker shadows, especially when the available light is overhead and high in contrast.</td></tr>
</table>

Lens	**Practice Picture:** 28–200mm f/3.5–5.6G ED-IF AF Zoom-Nikkor set to 28mm.
	On Your Own: Unless you need to reach out to photograph something at a distance, fast wide-angle prime lenses, or zoom lenses at a wide-angle setting are your best choice for night photography. Longer lenses usually have a smaller maximum aperture, and require more careful bracing to avoid blur from camera/photographer shake.
Camera Settings	**Practice Picture:** RAW capture. Shutter-priority AE with optimize image set to Vivid.
	On Your Own: Using shutter-priority mode, set your camera to the slowest shutter speed you find acceptable (based on whether you're handholding or using the camera on a tripod), and the metering system will select an f/stop. For wide-angle scenes extending to infinity, the depth of field is usually not important. Unless the foreground is very close to the camera, everything will be acceptably sharp even wide open.
Exposure	**Practice Picture:** ISO 800, f/3.5, 1/160 second.
	On Your Own: Although your D70's matrix metering system will do a good job with most night scenes, you may want to bracket exposures to get different looks.
Accessories	A tripod, a monopod, or even a beanbag can serve as a support for your camera during long nighttime exposures.

Night and evening photography tips

✦ **If you absolutely *must* use flash, use slow-sync mode.** This allows use of longer shutter speeds with flash so that existing light in a scene can supplement the flash illumination. With any luck, you'll get a good balance and reduce the direct flash look in your final image.

✦ **Shoot in twilight.** This allows you to get a nighttime look that takes advantage of the remaining illumination from the setting sun.

✦ **When blur is unavoidable due to long exposure times, use it as a picture element.** Streaking light trails can enhance an otherwise staid night-scene photo.

✦ **If you have a choice, shoot on nights with a full moon.** The extra light from the moon can provide more detail without spoiling the night-scene look of your photo.

✦ **Bracket exposures.** Precise exposure at night is iffy under the best circumstances, so it's difficult to determine the "ideal" exposure. Instead of fretting over the perfect settings, try bracketing. A photo that's half a stop or more under- or overexposed can have a completely different look and can be of higher quality than if you produced the same result in an image editor.

Online Auction Photography

Online auction sites such as eBay are great venues for those who want to clear out their attics, sell their older Nikon gear so they can buy new lenses and accessories, or locate a rare or unusual item.

The first thing sellers discover is that good photos lead to higher bids and more profit, because online buyers are more likely to purchase something if they can see exactly what they're getting.

You can sell just about any product on eBay, with some notable exceptions for firearms, human body parts, and other excluded items. In addition to photo gear, you'll find computers and accessories, clothing, videogames, books, automobiles, and other

6.52 There's a separate eBay Motors auction site for motor vehicles, but the photo rules remain the same. Picture the product you're selling in an attractive setting, so buyers will want to own what you're offering.

goodies for sale. Because shipping large items can be expensive, the vast majority of the items sold on eBay are roughly the size of a proverbial breadbox or two. That means that much of what you've learned about close-up or flower photography, or even indoor portraiture, can be applied to online auction photos. The goals are the same: to capture a clear, well-lit image of a subject.

The chief difference between online-auction photography and other sorts of close-up or product photography is that your end product must be Web-friendly, and probably will be resized to no more than about 600 x 400 pixels. However, by starting out with the tools available to Nikon D70 owners, you can be sure that your final photo will be superior to most of the efforts of the point-and-shoot crowd.

6.51 This photo was used on eBay to sell an older Nikon fish-eye lens that couldn't be used with a Nikon D70 but which was too good to stow in a closet to collect dust.

Inspiration

Unlike other photography you may produce, online-auction pictures take on a mass-production aspect. Where you might spend half an hour setting up a conventional close-up photo to get it exactly right, when you have 15 or 20 different items to photograph for this week's auctions you'll want to be able to crank out good pictures very quickly. The key is to have a setup you can use over and over, much in the way catalog photographers do. After the background and lights have been arranged, you can drop one product into the setting, take a photo or two, and then replace it with a different product. Instead of spending 30 minutes per photo, you might want to be able to shoot 10 or 20 pictures in 30 minutes.

If you want to work very fast, use a piece of fabric as a background, and find a location that has good natural lighting that will let you dispense with flash or lamps altogether. Mount your camera on a tripod so you can keep the same subject distance and angle for a series of similar-sized items, and consider using an infrared remote control so you don't even have to take more than a glance through the viewfinder between shots. With some practice, you'll be cranking out auction photos as quickly as an experienced catalog photographer.

Online auction photography practice

6.53 Lladró porcelain sells well in online auctions, but the piece must be presented attractively. Here, the specular highlights on the glossy finish bring this figure of a cat playing with a frog to life.

Table 6.16
Taking Auction Photos

Setup	**Practice Picture:** I draped a blue cloth over a living room couch and let the light from the windows behind the couch provide most of the illumination for the shot in figure 6.53.
	On Your Own: If you shoot many auction photos, you may want to set aside a corner as your permanent auction "studio" with background and lighting already in place. You'll find that a single setup can work with objects in a broad range of sizes.
Lighting	**Practice Picture:** Window light did the trick, providing a relatively soft illumination with just enough contrast to show details of the figurine, while speckling its surface with highlights that showed off its gloss. A single reflector located just below the camera lens filled in the shadows.
	On Your Own: Direct flash won't give good results for this kind of photography. It will be too harsh and you may even find that the camera's lens or lens hood casts a shadow on the item being photographed. Use desk lamps or off-camera flash, as described in the "Business Photography" section.
Lens	**Practice Picture:** 105mm f/2.8D AF Micro-Nikkor.
	On Your Own: Use a macro lens or close-focusing prime or zoom lens to provide the magnification you need. You can also use a 50mm f/1.8 or other prime lens with extension tubes to photograph objects from a few inches to a few feet from the camera.
Camera Settings	**Practice Picture:** RAW capture. Aperture-priority AE with saturation set to Enhanced.
	On Your Own: As with other close-up photos, you'll want to control the depth of field, so choose aperture-priority AE mode and set the white balance to the type of light in the scene.
Exposure	**Practice Picture:** ISO 200, f/11, 1/30 second.
	On Your Own: Usually, you'll want to use an f-stop between f/11 and f/22 to maximize front-to-back sharpness. If the camera is mounted on a tripod, you can use longer shutter speeds as required, and stick with an ISO setting of 200 for maximum quality.
Accessories	Use reflectors to fill in the shadows. A remote control will come in handy for tripping the shutter rapidly.

Online auction photography tips

✦ **Crop tightly.** If you're trying to fill a 600-pixel-wide image with information, crop tightly so you don't waste any space. You can crop in the camera, or later in your image editor. Fortunately, your D70 has pixels to spare — about 25 times more than you really need for an auction photo.

✦ **Use a plain background.** Although plain backgrounds are important for most kinds of close-up photography, they're even more important for online auction photos, which must present the product being sold with no distractions.

✦ **Use higher-contrast lighting.** Soft lighting obscures details, and snappier lighting shows off the details in the product you're trying to sell. Save the diffused illumination for your glamour photography.

✦ **Boost saturation — within limits.** For some kinds of products, it's a good idea to dial in some extra saturation to make your image more vivid and appealing. However, if the true colors of your item are an important selling point (as with clothing or dinnerware), go for a more realistic rendition that doesn't mislead your buyers.

Panoramic Photography

No scenic photo is quite as breathtaking as a sweeping panorama. Horizons look more impressive, mountain ranges more majestic, and vistas more alluring when presented in extra-wide views. If you shoot scenic photography — from landscapes to seascapes — you'll want to experiment with panoramas.

You can create them in your camera, or assemble them from multiple shots in your image editor.

Some of the charm of panoramas comes from the refreshing departure from the typical 3:2 aspect ratio that originated with 35mm still-photo film frames, and which lives on in the 3008-x-2000-pixel resolution of the Nikon D70. Even common print sizes, such as 5 x 7, 8 x 10, or 11 x 14 inches

6.54 This panorama was produced by taking an ordinary shot and cropping off the top and bottom to eliminate excess sky and foreground areas.

6.55 Another way to create a panorama is to take several photographs and stitch them together in an image editor. This view of Toledo, Spain, was assembled from two different images taken seconds apart.

provide a staid, squat, rectangular format. Only the panorama option of the now-discontinued Kodak APS system provided, in its 30mm-x-10mm images anything as adventurous as 3:1 proportions.

You can go far beyond that with your Nikon D70, producing panoramas that stretch across your screen or print in just about any ultra-wide view you choose.

Inspiration

There are several different ways to create panoramas. The easiest method is to take a wide-angle photo of your vista, and then crop off the top and bottom portions of the image to create a view that's much wider than it is tall. If you go this route, you'll want to start with the sharpest possible original image. Mount your camera on a tripod, set sensitivity to ISO 200, and work with the sharpest suitable lens in your collection, set to its sharpest f-stop.

Another method for creating a panorama is to take several photos and merge them in your image editor. (Photoshop CS and Photoshop Elements 4.0 have special tools for stitching photos together.) For the best results, mount your camera on a tripod and pan from one side to the other as you take several overlapping photos. (The term *pan* comes from panorama, by the way.) Ideally, the pivot point should be the center of the lens (there are special mounts with adjustments for this purpose), but for casual panoramas, mounting the camera using the D70's tripod socket will work fine.

Panoramic photography practice

6.56 Although the 8:5 aspect ratio of this image is modest by panorama standards, it still provides a wide-angle view of the mountain lake.

Table 6.17 Taking Panoramic Pictures	
Setup	**Practice Picture:** I wanted to use the trees and shore to frame the distant mountain range, so I used less-drastic panorama proportions for this landscape shown in figure 6-56.
	On Your Own: Look for scenes that can be cropped to produce images that are much wider than they are tall. Mountains and other kinds of landscapes and skylines are especially appropriate.
Lighting	**Practice Picture:** The existing daylight was just fine for this panorama.
	On Your Own: As with conventional landscape photography, your control over lighting will generally be limited to choosing the best time of day or night to take the photo. Unless you're taking a picture on the spur of the moment, think about planning ahead and showing up at your site when the lighting is dramatic.
Lens	**Practice Picture:** 12–24mm f/4G ED-IF AF-S DX Zoom-Nikkor at 24mm.
	On Your Own: Choose a good moderate wide-angle lens to capture your vista for panoramas created by cropping a single photo. If you're stitching pictures together, you may want to try a slightly wider zoom setting to reduce the number of images you need to collect. Avoid very-wide-angle lenses and the distortion they can produce.

Continued

Table 6.17 *(continued)*

Camera Settings	**Practice Picture:** RAW capture. Shutter-priority AE.
	On Your Own: Use shutter-priority AE and select a high shutter speed to produce the sharpest possible image.
Exposure	**Practice Picture:** ISO 200, f/8, 1/800 second.
	On Your Own: Unless you're including foreground objects for framing, you can select a high shutter speed and let the camera go ahead and open the lens fairly wide, with no worries about the shallower depth of field. Use ISO 200 in bright daylight, and consider increasing sensitivity to ISO 400 during early-morning or late-afternoon hours.
Accessories	For dawn or dusk shots, a tripod can help steady the camera during longer exposures.

Panoramic photography tips

✦ **Use a tripod.** If you're shooting several photos to be stitched together later, use a tripod to help you keep all the shots in the same horizontal plane.

✦ **Overlap.** Each photo in a series should overlap its neighbor by at least 10 percent to make it easier to stitch the images together smoothly.

✦ **Watch the exposure.** You'll make your life simpler if you use the same exposure for each photograph in a panorama series. Use the D70's exposure-lock feature, or else your camera will calculate a new exposure for each shot.

✦ **Save time with software.** If you don't have Photoshop CS or Photoshop Elements 4.0, do a Google search to find the latest photo-stitching software for your particular computer platform (Windows or Mac). Although you can stitch images together manually, the right software can save a lot of time.

Pattern Photography

Photography of patterns has a lot in common with abstract photography to the extent that the subject of the photograph may be the form and shape of the content, rather than the subject itself. However, photos of patterns are often more representational of the real objects in the picture. You can still tell that the photo shows a line of fence posts, or an overhead lighting grid, or some other recognizable object. However, the patterns that the content of the photo makes will be easily discernable and either add to the charm of the underlying photo if the pattern is subtle, or become the most striking element of the picture if the pattern is strong and dynamic.

You can find patterns everywhere you look. Human-made objects tend to be designed around regular forms that repeat themselves at intervals. Buildings may have arrays of windows or a series of arches. Nature also creates wondrous patterns, from the hexagons of a beehive's honeycomb to the streamlined formations migrating birds assemble as they fly south for the winter. You'll find patterns indoors or out, in any weather and at any time of day. If abstract photos are too abstract for you, patterns may satisfy your creative urges.

6.58 Patterns needn't be rigidly regular. This Indian corn shows lots of variation in color, kernel size, and orientation, yet the casual pattern is pleasing.

You can specialize in one kind of pattern, too, seeing how many variations on, say, railroad tracks or spider webs you can find. Or choose the type of pattern itself as your specialty, and shoot disparate subjects that all share the same kind of geometric arrangement. You might group the concentric circles of a Ferris wheel with hubcaps or dartboards.

6.57 The rounded shape of the blown-glass flowers contrast with the rigid straight lines of the overhead panels that frame them.

Inspiration

To really flex your mind muscles, give yourself an assignment to go out and seek out patterns. Photographer Simon Nathan used to photograph individual letters of the alphabet on signs, buildings, or wherever he found them, eventually collecting them all onto a CD-ROM that showed the endless variety of patterns that could be found in something as simple as the alphabet.

6.59 Patterns are found everywhere in nature.

Pattern photography practice

6.60 The contrasting colors in this leaf made a striking pattern as I walked past, so I paused just long enough to capture the fragile vein structure in a close-up.

Table 6.18
Taking Pictures of Patterns

Setup	**Practice Picture:** I passed this plant shown in figure 6.60 on a walk one late afternoon, and the low sun in the sky was illuminating the leaves from behind. My favorite macro lens was already mounted on my D70, so I just stepped in and shot the extreme close-up.

On Your Own: Although some patterns are built into the makeup of your subject, others appear when you choose a particular angle or perspective. When you spot a promising subject, examine it from all sides to find the one shot that best shows off the pattern you've discovered.

Lighting

Practice Picture: The sunlight shining through the leaf provided all the illumination required.

On Your Own: Favorable lighting can make or break a pattern. Strong light from an angle emphasizes texture and edges. Dark shadows build contrast that can make a pattern seem even more dramatic. If you're shooting indoors with complete control over the lighting, use these characteristics to make your patterns more vivid. Outdoors, look for angles that make the most of the light that is available to emphasize your pattern.

Lens

Practice Picture: 105mm f/2.8D AF Micro-Nikkor.

On Your Own: Your lens choice really depends on the subject. Some patterns can be found in close-ups shot with macro lenses. Others appear when you use a telephoto lens to compress the distance between objects, merging them together into a new pattern. Wide-angle lenses can emphasize patterns in the foreground of the photo.

Camera Settings

Practice Picture: RAW capture. Aperture-priority AE with saturation set to Enhanced.

On Your Own: You'll want to control the depth of field, so choose aperture-priority AE mode and set the white balance to the type of light in the scene.

Exposure

Practice Picture: ISO 200, f/11, 1/800 second.

On Your Own: When shooting close-up patterns handheld without out a net (that is, a tripod), choose a small f/stop and a fast shutter speed to counter camera shake. Boost the ISO to 400 under dimmer lighting to make sure you can use both a depth-of-field-enhancing aperture and an action-freezing shutter speed.

Accessories

A polarizing filter is sometimes handy for reducing reflections on the glass or metal panels that often are found in architectural patterns.

Pattern photography tips

✦ **Create your own patterns.** Arrange objects in a pattern that pleases you, or rearrange an existing pattern to provide a more artistic arrangement. Several stacks of coins, for example, can be arranged so they're perfectly straight, or slightly skewed, each creating a different pattern effect.

✦ **Use scale to enhance or diminish the realism of your pattern.** If you don't include any objects of known size in the photo, the viewer may not be able to visualize

the scale of the objects in your pattern. If you're looking for an abstract quality, that can be a good thing. Yet, if you want a realistic photo in which the pattern is only a strong element in the composition, make sure the scale is obvious from the photo's context.

✦ **Keep in mind that patterns don't have to be physical objects.** Light shining through a grille or series of fence posts can create interesting patterns. Colors can create patterns, too.

Season Photography

If you live in an area that has honest-to-gosh changing seasons (rather than just warm-and-wet versus hot-and-dry), you'll want to record the varied weather, wildlife, and moods that mark the march of time. Seasonal changes always spark new activities as people celebrate the changing fall colors, the pristine new-fallen snow, the emerging blossoms of spring, or the lazy, hazy days of summer. These are photo opportunities you can use to get your own creative juices flowing.

Each season has its own requirements from a technical standpoint, as well as its own opportunities.

Summer

Summer always means longer days and more time to shoot. Clear and dry summer afternoons and evenings are often dotted with sports activities like swimming, baseball, and motor sports, and lots of chances to capture action pictures. Those tempting sunset shots occur much later in the day. Summer is a great time for landscape and wildlife photography, too, if you avoid midday when the light is harsh and the animals are likely out of sight taking a nap. Have your tripod ready for long-lens use, reflectors to soften the brilliant light when shooting portraits, and polarizing filters to reduce the glare.

6.61 Peaceful winter scenes have a quiet purity that echoes how much of the natural world slumbers during this season.

6.62 Spring and summer are the perfect times to photograph plant life, such as this blooming thistle early one sunny afternoon.

Fall

You'll find fall *the* time to capture rich colors as the trees change their foliage from green to vivid reds, oranges, and yellows. It's a great time for a road trip, as the colors will change as you travel from north to south, or even just from one state to another. Tourist boards in most areas will know when the fall color will be at its peak, so you can plan ahead. You'll often need to carry rain gear, because a sunny day can quickly turn windy and rainy. Sunsets and the long, dramatic shadows they cast are still ideal for photography, but they take place earlier in the evening. Sometimes you'll need to

6.63 Four seasons, and four different views of the same country road, all taken from roughly the same position at different times of the year.

grab a quick bite of dinner to leave time for some late-afternoon photography. Don't forget the key autumn holidays, such as Halloween and Thanksgiving, and the festivities that surround them. During this time of year, try setting your D70's saturation level to Enhanced to get some extra color in your photos.

Winter

It's tempting to hole up for the entire winter season, because days may seem dreary and the landscape in the northern latitudes is cloaked in a layer of snow. However, the chill weather is your chance to capture spots of dramatic color in the monochrome landscapes. Clouds in the sky and the colors of sunset can be particularly dramatic when contrasted with winter snow. Monitor your exposures carefully, and use the D70's EV compensation and histograms to capture snow scenes that are well-exposed and full of detail.

Spring

In the springtime, people who spent long hours indoors escaping the winter weather burst from their dens like the flower buds erupting from the thawing soil. You'll find lots of vibrant colors for your photography, with sufficient overcast skies to provide softer, more-diffuse lighting for much of the day. Like fall, spring is a time when you need to be prepared for changing weather, both in terms of protective rain/wind gear and in terms of photographic opportunities. You'll find lots of new plants and revitalized wildlife ready for your camera.

Inspiration

One interesting photo idea is to take pictures of a particular scene under different weather conditions at different times of the year. Find a spot that you'll be able to locate again and take some photos of the views you find. Record the lens and camera settings. Then return throughout the year to duplicate your original photo under the changing weather and seasonal conditions. You can start at any time in the cycle. Just remember to take photos. Start with traditional ideas such as a child in a field of daisies and see what new twists and interpretations you can come up with. For example, because spring is symbolic of renewal, and because people of all ages are renewed, have a grandmother in a field of daises with the child or by herself.

Seasonal photography practice

6.64 Holiday festivities, such as Halloween, Thanksgiving, New Year's celebrations, and the Fourth of July all offer exciting picture-taking opportunities, such as this cluster of pumpkin seekers looking for the perfect jack o' lantern.

Table 6.19
Picturing the Seasons

Setup	**Practice Picture:** For the image in figure 6-64, I made the annual trek with my family to a nearby pumpkin farm. The farmers do everything they can to add to the festivity, including pony rides and hayrides, colorful decorations, as well as cider and other refreshments. The event is a photo opportunity of the first order — and it goes on for weeks!

Continued

Table 6.19 *(continued)*

	On Your Own: Colorful trees in the fall, fireworks in the summer, and snow scenes in the winter are all common setups. Use your creativity to find seasonal pictures that aren't overdone, emphasizing good composition, color, or patterns to give your photos a distinctive look.
Lighting	**Practice Picture:** Natural late-afternoon sunlight with clear skies provided a bright look and brilliant colors. **On Your Own:** Mother Nature's lighting varies widely throughout the different seasons. Learn to work with what you have for the most natural look, but be prepared to use reflectors or fill flash to light up the shadow areas under the harshest light.
Lens	**Practice Picture:** 12–24mm f/4G ED-IF AF-S DX Zoom-Nikkor set to 20mm. **On Your Own:** Wide-angle lenses will frequently be your optic of choice for seasonal photos that involve landscapes that capture the seasonal changes. Switch to a telephoto zoom to pull in distant views.
Camera Settings	**Practice Picture:** Aperture-priority AE mode with white balance set to Daylight. **On Your Own:** In bright daylight, your shutter speed is likely to be short enough to freeze a moment, so you can use aperture-priority AE mode to select a suitable f/stop. If the light is low, switch to shutter-priority AE mode. Be sure to set the white balance to match the type of light in the scene.
Exposure	**Practice Picture:** ISO 200, f/11, 1/400 second. **On Your Own:** Outdoors, ISO 200 should serve you well for most seasonal photographs. Use an f/stop, such as f/8 or f/11 to give you enough depth of field. When the light wanes, switch to shutter-priority and select a speed no slower than 1/60 second. Use a tripod or monopod for longer exposures.

Seasonal photography tips

✦ **Summer:** Watch out for extra-contrasty scenes, particularly at the beach, and modify your exposure as required to compensate. You may need a gradient filter to darken the sky so you'll have both clouds and details in the foreground areas.

✦ **Fall:** Try shooting late in the day as sunset nears for particularly brilliant and rich foliage colors.

✦ **Winter:** Experiment with slower shutter speeds so falling snow appears as white streaks.

✦ **Spring:** New plant life can often be best photographed on dewy mornings, covered in moisture and surrounded by mist and fog.

Seascape Photography

Photographers of seascapes fall into two different categories: those who live near the ocean, and those who wish they did. For such a simple subject — basically a seashore lapped by a relentless ocean of water — seascapes can be taken in an almost infinite variety. In that sense, seascapes are like sunsets: Despite the same basic elements, no two are exactly alike.

Seascapes can be demanding because of environmental considerations. Beaches are often sunny, but just as often beset by murky fog, so you'll be struggling with excessively contrasty lighting one day, and bland lighting the next. Rain, salty spray, and other weather hazards can make pursuit of the perfect seascape challenging.

Like other kinds of landscape photography, seascapes are often best when unpopulated by humans, and devoid of structures, other than, perhaps, a grass hut or two when photographing that uncharted desert isle. You can often avoid this problem simply by taking a trek down the shore to a less popular area, or scheduling your session for early mornings when only a few shell collectors or fishermen are likely to be about. At sunset, most of the sunbathers have left and the few party-oriented folks who remain usually cluster around their campfires.

With a little ingenuity, you'll find the beach scene of your dreams and capture some memorable seascapes.

6.65 Who says beach photos have to be taken under blazing sunlight? This Samoan scene was rendered in moody, muted colors on this overcast day.

Inspiration

6.66 Long stretches of sand can be boring. Look for rocky inlets with the tide coming in for more-interesting seascapes.

Seascape Variations on a Theme

Seascapes are photographed so much that you'll want to give yourself an assignment to shoot something really different the next time you take up photography at the shore. Here are some idea starters.

✦ **Shoot from offshore.** Instead of standing at one end of a beach and pointing your camera up or down the shore, find a way to position yourself offshore, and shoot the beach from the perspective of a breaker. A fishing pier that extends a healthy distance out from the shore is a good place to start. You can also shoot from this vantage point onboard a boat that's brought to a halt a safe distance from shore.

✦ **Use a high angle.** Shoot down on the shore from a nearby cliff, a lighthouse that's open to the public, or, if you're adventurous, a hang-glider.

✦ **Use a low angle.** Get down so your camera is almost resting on the sand (but keep the send out of your camera!) and try some seascapes that are heavy on foreground emphasis and quite unlike anything you've seen before.

✦ **Blur the waves.** Mount your camera on a tripod, add at least an 8X neutral density filter to your lens, and try a long exposure that lets the waves merge into a foamy blur. At ISO 200 with an ND filter, you should be able to shoot at 1/15 second at f/32, or 1/8 second at f/32 on an overcast day. Substitute an infrared filter like the Hoya R72, and you can easily manage several-second exposures — and get some weird infrared effects to boot.

✦ **Include some wildlife.** Although people and most buildings detract from true seascapes, a few seagulls scattered along the shore can break the monotony and add some interest. Spread a little seagull food along the sand, then back off 20 or 30 yards and compose your shot as your extra cast members arrive.

Seascape photography practice

6.67 The best seascapes aren't always horizontal compositions. A high vantage point overlooking a rocky shore makes a vertical orientation best for this shot.

Table 6.20
Taking Seascapes

Setup	**Practice Picture:** It was almost sunset before the interesting seaside local in figure 6.67 turned up, but the shore was rocky and deserted — and ready for an interesting vertically oriented composition.
	On Your Own: Rough-looking roads and trails leading off the main highway often dead-end at scenic overlooks and interesting hiking routes that are perfect for photography. If you're new to an area, ask one of the locals for directions to the most stunning views.
Lighting	**Practice Picture:** Waiting until the sun was behind a cloud produced this dramatic lighting effect.
	On Your Own: As with other types of landscape photography, you usually can't choose your lighting, but you can choose to wait until the illumination looks good. Sometimes you'll have to come back a different day, but when the lighting is just right you'll know that being patient was worth it.
Lens	**Practice Picture:** 12–24mm f/4G ED-IF AF-S DX Zoom-Nikkor set to 24mm.
	On Your Own: Wide-angle lenses work well with seascapes, and a zoom is handy to have if your photographic perch makes it difficult to move closer or farther away from your favored vista. You'll need a telephoto zoom only to pull in distant views.
Camera Settings	**Practice Picture:** RAW capture. Shutter-priority AE.
	On Your Own: Choose a shutter speed that will neutralize camera/photographer shake and let the exposure system set an aperture for you.
Exposure	**Practice Picture:** ISO 200, f/8, 1/400 second.
	On Your Own: It's easy to handhold a wide angle lens at 1/400 second, and f/8 will usually be a good sharp aperture to use for subject matter that extends out to infinity. If it's very cloudy or near dusk, you may want to up the sensitivity to ISO 400.
Accessories	A waterproof camera bag will help store your extra lenses and provide a safe haven for your camera to protect it from rain and surf.

Seascape photography tips

✦ **Keep the horizon level.** A seascape photo will almost always have the sea on the horizon somewhere, and a sloping horizon is a sure tip-off that you didn't compose your photo carefully.

✦ **Monitor your exposures.** Use the D70's histogram feature to review your shots after the first few, and

then use exposure compensation to add or subtract a little if required to get photos with detail in the shadows without washing out the highlights.

✦ **Don't let sand gum up your works.** Back when film cameras used lots of precision-made gears, rollers, springs, and other components, a few grains of sand could quickly disable a fine piece of machinery. Digital cameras are rugged, and have electronic components that are less prone to damage from a little dust or sand, but you *definitely* don't want to get any silicon dioxide granules inside your lens or lens mount, within the mirror box chamber, or *anywhere* near the sensor. Use caution when operating your D70 around sand and saltwater, and change lenses only when you're certain a gust of wind or an overmuscled bully won't kick sand into the innards.

✦ **Remember the tides.** High tide will provide a clean beach, but low tide leaves behind a treasury of shells, seaweed, and other objects (including old shoes and tires) that can enhance or detract from your photos. Learn which time of day a particular seashore is most photogenic before setting out on your seascape trek.

Street Life Photography

Photography of street life has been a cornucopia of photographic opportunities for as long as cameras have been used in cities.

Urban areas have a charm of their own. The pace is more hurried, the ambience a little grittier, and the variety of photo subjects almost infinite. You can easily spend a year photographing everything within a one-block area, and still not exhaust all the possibilities.

The focus of street-life photography is often on the people, but there's a lot more to explore. Old buildings, monuments, storefront windows, or kiosks packed with things for sale all present interesting photographic fodder. Or you can concentrate on the streets themselves, the bustle of traffic and pedestrians, or the daring-do of whistle-blowing bicycle messengers. The animals that populate the streets, including stray dogs, voracious pigeons, and darting squirrels are worthy of photographic study. Take refuge in the peace of an urban park and capture the contradictions of an island of natural beauty hemmed in by tall buildings.

6.68 So much fine art is associated with Paris that I wanted to create an impressionistic photo in tribute. The flower-bedecked arbors and the geometric pattern of the arches and benches were perfect for some pointillistic post-processing in Photoshop.

Inspiration

6.69 Every city is populated with interesting characters who find their own ways to relax and amuse themselves. You can capture their personalities if you're careful not to intrude.

Photographing people on the streets has become more complex in the 21st century. Security concerns have tightened restrictions on photography around certain buildings, including most government installations. Paparazzi have given impromptu people-photography something of a sour reputation as an intrusive invasion of privacy. In parts of some cities, a few denizens may be engaging in activity that they don't want captured on film. If you want to be successful on the streets, you'll need to follow a few rules:

✦ **Ask permission to shoot people on the street.** You don't need to walk up to every photo subject and say, "Hi, I'm a photographer. May I take your picture?" A simple quizzical nod and a gesture with your camera will alert your subject that you'd like to snap a photo. If

you're met with a smile or ignored, go right ahead and shoot. Should your victim turn away from you, glare, or flash a finger salute, that's your signal to back off.

✦ **Never photograph children without asking the adult they're with.** If the child is unaccompanied, look for another subject. Granted, you'll miss some cute kid shots, but the chance of being mistaken for a bad person is too much to risk. The only possible exception to this rule may be if you're a female photographer, preferably accompanied by children of your own.

✦ **Leverage your personality.** Recognize that photographers, including yourself, fall into one of several different personality types. Some folks have an outgoing way that lets them

photograph people aggressively without offending or alarming their subjects. Other people approach street photography more tentatively, or tend to blend into the background. If you know which style is more suitable for you, work with your personality rather than against it.

✦ **Don't act in a suspicious way.** Photographing with a long lens from a parked car is a good way to attract unwanted attention to yourself. In fact, *any* kind of furtive photography is likely to ensure that your street shooting session is a short one.

Street life photography practice

6.70 You don't have to be able to read Italian to understand the humor in this street vendor's display.

Table 6.21
Taking Pictures of Street Life

Setup	**Practice Picture:** Public markets and storefronts are a good place to catch colorful displays of goods for sale. You won't see anything like the scene shown in figure 6-70 in the suburban United States! **On Your Own:** In seeking your street subject matter, look for simple arrangements of people or objects that make an interesting composition. You'll rarely be able to rearrange your subjects to suit your needs, so explore all the angles to get the best perspective.
Lighting	**Practice Picture:** It was a bright day, but there was a slight overcast that softened the shadows of this street shot. **On Your Own:** Using reflectors, flash, or other extra lighting will quickly destroy the mood of your street scene, so try to work with the lighting that is already there. City streets can often be fairly shady because of the shadows cast by tall buildings, so you'll often find that exactly the sort of diffuse lighting you need is already available.
Lens	**Practice Picture:** 18–70mm f/3.5–4.5G ED-IF AF-S DX Zoom Nikkor at 22mm. **On Your Own:** Crowded streets often call for wide-angle views, but you'll also need to be able to zoom in for an impromptu portrait. The D70's kit lens provides the perfect range. You may need a wider optic for photos that include buildings, and a faster lens can come in handy in lower light levels and at night. The Nikon 50mm f/1.8 is an excellent lens for urban photography when light isn't abundant.
Camera Settings	**Practice Picture:** RAW capture. Aperture-priority AE, with saturation set to Enhanced. **On Your Own:** Aperture-priority AE mode gives you greater control over the depth of field, but if light levels are low, you may want to switch to shutter-priority to make sure that your shutter speed is high enough to counter camera shake.

Exposure	**Practice Picture:** ISO 200, f/11, 1/200 second.
	On Your Own: To ensure front-to-back sharpness, set a narrow aperture such as f/8 or f/16. If the background is distracting, use a wider aperture such as f/5.6 or f/4.0. Set the ISO to 200 or 400, depending on the amount of light available.
Accessories	A monopod for steadying the camera is more practical than a tripod in urban situations. It's easier to set up, requires less room, and won't bog you down with unnecessary weight.

Street life photography tips

✦ **Tell a story.** Some of the best photos of street life are photojournalist-style images that tell a story about the people and their activities in the urban area you picture.

✦ **Travel light.** When working in cities, you'll be on foot much of the time, scooting between locations by bus or taxi. You won't want to be lugging every lens and accessory around with you. Decide in advance what sort of pictures you're looking for, and take only your D70 and a few suitable lenses and accessories.

✦ **Cities are busy places; incorporate that into your pictures.** Don't be afraid to use blur to emphasize the frenetic pace of urban life. Slower shutter speeds and a camera mounted on a monopod can yield interesting photos in which the buildings are sharp, but pedestrians and traffic all have an element of movement.

✦ **Learn to use wide-angle lenses.** The tight confines of crowded streets probably mean you'll be using wide-angle lenses a lot. Experiment with ways to avoid perspective distortion, such as shooting from eye-level, or exaggerate it by using low or high angles.

Still Life Photography

Still-life pictures have long been a favorite of artists and photographers looking for infinitely patient models that can become the basis for images that explore form and light to its fullest. The best thing about still-life photography is that, after you're finished, you don't need to buy your model lunch — your model can *be* lunch!

You'll find shooting still life photos a perfect rainy-day activity. A quick visit to your collection of porcelain figurines, pewter soldiers, or artificial flowers can yield enough subject matter to keep you busy for hours. Or you might find the subject matter you need in the refrigerator.

6.71 This ceramic jug has subtle color and an interesting shape that can be used in a variety of still-life setups, either alone or with other objects.

The most labor-intensive part of photographing a still life is coming up with pleasing arrangements that lend themselves to creative compositions. Count on spending time positioning your objects, perhaps adding something here, or removing an item that doesn't quite work. Setting up a still-life arrangement is the closest a photographer can come to sculpting or painting.

You may be attempting to create photographic art or illustrate a cookbook, but still-life photography is challenging under any circumstances.

Inspiration

Still-life photography is like macro photography but a step or two farther from your subject. Your subject matter is likely to be a bit larger, sometimes covering an entire table. You probably won't need a macro lens to focus close enough. Yet the same principles of lighting and composition apply. You'll want to use auxiliary lighting such as flash or incandescent lights, maintain control with umbrellas or reflectors, and, after you've selected the best composition, lock your camera down on a tripod.

In fact, you can light many still-life setups as you would a portrait sitting.

✦ Use a main light to create shadows that provide your subject with shape and form.

✦ Illuminate the shadows with reflectors or fill lights.

✦ Consider lighting the background on its own to provide separation between your subject and its surroundings.

✦ The same techniques like short lighting or broad lighting, discussed in the "Indoor Portraits" section can be applied to still lifes to create a more flattering rendition.

6.72 The goal of still-life photography of food is to make the viewer want to reach out and take a bite. Photographed using natural light from a kitchen window, these strawberries look good enough to eat.

Still life photography practice

6.73 Simple setups such as this are easy and quick to create, and with them you can create clean images of products for promotions on a Web site.

Table 6.22
Taking Still-Life Pictures

Setup	**Practice Picture:** There was a sale of on-the-vine tomatoes, so I grabbed a few for dinner, but I couldn't resist resting them on a piece of poster board that had been curved to form a seamless background. A water spritzer added some drops of moisture to the tomatoes, as you can see in figure 6-73.
	On Your Own: Some of the best still-life photos are the simplest. Use the natural beauty of food or a handcrafted object, and don't clutter up the picture with other props.
Lighting	**Practice Picture:** I used a pair of white umbrellas placed to the left and right of the camera, and turned them around to shoot *through* the fabric to create extra-soft lighting.
	On Your Own: Many umbrellas are backed with black fabric (often removable) to reduce light loss. If your electronic flash is powerful enough, you can use the extra diffusion from shooting through the umbrellas to produce an even softer lighting arrangement. You'll find add-ons called *soft boxes* that produce even smoother, broad lighting.
Lens	**Practice Picture:** 60mm f/2.8D AF Micro-Nikkor.
	On Your Own: A close-up macro lens has the advantage of extra sharpness and the ability to focus close, but you don't necessarily need such a lens for your still-life photography. Any zoom lens that focuses down to a foot or two is suitable for all but the tightest compositions.
Camera Settings	**Practice Picture:** RAW capture. Aperture-priority AE with a custom white balance. Saturation set to Enhanced.
	On Your Own: You'll want to control the depth of field, so choose aperture-priority AE mode and set the white balance to the type of light in the scene, either tungsten or flash.
Exposure	**Practice Picture:** ISO 200, f/16, 1/250 second.
	On Your Own: Close-up photos call for smaller f-stops and extra depth of field, and most still-life pictures are in that distance range.
Accessories	Umbrellas with external flash units are your best choice, but desk lamps and reflectors can also be used. A tripod is handy for locking down a composition and holding the camera steady if the exposure time is longer than 1/125 second.

Still life photography tips

✦ **Use your imagination.** Seek out still-life subjects and backgrounds that you may not think of immediately. For example, an end table carefully arranged with lamp, television remote control, newspaper folded open to the crossword puzzle, and pencil could become an interesting still life, rather than a picture of some cluttered furniture.

✦ **Inject the element of surprise.** A little bit of the unexpected or a humorous touch can spice up a mundane still life. An arrangement of green peppers with one yellow pepper in the middle will attract attention. A cluster of stainless-steel nuts making a nest for a single walnut is a visual pun that can tickle the funny bone — especially if you can work a confused stuffed toy squirrel into the picture.

✦ **Small touches mean a lot.** Spritzing a little water on food can make it seem more appetizing. The difference between a suitable background and the *perfect* background can be significant. For example, a layout of a picnic basket and its contents on a checkered tablecloth may be interesting, but a background of an old slab of wood from a weathered picnic table resting on a few tufts of grass may be better.

✦ **Try different angles.** Even if you've meticulously set up your still life, you may find that another angle you hadn't considered looks even better. Don't ignore the possibility of happy accidents.

Sunset and Sunrise Photography

Sunsets and sunrises are classic photo subjects that are difficult to mess up. Their crisp compositions tolerate a wide range of exposures and tend to provide vivid colors in infinite variety; a picture taken from one position on one day might look entirely different from one taken at the same place the next day. Sunrises and sunsets are so beautiful they make even average photographers look brilliant.

6.74 This winter sunset backlit an ice-encrusted tree and provided an interesting combination of tones, with the deep blue of the sky echoed by the blue-tinted snow in the foreground, and the yellow setting sun cutting a swathe through the middle.

You can shoot unadorned sunrises and sunsets with nothing but the sky and horizon showing, or incorporate foreground subjects into the picture. Place the emphasis on the sky itself with a wide-angle lens, or zero in on the majesty of the setting sun with a telephoto.

Your choice of shooting a sunrise or a sunset depends primarily on whether you're willing to get up early, and where the sun will be at the time you take the picture. For example on the East Coast of the United States, the sun peeping over the ocean's edge must be captured in the early-morning hours. On the West Coast, sunsets over the Pacific are the norm. However, you can shoot the setting or rising sun with a lake, mountain range, or city skyline, too, simply by choosing your position.

Shooting Silhouettes

Because sunrises and sunsets, by definition, are backlit, they're the perfect opportunity to shoot silhouettes. You can outline things at the horizon, or create silhouettes from closer subjects, such as people or buildings. Here are some things to consider:

✦ **Make underexposure work for you.** Silhouettes are black outlines against a bright background, so you'll usually have to underexpose from what the D70 considers the "ideal" exposure. Use the exposure value compensation to reduce exposure by two stops.

✦ **Shoot sharp.** Silhouettes usually look best when the outlined subject is sharp. Watch your focus, using the focus lock button or manual focus if necessary to ensure sharp focus.

✦ **Use imaginative compositions.** It's too easy to just find an interesting shape and shoot it at sundown in silhouette mode. Use the dramatic lighting to enhance your composition. For example, one favorite wedding shot is the bride and groom in profile facing each other, jointly holding a half-filled wine glass. Shot at sunset as a silhouette, the shapes of their faces contrasts beautifully with the non-silhouetted image of the transparent wine glass.

✦ **Use colored filters or enhanced saturation to make the sunset more brilliant, while retaining the dramatically dark outline of the silhouette.**

Inspiration

6.75 Here, the contrast is between the soft contours of nature and the multicolored sky hues in the sunset, and the rigid geometric shapes of the row of identical suburban dwellings.

Sunset and sunrise photography practice

6.76 Although the sun was low in the sky on this crisp fall day, it was still a couple hours from sunset. I cheated by underexposing the picture by three f/stops and warming the image in an image editor.

Table 6.23
Taking Sunset and Sunrise Pictures

Setup	**Practice Picture:** I spotted the scene in figure 6.76 while strolling around a lake one fall afternoon and liked the curve of the shore. I decided the composition would work better as a sunset silhouette, so that's how I shot it.
	On Your Own: As with other kinds of landscape photography, the key to finding a good composition is to scout the area beforehand and then come back, if necessary, when lighting is ideal.
Lighting	**Practice Picture:** I maneuvered to find a spot where the sun would silhouette the trees in an interesting way.
	On Your Own: Sometimes, taking a few steps to the left or right can dramatically change the relationship and lighting provided by the setting and rising sun and objects in the foreground.
Lens	**Practice Picture:** 18–70mm f/3.5–4.5G ED-IF AF-S DX Zoom Nikkor at 50mm.
	On Your Own: Wide-angle lenses are fine if you want to take in a large area of sky. A telephoto setting is a better choice to emphasize the sun and exclude more of the foreground.
Camera Settings	**Practice Picture:** RAW capture. Shutter-priority AE.
	On Your Own: Use a high shutter speed to minimize camera shake and a small f/stop to underexpose the foreground in a silhouette.
Exposure	**Practice Picture:** ISO 200, f/16, 1/800 second.
	On Your Own: Underexpose by one or two f/stops to create your silhouette effect.
Accessories	A star filter can add an interesting effect to the sun, but a small f/stop will tend to produce a starlike effect anyway.

Sunset and sunrise photography tips

✦ **Keep in mind that sunrises and sunsets aren't created equal.** There are some subtle differences between sunrises and sunsets, which can be accentuated depending on the time of year. For example, with a sunrise after a cold night, you might encounter a lot of fog that forms in the cool air above a warmer ground. In some parts of the country, sunsets can be plagued by smog or haze that clears up by morning.

✦ **Experiment with filters.** Try split-gradients, star filters, colors, diffraction gratings, and other add-ons for some interesting variations.

Travel Photography

Travel, whether foreign or domestic, provides a perfect opportunity to cut loose and experiment with your digital camera. You can capture new and exotic locales, interesting people, and historic buildings or monuments — all while having the time of your life.

Unless you're traveling on business and your business isn't photography, you'll have lots of free time to photograph the places and events you're enjoying. And, while memories fade, your images will still be there to remind you of a special time.

6.77 The interesting and exotic can vary, depending on where you're from. For those who live far from the Great Lakes or an ocean, lighthouses hold endless fascination. When you arrive in a foreign country, *everything,* from clothing to soda cans, is likely to be strange and interesting.

What to Take When You Travel

Experienced travelers pack light, taking only the minimal amount of clothing and other gear. Experienced photographers make certain that their short list of equipment and accessories includes everything they'll absolutely need for the trip. Some things you may forget include:

✦ **A cleaning kit:** Make sure you have a cleaning cloth and lens tissue for keeping your lens and camera spotless. You'll also want to have a blower brush for dusting off your sensor, and perhaps a few silica packets to absorb moisture. Be sure and use only your manufacturer's recommended procedures for cleaning your sensor!

✦ **A roll-up plastic rain poncho:** You'll want to keep you and your camera dry when unexpected weather strikes.

✦ **Plenty of memory cards:** You'll want enough to record an entire vacation, unless you also have a laptop or a portable hard drive/CD-burner with you to offload pictures from the flash memory. If you shot a meager three rolls of film a day in your film-shooting period, you'll need at least a 512MB card each day if you shoot RAW files, or 256MB of memory space if you're shooting JPEG Fine.

Inspiration

6.78 Unusual angles, like this shot taken from the base of a massive statue atop a mountain in Spain, provide an unusual viewpoint that takes photo beyond the mundane.

In many ways, foreign-travel photography shares a lot of the attributes of the architecture, event, landscape, seascape, night, and street-life situations already covered in this chapter. What makes it most exciting are the differences you'll find. Clothing and jewelry may differ sharply; common items such as soda cans, candy bars, or electric outlets may be interestingly odd. Even plant and animal life may not be what you're accustomed to.

Be sensitive to cultural differences. Some cultures frown upon photographic images of other human beings, and women wear clothing designed to hide their appearance. In some of these countries, photographing people can be a serious offense.

Although you'll want any people you photograph to appear natural, it's still a good idea to ask their permission first. In poor countries, they may want a few coins in exchange. Emphasize that you want the picture to be natural, and that they should return to what they were doing before. Don't forget to provide feedback, and indicate that you're glad they granted you the favor of their photograph. You may want to let them review the pictures you took on your camera's LCD.

Travel photography practice

6.79 A brilliant sun gave this photo of a medieval castle extra snap and contrast.

Table 6.24
Taking Travel Pictures

Setup	**Practice Picture:** Like many castles, this one in figure 6.79 was mounted on a hilltop overlooking the countryside. The climb to the summit was worth it.
	On Your Own: Monuments and ancient structures have a timeless quality. If you can compose your photo so that modern buildings and artifacts are hidden, the scene can look much as it did 400 to 500 years ago. Hunting for unspoiled treasures can be an enjoyable pastime on its own, and recording your find in pixels is just the culmination of the hunt.
Lighting	**Practice Picture:** The early-afternoon sun was almost perfect for bringing out the contrast of the rough-hewn stone against the brilliant sky. If I'd had time, I would have hung around until dusk to capture an even more spectacular photograph at sunset.
	On Your Own: When traveling through an area, you'll rarely be able to wait for the lighting to change, so you'll have to make do with what you've got. In bright sunlight, go for vivid; at dusk, try to use the dramatic lighting; on overcast days, try for a moody look.

Lens	**Practice Picture:** 12–24mm f/4G ED-IF AF-S DX Zoom-Nikkor set to 18mm.
	On Your Own: Wide-angle lenses work well with travel photos involving castles, cathedrals, and landscapes, providing you can get far enough back to avoid tilting the camera. If quarters are tight, crop your view and emphasize interesting details rather than the big picture.
Camera Settings	**Practice Picture:** RAW capture. Shutter-priority AE with a custom white balance.
	On Your Own: Shutter-priority AE mode lets you select a shutter speed to eliminate camera shake, and you can set the white balance to the type of light in the scene.
Exposure	**Practice Picture:** ISO 200, f/1, 1/400 second.
	On Your Own: Consider bracketing a stop or two on either side of the exposure recommended by your camera, because a slightly darker or lighter version can look quite different.
Accessories	You won't want to carry a tripod on a trip, and even a monopod might be overkill unless you're shooting a lot of interior photos (say, inside cathedrals or museums). Instead, consider taking along a beanbag you can use as a camera support just about anywhere you can find a solid surface.

Travel photography tips

✦ **Capture the cultural environment.** Look for things that are unusual back home, and shoot lots of photos. Show people playing, relaxing, and working, because these behaviors may be different in foreign countries — or even in different parts of your own country.

✦ **Move in close.** You may be tempted to shoot the vistas, but close-up details provide lots of interest and add intimacy to your portrayal of a strange land and its people. You'll find that even a person's hands can tell you a lot about that person and what he's done, whether it's repairing computers or watches or doing manual labor.

✦ **Mix it up.** Shoot both horizontal and vertical photos of people, buildings, and landscapes. You'll avoid getting locked into one mindset and having all your travel photos look exactly the same.

Weather Photography

Everybody talks about the weather, and your Nikon D70 gives you the opportunity to do something about it. Instead of hunkering down indoors when skies are dark and cloudy, the air is cold, and precipitation is enthusiastically precipitating, you can go out and grab some interesting shots that reflect Mother Nature at work. Of course, bright sunny days are weather, too, but windy, overcast, snowy, or rainy conditions have the makings of some interesting photos.

6.80 A rainy day in which all the street vendors' carts were under cover, and most of the tourists were lurking under awnings or heading indoors. That's the perfect time to shoot a moody photo like this one.

Weather pictures can be used to create photographic art, as documentation for changing climates, or as a tool for reporting damage to your insurance company following a major storm.

Inspiration

6.81 I didn't even have to step outdoors for this photo. I spotted this icicle hanging on for dear life at dusk outside a window in my home. I cranked open the window and snapped the frozen finger of ice, which endured only a few more breezy moments.

You don't have to hunt for weather — it'll seek you out, wherever you happen to be. The key is to be prepared so you and your equipment are in no danger of getting wet, overly cold, or thrown about. Some larger camera shoulder bags have a built-in "raincoat" that allow them to be used in inclement weather. The covering pulls out and makes it easy for sports photographers to continue working even in the worst conditions.

You can make a water-resistant case for your Nikon D70 out of a resealable plastic bag. Cut a hole for the lens to peep through, and place a clear-glass UV filter over the lens to protect it from moisture. You can activate most camera controls right through the plastic bag.

Lightning is among the most interesting weather phenomena to photograph. There are even storm chasers who drive around looking for storms so they can photograph bolts from the sky. All you need is to mount your D70 on a tripod, switch to Manual, and choose a small f/stop and long exposure. Point the camera in a direction where you've seen lightning in the last few minutes, and wait for another flash to pop. Just be certain you're not out in the open and liable to lure a strike yourself!

The less adventurous might want to specialize in cloudy skies instead. There are lots of different types of clouds, ranging from wispy to menacing, and all make good photo subjects. Indeed, you can shoot clouds and then use an image editor to drop them into cloudless skies in other photographs you've taken.

Weather photography practice

6.82 This is a grab shot of some frozen berries hanging from a tree on the lawn right next to the street. Although a split-level suburban home dominated the original background, opening the lens wide and focusing carefully on the berries totally blurred the obtrusive structure.

Table 6.25 Taking Weather Pictures	
Setup	**Practice Picture:** It was a cold day after an ice storm, so I cruised around in the warmth of my car through several different rural areas that were particularly filled with ice-encrusted trees. As luck would have it, I had finished and headed back to the city when I noticed the tree shown in figure 6-82, less than a foot from the street, groaning under the weight of its ice coat.
	On Your Own: Interesting weather conditions are definitely worth a little field trip looking for good shooting situations. When the worst of a storm, snowfall or rain shower are over, venture out looking for interesting compositions.
Lighting	**Practice Picture:** It was late in the day, so the sun was low in the sky. Some backlighting would have been even better, but the angles were all wrong. So I worked with the diffuse light that was available.
	On Your Own: Although you can work with the light on hand, if it's not actually raining or snowing you can use reflectors to bounce light into areas that could use a little extra illumination. Fill flash, if used in moderation, can also help provide a little extra snap.

Lens	**Practice Picture:** 105mm f/2.8D AF Micro-Nikkor. **On Your Own:** Use the same lenses you'd work with for landscape photography; wide-angles for the big picture, and longer lenses and zooms to capture details. Close-up photos of ice or icicles can benefit from a macro lens, but many zoom lenses will get you down to the roughly 1- to 2-foot distance you'll need for photos of this type.
Camera Settings	**Practice Picture:** RAW capture. Aperture-priority AE. Saturation set to Enhanced. **On Your Own:** Use aperture-priority AE mode to control depth of field for close-ups. In dim light, switch to shutter-priority so you can be certain that you're using a high enough shutter speed to prevent blur from camera shake.
Exposure	**Practice Picture:** ISO 400, f/2.8, 1/800 second. **On Your Own:** If the background is distracting, as in this case, use the widest aperture possible to blur the background. ISO 200 or 400 should be enough for good exposures, but on very stormy days you may have to jump up to ISO 800.
Accessories	Silver reflectors are useful for close-ups on overcast days even though lighting is already fairly diffuse. Bouncing a little extra light onto your subject from a silver reflector can add a little contrast.

Weather photography tips

✦ **A circular polarizer may be useful for cutting down on atmospheric haze and improving contrast.** Polarizers always work best when the camera is pointed at right angles to the sun.

✦ **Use graduated gray or colored filters.** They can darken the sky to improve the rendition of the foreground.

✦ **Steady the camera.** Bad weather often calls for a tripod or monopod to steady your camera.

✦ **Experiment with the shutter speed.** When shooting lightning pictures, take a few with the shutter open long enough to capture two or three bursts in one photo, for a particularly dramatic effect.

Zoo and Animal Photography

It's an apparent contradiction: Everybody likes interesting pictures of animals, but *nobody* likes photographs of caged animals in zoos. Most of us can't afford photo safaris to exotic locations to capture charging rhinos and prowling lions, but we *can* find the most interesting wildlife at zoos. The solution is to photograph animals *as if* you were on a safari and they were in their natural habitat. No one will be fooled into thinking you took a trip to the African grasslands, but if you do a good job, even the most jaded viewer will

6.83 Catching animals doing human-like things — such as this polar bear sticking out his tongue — adds a touch of personality to your photos.

enjoy your animal photographs as much as if they were snapped in the wild.

Zoo animals are better cared for and less mangy than the in-the-wild variety, so you're likely to get more attractive-looking creatures to photograph. Modern zoos go to great lengths to duplicate the animals' natural habitats, and you'll find a minimum of bars and other barriers that inhibit your photography. It's likely you can get up close and personal with quite a few interesting fauna, with no danger to you or them.

There's no reason to take a trip to the zoo every time you want to do some animal photography. Your own pets, or those of friends and family are perfect models. You can also visit parks and grab photos of that Frisbee-catching dog, or that frog lurking in the pond.

Inspiration

6.84 Pets make good subjects for photos. Domesticated animals, such as this cat, will often sit contentedly for hours allowing you to take their photo.

Tips for Zoos

Veteran visitors to zoos know that their photo safaris will be more successful if they plan ahead of time.

✦ **Go early.** The animals are more active early in the morning. By the time the sun is high in the sky and the real crowds arrive, many of the animals will be ready for a nap. Phone ahead to find out when feeding times are, so you can capture the big cats gobbling up their lunch.

✦ **Use a tripod.** That long lens calls for either a high shutter speed or the steadiness a tripod can provide. A monopod can serve as a substitute, but you'll find that a lightweight tripod won't be that difficult to carry around even the largest zoos for the few hours you'll be there.

✦ **Open wide.** If you must shoot through bars or a fence, use a longer lens and open your aperture all the way to throw the obstruction out of focus. Selective focus will also let you disguise the walls or fake rocks in the background that advertise that your animal is *not* in the wild. Use the D70's depth-of-field preview button to confirm that your depth-of-field trick is working.

✦ **Get down to their level, or below.** Think like prey — or predator. Animals don't spend a lot of time looking at what's above them, and overhead is not a great angle for photographing wildlife, either. If you have a choice of angles, get low.

✦ **If you have to shoot through glass, shoot at an angle, and either bracket flash exposures or calculate exposure manually.** Your camera may not calculate the settings accurately under those conditions.

Zoo and animal photography practice

6.85 A long lens brought this tiger to within pouncing distance.

Table 6.26 **Taking Pictures at Zoos**	
Setup	**Practice Picture:** A rock wall and steep moat separated me from this tiger in figure 6.85. I set up my camera on a tripod and waited for him to do something interesting. In this case, a yawn gave me a look at his impressive teeth. **On Your Own:** Patience is its own reward at zoos. Plan on spending the morning there shooting animals, then wander around photographing flowers and plant life during the hottest hours of the day. Then return to shooting the animals in the late afternoon and evening when they become active again. Find a creature you like, spend enough time to learn its habits, and the payoff will be a picture that far surpasses the snapshots the other zoo visitors will get.

Lighting	**Practice Picture:** The tiger's compound had lots of trees, so I took most of my pictures when he decided to bask in a sunny spot.
	On Your Own: You'll be working with the available light most of the time. Unless you can get closer than about 15 feet to the animal, fill flash won't do you much good.
Lens	**Practice Picture:** Sigma 170–500mm f/5-6.3 APO Aspherical AutoFocus Telephoto Zoom Lens at 400mm.
	On Your Own: A long lens will let you shoot close-up photographs of animals that are 40 to 50 feet away. You probably won't need a wide-angle lens much at zoos, so pack your longest lens. A long prime lens with a large maximum aperture (f/4 to f/2.8) is preferable to a slower zoom lens.
Camera Settings	**Practice Picture:** RAW capture. Shutter-priority AE. Saturation set to Enhanced.
	On Your Own: Even with a tripod, you'll want to use a relatively high shutter speed. I've found that 400mm to 500mm lenses are almost impossible to handhold on a D70, even with 1/1,000 or 1/2,000 second shutter speeds.
Exposure	**Practice Picture:** ISO 400, f/8, 1/1000 second.
	On Your Own: You'll want to use selective focus to eliminate elements of the cage or enclosure, so an aperture like f/8 is a good choice. Use a high shutter speed to freeze any movement of the animal, and to eliminate residual camera shake.
Accessories	Bring along a tripod or monopod.

Zoo photography tips

✦ **Get close.** You'll probably have to use a telephoto lens to get close to most animals, but a headshot of a yawning tiger is a lot more interesting than a long shot of the beast pacing around in his enclosure.

✦ **Don't annoy the animals.** Chimps won't say "cheese!" and smile, nor will tigers turn your way just because you jump up and down and yell. If there are monkeys about, you probably *don't* want to attract their attention (don't ask why). Instead, just watch patiently until your animal poses in an interesting way on its own.

✦ **Favor outdoor locations.** Many zoo exhibits of larger animals have both an indoor and outdoor component. The animals may come inside to feed or at night, and choose to spend other time outdoors in good weather. You want photographs of them outdoors, not inside.

Downloading and Editing Pictures

Once you've finished your latest photo safari, you'll be eager to download your photos, tweak them with an image-editing program, and organize them for display or printing. You perform most of those functions using the software included with your D70, but if you want to go beyond the basics, there are other applications and utilities you'll find useful. This chapter explains some of the things you may want to do, and the software available to do them.

Nikon PictureProject and Nikon Capture

Nikon includes two software programs with the D70: the full version of Nikon PictureProject (a replacement for the earlier Nikon View program) and Nikon Capture, which is offered in a try-out version that you can upgrade to the registered edition for about $100 after a 30-day trial period (or sooner if you decide you want to make the commitment).

PictureProject is a simple application for downloading, viewing, and organizing your photos, with some features for cropping and making minor retouching modifications. You can also print photos from within PictureProject, burn them onto a CD or DVD, or send pictures by e-mail.

Nikon Capture is a more full-featured program offering a finer degree of control over your images (especially RAW files), and some nifty additional features, such as the ability to control your camera remotely using the USB cable.

PictureProject

If you're new to digital cameras and/or image editing, PictureProject offers a quick way to perform many of the basic functions involved in importing, touching up, and organizing your photos. A full manual is provided for PictureProject on a CD furnished with the camera. This section outlines the application's basic features.

Picture transfer

When PictureProject is installed, you can specify it as the default photo import facility, or continue to use another importer. For example, Adobe Photoshop Elements 4.0 and Microsoft Windows XP, as well as iPhoto on the Macintosh, also include pop-up utilities that recognize when a digital camera has been connected to the computer through a USB cable, or when a memory card has been inserted in a card reader attached to the computer. Even if you use one of these other options most of the time, you can still transfer images using PictureProject by selecting Transfer from the PictureProject Tools menu, or by clicking the Transfer button at the right end of the toolbar.

In either case, the Transfer wizard appears when a connected camera or card reader has new photos available. The PictureProject Transfer dialog box includes several options.

If you click the triangle icon next to Show thumbnails, a series of miniature views of each picture appears at the bottom of the dialog box. To select the photos to be transferred, you can do the following:

✦ Click an individual photo.

✦ Ctrl+click (⌘+click on the Mac) additional photos to add them to the selection.

7.1 PictureProject Transfer dialog box.

✦ Click the first in a contiguous series of photos, and then hold down the Shift key and click the last in the series to select all the photos between them.

✦ Ctrl+click (⌘+click on the Mac) a selected photo to remove it from the selection.

✦ Click the Select All button to choose all the thumbnails.

✦ Click the Select All or Select Protected buttons to choose all the pictures that have been marked or protected in the camera.

✦ Click the Deselect button to unselect all the thumbnails.

You can also choose to import the transferred photos into your current PictureProject collection, delete the files from your memory card once they've been transferred, and upload the files to the Nikon.net online display service after they've been transferred.

To transfer the selected photos, click the Transfer button.

If you prefer to use a different transfer pop-up, you can disable PictureProject Transfer by choosing Tools ➪ Options and selecting the Autolaunch tab in PictureProject.

Click the Advanced button in the PictureProject Transfer dialog box to access three other dialog boxes of options:

✦ **General:** Includes options for synchronizing your camera to the computer's clock (only when the camera is connected via the USB cable), copying hidden files,

including the color profile information in the file, adding a preview to RAW (NEF) images, displaying images shot in vertical orientation (if you've selected that option in the camera).

✦ **File Destination:** Specify the folders used to store the transferred pictures on your computer. You can tell PictureProject Transfer to create a new folder each time photos are transferred, which can make it simpler to organize the fruits of your various shooting sessions.

✦ **File Name:** Tell PictureProject Transfer whether to use the original filename created in the camera, or to rename each photo using a name you specify.

7.2 General parameters tab.

Advanced

General | File Destination | File Name

Folder

C:\Documents and Settings\David\My Documents\ Browse...

☑ Create a new subfolder for each transfer
☐ Copy folder names from camera

Subfolder

Prefix: Img

Suffix:

Between Prefix and Suffix: Use sequential number ▼

Start numbering at: 1

Length of number: 4 digits

Hide Details Sample: Img0001

OK Cancel

7.3 Specify file destination.

Advanced

General | File Destination | File Name

File

☑ Change file name

Prefix: ○ Original file name ● Other Img

Suffix: ○ Original file name ● Other

Between Prefix and Suffix: Use sequential number ▼

Start numbering at: 1

Length of number: 4 digits

☐ Reset the starting number to 1 for each transfer

Hide Details Sample: Img0001.JPG

OK Cancel

7.4 Specify a filename.

Organizing and viewing pictures

PictureProject lets you examine individual images, organize them into collections, or view a series of photos in a slide show.

The left side of the PictureProject window shows a list of picture collections. Just click on a collection name to view all the images in that collection in a scrolling thumbnail panel in the center of the PictureProject window. A zoom slider lets you change the size of the thumbnails. You can choose whether to view thumbnails only, or add a larger preview of a selected image shown below the thumbnails. At the right side of the screen are panels that show more information about a selected photo, as well as a search box for finding specific images using the filename, a keyword you've previously entered after the images have been imported as a way of organizing them, or the date when the image was taken. Click the More Information box to see additional data about a selected image.

Thumbnails can be sorted within a collection by choosing Sort Key from the View menu, and selecting Name, Modified Date, File Size, Extension, or Custom as the parameters to sort the files by. Use Custom to sort your photos manually with the mouse, say, to arrange your favorites first in the collection.

Select a collection or folder of images and click the Slide Show button on the PictureProject toolbar to view a series of images, one after another.

Although PictureProject automatically loads pictures it transfers into collections, you can also add photos already residing on your hard drive by choosing Import Assistant from the Tools menu.

7.5 Organize your photos into collections.

More Information (1 images)

General | Photo Information | Additional Information (IPTC fields)

```
Nikon D70
2004/08/17 14:07:53.1
JPEG (8-bit) Basic
Image Size:  Large (2000 x 3008)
Lens: 28-200mm F/3.5-5.6 G
Focal Length: 200mm
Exposure Mode: Shutter Priority
Metering Mode: Multi-Pattern
1/200 sec - F/9
Exposure Comp.: 0 EV
Sensitivity: ISO 200
Optimize Image: Vivid
White Balance: Auto
AF Mode: AF-S
Flash Sync Mode: Not Attached
Color Mode: Mode IIIa (sRGB)
Tone Comp: Auto
Hue Adjustment: 0°
Saturation: Normal
Sharpening: Auto
Image Comment: (c)2004 David D. Busch
Noise Reduction: OFF
```

OK | Cancel | Apply

7.6 View additional information.

Retouching pictures

PictureProject has some limited picture retouching features that you might find handy if you are in a hurry or aren't inclined to become heavily involved in image editing. For more-serious editing, you'll probably be happier with a program like Adobe Photoshop Elements, Photoshop (for both Mac and Windows), or PaintShop Pro (Windows only). PictureProject locates your other editing programs when it is installed and places links to them in the File Menu under Edit Using Other Programs.

To edit in PictureProject, double-click any photo in a collection, or select a photo and click the Edit button at the right side of the PictureProject window. You can choose from the following functions:

✦ Click the Auto Enhance button, and PictureProject will make its best effort to automatically fix the brightness, color saturation, and sharpening for the image.

✦ Click the Auto Red-Eye button to automatically remove demon red eyes from pictures of people.

✦ In the Photo Enhance section, mark the Brightness, Color Booster (Saturation), or Sharpening check boxes, then use the slider and options offered for each to make the adjustments manually.

✦ Click one of the tool buttons immediately above the editing preview

window to rotate the image, move it around, zoom in or out, crop, or remove red-eye manually.

Sharing pictures

PictureProject also has functions for sharing your photos. These include:

✦ Printing one or a selection of photos from a collection.

✦ Sending one or more photos by e-mail using Outlook, Outlook Express, Eudora (Windows) or Entourage X, Mail, or Eudora (Mac).

✦ Arranging photos into a layout for printing or e-mailing.

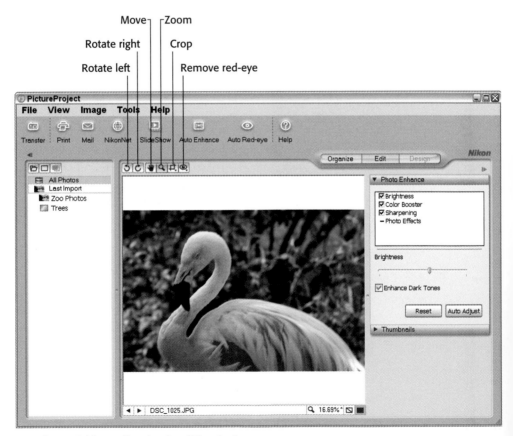

7.7 PictureProject offers basic editing features.

NikonNet Publishing Preview ✕

1 Photos

DSC_1025.JPG

Caption

My Favorite Flamingo

Keywords

flamingo zoo pink

◀ 1 of 1 ▶

Description

Originally a resident of Six Flags Worlds of
Adventure, this Flamingo was donated to the
Akron Zoo when the amusement park was

Options (Applied to all Uploaded Images)

Dimensions:

Original

(images will not be enlarged)

JPEG Quality: Good Balance

☐ Don't show this dialog again

OK Cancel

Hide Details

7.8 NikonNet can host your best images for sharing.

✦ Uploading pictures to www.
nikon-image.com (Nikon.net) for
viewing by friends, family, and col-
leagues. Web site membership is
free, and you get 50MB of free
online storage space. You'll be able
to add a title, keywords, and basic
information about images
uploaded, as well as choose the
JPEG compression level (to set a
trade-off between quality and
download times).

✦ Copying pictures to a PDA that
supports photo display.

Nikon Capture 4

Nikon Capture 4 is a considerably more
sophisticated application and not an essen-
tial for every D70 user, which is why Nikon
makes it an optional tool with a $99 price

tag. It's optional because two of its three
main functions — image transfer/conversion
and image editing — can be performed with
equal facility using other programs, such as
PictureProject (transfer), Photoshop (editing
and RAW conversion) or Bibble Pro (for con-
verting files from RAW format). The third
function is to communicate directly with the
D70 in advanced ways, for example to con-
trol the camera for automatic time-lapse
photography or to upload custom tonal
compensation curves from your computer
to the camera.

Best of all, Capture can operate on batches
of files, so you can apply many types of
changes to groups of pictures automatically.
That's especially handy when you need to,
for example, convert an entire group of NEF
files to TIFF format.

Here's an overview of its key features.

Transfer/RAW conversion

Nikon Capture can import RAW/NEF images and save them in a standard format such as TIFF, either using the original settings from the camera file or fine-tuned settings for things like sharpening, tonal compensation, color mode, color saturation, white balance, or noise reduction.

Capture also has an "image dust off" feature for subtracting dust spots caused by artifacts that have settled on the sensor. Just take a *dust reference photo* — a blank exposure that Capture uses for reference — and the application will subtract the dust in the exact same location in subsequent images that are imported.

Image editing

Once you get past the fine-tuning controls available when converting RAW files, Nikon Capture isn't much more sophisticated than PictureProject in its image-editing capabilities. Photos can be rotated, cropped, zoomed, and given an automatic brightness or color saturation adjustment. The biggest improvement is the LCH Editor, which gives you access to correction curves for lightness, chroma, and hue components of an image. It also lets you transfer a selected image to another program, such as Photoshop.

Where this editor really shines, however, is in its facilities for correcting certain lens defects, such as vignetting and fish-eye

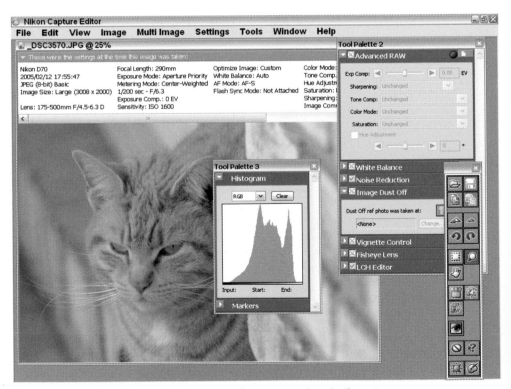

7.9 Image conversion and fine-tuning are the strong suits of Nikon Capture.

distortion. For example, some lenses are known for producing images that are darker in the corners; Nikon Capture can correct for this tendency or add darkness or lightness if you want them as a special effect.

Owners of the Nikkor 10.5mm fish-eye lens absolutely love Nikon Capture's capability for "defishing" these images, creating a rectangular, rectilinear photo from the original round fish-eye rendition.

Camera communications

Nikon Capture's Camera Control Module lets you communicate with your D70 in powerful ways. For example, you can control the camera remotely when it's connected to your computer using a USB cable. Perhaps you've set up a hummingbird feeder outside your home-office window and you want to mount your D70 on a tripod near the feeder and trip the shutter from your computer as you keep one eye on the feeder as you work. You can't preview the image before you take it, of course (no digital SLR allows you to do that), but you can control virtually every camera feature right from your workstation. (Notice the viewfinder LED readout at the bottom of figure 7-10.

The Camera Control Module also lets you change settings, including those that are clumsy to enter using the camera controls alone, such as the image comment appended to every photo. You can also upload custom exposure curves to change the tonal rendition the camera uses (in the Shooting Menu's Optimize Image ⇨ Custom choice).

7.10 Control your camera from your computer!

Perhaps the most interesting capability is the Time Lapse facility, which allows you to take a series of pictures at intervals that range from seconds to days. Replace that hummingbird feeder with a flower bud just about to blossom, and you can capture every fleeting moment. Choose from 2 to 9,999 shots (luckily, each photo is stored directly to your hard drive, and not to the camera's memory card), and a delay from 1 second to 99 hours, 59 minutes, and 59 seconds between shots. You can even bracket exposure or white balance between pictures. If you're shooting a very long time-lapse sequence, it's a good idea to use the D70's optional AC power supply; direct connection through the USB cable uses more juice than untethered shooting anyway, so your battery may poop out before your sequence is finished.

Time Lapse Photography ☒

☑ Autofocus before each shot

☐ Keep shooting until cancelled

Shots: 4

Delay: 0 Hours 0 Minutes 10 Seconds

☐ Process images before saving (Live Batch)

☑ Auto Bracketing Set BKT...

Start Cancel Help

7.11 Shoot time-lapse sequences using your D70.

Other Software Options

You'll find that image editors and RAW file utilities are available from a wide range of suppliers and can cost you nothing (in the case of IrfanView), or be included in the cost of other software (which is the case with Photoshop). Alternatively, you can pay $129 for a sophisticated utility like Bibble Professional, or as much as $500 for a top-of-the-line program like PhaseOne's Capture One Pro (C1 Pro).

Software to consider includes:

✦ **IrfanView:** This freeware Windows-only program can be downloaded at www.irfanview. com. It can read many common RAW photo formats, including Nikon's, and provides a quick way to view RAW files, just by dragging and dropping to the application's window. You can crop, rotate, or correct your image, do some cool

things like swapping the colors around (red for blue, blue for green, and so forth) to create false color pictures.

✦ **Phase One Capture One Pro (C1 Pro):** This premium-priced RAW converter program does everything, but there are reduced-function versions for those who don't need such a flexible application, called Capture One dSLR, and Capture One dSLR SE. Available for both Windows and Mac OS X, it offers special noise reduction controls, a quick develop option that allows speedy conversion from RAW to TIFF or JPEG formats, dual-image side-by-side views for comparison purposes, and helpful grids and guides that can be superimposed over an image. www.phaseone.com.

✦ **Bibble Pro:** This utility offers instantaneous previews and real-time feedback as changes are made. That's important when you have to convert many images in a short time using Bibble's batch processing capabilities to process large numbers of files using custom settings with no user intervention. You can even create a Web gallery from within Bibble. www. bibblelabs.com.

✦ **Photoshop/Photoshop Elements:** Photoshop is the serious photographer's number-one choice for image editing, and Elements is an excellent option for those who need most of Photoshop's power, but not all of its professional-level features. Both use the latest version of Adobe's Camera Raw plug-in, which makes it easy to adjust things like color

space profiles, color depth (either 8 bits or 16 bits per color channel), image resolution, white balance, exposure, shadows, brightness, sharpness, luminance, and noise reduction. www.adobe.com.

✦ **Corel PhotoPaint:** This is the image-editing program that is included in the popular CorelDRAW Graphics suite. Various versions of this program are available for both PCs and the Mac. It's a full-featured photo retouching and image-editing program with selection, retouching, and painting tools for manual image manipulations and also includes convenient automated commands for a few common tasks, such as red-eye removal. PhotoPaint accepts Photoshop plug-ins to expand its assortment of filters and special effects. www.corel.com.

✦ **Jasc Paint Shop Pro:** This is a general-purpose image editor that has gained a reputation as the "poor man's Photoshop" for providing a substantial portion of Photoshop's capabilities at a fraction of the cost. It includes a nifty set of wizard-like commands that automate common tasks, such as removing red eye and scratches, as well as filters and effects, which can be expanded with other Photoshop plug ins. www.jasc.com.

✦ **Macromedia Fireworks:** This is the image-editing program originally from Macromedia (recently purchased by Adobe) which specializes in Web development and animation software like Dreamweaver and Flash. If you're using your D70 images on Web pages, you'll like this program's

capabilities in the Web graphics arena, such as banners, image maps, and rollover buttons. www.macromedia.com.

✦ **Corel Painter:** Here's another image-editing program from Corel. This one's strength is in mimicking natural media, such as charcoal, pastels, and various kinds of paint. Painter includes a basic assortment of tools that you can use to edit existing images, but the program is really designed for artists to use in creating original illustrations. As a photographer, you might prefer another image editor, but if you like to paint on top of your photographic images, nothing else really does the job of Painter. www.corel.com.

✦ **Ulead PhotoImpact:** This is a general-purpose photo-editing program with a huge assortment of brushes for painting, retouching, and cloning in addition to the usual selection, cropping, and fill tools. If you frequently find yourself performing the same image manipulations on a number of files, you'll appreciate PhotoImpact's batch operations. Using this feature, you can select multiple image files and then apply any one of a long list of filters, enhancements, or auto-process commands to all the selected files. www.ulead.com.

✦ **Noise Ninja:** This program is among the best of a group of utilities that can process your Nikon D70's images to reduce the noise that results from shooting at high ISO ratings and long exposures. It uses a sophisticated approach that can identify and recognize noise that presents itself at different

frequencies, in various parts of your image, and in varying color channels. Unlike the D70's built-in noise reduction feature, Noise Ninja gives you control over how its algorithms are applied, using easy-to-operate sliders with real-time previews for feedback. There's also a "noise brush" you can apply to selectively modify the noise in those parts of the image where it's particularly troublesome. www.picturecode.com.

Glossary

additive primary colors The red, green, and blue hues which are used alone or in combinations to create all other colors that you capture with a digital camera, view on a computer monitor, or work with in an image-editing program, such as Photoshop. See also *CMY(K) color model*.

AE/AF lock A control that lets you lock the current autoexposure and/or autofocus settings prior to taking a picture, freeing you from having to hold the shutter release partially depressed, although you must depress and hold the shutter release partially to apply the feature.

ambient lighting Diffuse, non-directional lighting that doesn't appear to come from a specific source but, rather, bounces off walls, ceilings, and other objects in the scene when a picture is taken.

analog/digital converter The electronics built into a camera that convert the analog information captured by the sensor into digital bits that can be stored as an image bitmap.

angle-of-view The area of a scene that a lens can capture, determined by the focal length of the lens. Lenses with a shorter focal length have a wider angle-of-view than lenses with a longer focal length.

anti-alias A process that smoothes the look of rough edges in images (called *jaggies* or *staircasing*) by adding partially transparent pixels along the boundaries of diagonal lines that are merged into a smoother line by our eyes. See also *jaggies.*

aperture-preferred A camera setting that allows you to specify the lens opening or f-stop that you want to use, with the camera selecting the required shutter speed automatically based on its light-meter reading. See also *shutter-preferred.*

artifact A type of noise in an image, or an unintentional image component produced in error by a digital camera during processing, usually caused by the JPEG compression process in digital cameras.

aspect ratio The proportions of an image as printed, displayed on a monitor, or captured by a digital camera.

autofocus A camera setting that allows the D70 to choose the correct focus distance for you, usually based on the contrast of an image (the image will be at maximum contrast when in sharp focus) or a mechanism such as an infrared sensor that measures the actual distance to the subject. Cameras can be set for *single autofocus* (the lens is not focused until the shutter release is partially depressed) or *continuous autofocus* (the lens refocuses constantly as you frame and reframe the image).

autofocus assist lamp A light source built into a digital camera that provides extra illumination that the autofocus system can use to focus dimly lit subjects.

averaging meter A light-measuring device that calculates exposure based on the overall brightness of the entire image area. Averaging tends to produce the best exposure when a scene is evenly lit or contains equal amounts of bright and dark areas that contain detail. The D70 uses much more sophisticated exposure measuring systems, which are based in center-weighting, spot-reading, or calculating exposure from a matrix of many different picture areas. See also *center-weighted meter* and *spot meter.*

backlighting A lighting effect produced when the main light source is located behind the subject. Backlighting can be used to create a silhouette effect, or to illuminate translucent objects. See also *front lighting* and *sidelighting.*

barrel distortion A lens defect that causes straight lines at the top or side edges of an image to bow outward into a barrel shape. See also *pincushion distortion.*

blooming An image distortion caused when a photosite in an image sensor has absorbed all the photons it can handle, so that additional photons reaching that pixel overflow to affect surrounding pixels, producing unwanted brightness and overexposure around the edges of objects.

blur To soften an image or part of an image by throwing it out of focus, or by allowing it to become soft due to subject or camera motion. Blur can also be applied in an image-editing program.

bokeh A buzzword used to describe the aesthetic qualities of the out-of-focus parts of an image, with some lenses producing "good" bokeh and others offering "bad" bokeh. *Boke* is a Japanese word for "blur," and the *h* was added to keep English speakers from rhyming it with *broke.* Out-of-focus points of light become discs, called the *circle of confusion.* Some lenses produce a uniformly illuminated disc. Others, most notably mirror or catadioptic lenses, produce a disc that has a bright edge and a dark center, producing a "doughnut" effect, which is the worst from a bokeh standpoint. Lenses that generate a bright center that fades to a darker edge are favored, because their bokeh allows the circle of confusion to blend more smoothly with the surroundings. The bokeh characteristics of a lens are most important when you're using selective focus (say, when shooting a portrait) to deemphasize the background, or when shallow depth of field is a given because you're working with a macro lens, with a long telephoto, or with a wide open aperture. See also *circle of confusion.*

bounce lighting Light bounced off a reflector, including ceiling and walls, to provide a soft, natural-looking light.

bracketing Taking a series of photographs of the same subject at different settings, including exposure, color, and white balance, to help ensure that one setting will be the correct one. The D70 allows you to choose the order in which bracketed settings are applied.

buffer The digital camera's internal memory where an image is stored immediately after it is taken until it can be written to the camera's non-volatile (semi-permanent) memory or a memory card.

burst mode The digital camera's equivalent of the film camera's motor drive, used to take multiple shots within a short period of time.

calibration A process used to correct for the differences in the output of a printer or monitor when compared to the original image. Once you've calibrated your scanner, monitor, and/or your image editor, the images you see on the screen more closely represent what you'll get from your printer, even though calibration is never perfect.

Camera Raw A plug-in included with Photoshop and Photoshop Elements that can manipulate the unprocessed images captured by digital cameras, such as the D70's NEF files.

camera shake Movement of the camera, aggravated by slower shutter speeds, which produces a blurred image. Nikon offers several vibration reduction lenses that shift lens elements to counter this movement.

CCD See *charge-coupled device (CCD)*.

center-weighted meter A light-measuring device that emphasizes the area in the middle of the frame when calculating the correct exposure for an image. See also *averaging meter* and *spot meter.*

charge-coupled device (CCD) A type of solid-state sensor that captures the image. It is used in scanners and digital cameras, including the Nikon D70.

chromatic aberration An image defect, often seen as green or purple fringing around the edges of an object, caused by a lens failing to focus all colors of a light source at the same point. See also *fringing.*

circle of confusion A term applied to the fuzzy discs produced when a point of light is out of focus. The circle of confusion is not a fixed size. The viewing distance and amount of enlargement of the image determine whether we see a particular spot on the image as a point or as a disc. See also *bokeh.*

close-up lens A lens add-on that allows you to take pictures at a distance that is less than the closest-focusing distance of the lens alone.

CMOS See *complementary metal-oxide semiconductor (CMOS).*

CMYK color model A way of defining all possible colors in percentages of cyan, magenta, yellow, and frequently, black. (K represents black, to differentiate it from blue in the RGB color model.) Black is added to improve rendition of shadow detail. CMYK is commonly used for printing (both on press and with your inkjet or laser color printer).

color correction Changing the relative amounts of color in an image to produce a desired effect, typically a more accurate representation of those colors. Color correction can fix faulty color balance in the original

image, or compensate for the deficiencies of the inks used to reproduce the image.

complementary metal-oxide semiconductor (CMOS) A method for manufacturing a type of solid-state sensor that captures the image, used in scanners and digital cameras such as the Nikon D2X.

compression Reducing the size of a file by encoding, using fewer bits of information to represent the original. Some compression schemes, such as JPEG, operate by discarding some image information, while others, such as TIF, preserve all the detail in the original, discarding only redundant data.

continuous autofocus An automatic focusing setting (AF-C) in which the camera constantly refocuses the image as you frame the picture. This setting is often the best choice for moving subjects. See also *single autofocus.*

contrast The range between the lightest and darkest tones in an image. A high-contrast image is one in which the shades fall at the extremes of the range between white and black. In a low-contrast image, the tones are closer together.

dedicated flash An electronic flash unit, such as the Nikon SB-600 or SB-800, designed to work with the automatic exposure features of a specific camera.

depth of field A distance range in a photograph in which all included portions of an image are at least acceptably sharp. With the Nikon D70, you can see the available depth of field at the taking aperture by pressing the depth of field preview button, or estimate the range by viewing the depth of field scale found on many lenses.

diaphragm An adjustable component, similar to the iris in the human eye, which can open and close to provide specific-sized lens openings, or f-stops.

diffuse lighting Soft, low-contrast lighting.

digital processing chip A solid-state device found in digital cameras that's in charge of applying the image algorithms to the raw picture data prior to storage on the memory card.

diopter A value used to represent the magnification power of a lens, calculated as the reciprocal of a lens's focal length (in meters). Diopters are most often used to represent the optical correction used in a viewfinder to adjust for limitations of the photographer's eyesight, and to describe the magnification of a close-up lens attachment.

equivalent focal length A digital camera's focal length translated into the corresponding values for a 35mm film camera. This value can be calculated for lenses used with the Nikon D70 by multiplying by 1.5.

exchangeable image file format (Exif) Developed to standardize the exchange of image data between hardware devices and software. A variation on JPEG, Exif is used by most digital cameras, and includes information such as the date and time a photo was taken, the camera settings, resolution, amount of compression, and other data.

Exif See *exchangeable image file format (Exif).*

exposure The amount of light allowed to reach the film or sensor, determined by the intensity of the light, the amount admitted by the iris of the lens, and the length of time determined by the shutter speed.

exposure program An automatic setting in a digital camera that provides the optimum combination of shutter speed and f-stop at a given level of illumination. For example the D70's sports exposure program uses a faster, action-stopping shutter speed and larger lens opening instead of the smaller, depth of field-enhancing lens opening and slower shutter speed that might be favored by its close-up mode at exactly the same light level.

exposure values (EV) EV settings are a way of adding or decreasing exposure without the need to reference f-stops or shutter speeds. For example, if you tell your camera to add +1EV, it will provide twice as much exposure, either by using a larger f-stop, slower shutter speed, or both.

fill lighting In photography, lighting used to illuminate shadows. Reflectors or additional incandescent lighting or electronic flash can be used to brighten shadows. One common technique outdoors is to use the camera's flash as a fill.

filter In photography, a device that fits over the lens, changing the light in some way. In image editing, a feature that changes the pixels in an image to produce blurring, sharpening, and other special effects. Photoshop includes several interesting filter effects, including Lens Blur and Photo Filters.

flash sync The timing mechanism that insures that an internal or external electronic flash fires at the correct time during the exposure cycle. A digital SLR's flash sync speed is the highest shutter speed that can be used with flash, ordinarily 1/500 of a second with the Nikon D70. See also *front curtain sync* and *rear curtain sync*.

focal length The distance between the film and the optical center of the lens when the lens is focused on infinity, usually measured in millimeters.

focal plane An imaginary line, perpendicular to the optical access, which passes through the focal point forming a plane of sharp focus when the lens is set at infinity. A focal plane indicator is etched into the Nikon D70 at the lower-right corner of the top panel.

focus lock A camera feature that lets you freeze the automatic focus of the lens at a certain point, when the subject you want to capture is in sharp focus.

focus servo A digital camera's mechanism that adjusts the focus distance automatically. The focus servo can be set to single autofocus (AF-S), which focuses the lens only when the shutter release is partially depressed, and continuous autofocus (AF-C), which adjusts focus constantly as the camera is used.

focus tracking The ability of the automatic focus feature of a camera to change focus as the distance between the subject and the camera changes. One type of focus tracking is *predictive*, in which the mechanism anticipates the motion of the object being focused on, and adjusts the focus to suit.

fringing A chromatic aberration that pro duces fringes of color around the edges of subjects, caused by a lens's inability to focus the various wavelengths of light onto the same spot. Purple fringing is especially troublesome with backlit images.

front-curtain sync The default kind of electronic flash synchronization technique, originally associated with focal plane shutters, which consist of a traveling set of curtains,

including a *front curtain* (which opens to reveal the film or sensor) and a *rear curtain* (which follows at a distance determined by shutter speed to conceal the film or sensor at the conclusion of the exposure). For a flash picture to be taken, the entire sensor must be exposed at one time to the brief flash exposure, so the image is exposed after the front curtain has reached the other side of the focal plane, but before the rear curtain begins to move. Front-curtain sync causes the flash to fire at the beginning of this period when the shutter is completely open, in the instant that the first curtain of the focal plane shutter finishes its movement across the film or sensor plane. With slow shutter speeds, this feature can create a blur effect from the ambient light, showing as patterns that follow a moving subject with the subject shown sharply frozen at the beginning of the blur trail. See also *rear-curtain sync.*

front-lighting Illumination that comes from the direction of the camera. See also *backlighting* and *sidelighting.*

f-stop The relative size of the lens aperture, which helps determine both exposure and depth of field. The larger the f-stop number, the smaller the f-stop itself.

graduated filter A lens attachment with variable density or color from one edge to another. A graduated neutral density filter, for example, can be oriented so the neutral density portion is concentrated at the top of the lens's view with the less dense or clear portion at the bottom, thus reducing the amount of light from a very bright sky while not interfering with the exposure of the landscape in the foreground. Graduated filters can also be split into several color sections to provide a color gradient between portions of the image.

gray card A piece of cardboard or other material with a standardized 18-percent reflectance. Gray cards can be used as a reference for determining correct exposure or for setting white balance.

high contrast A wide range of density in a print, negative, or other image.

highlights The brightest parts of an image containing detail.

histogram A kind of chart showing the relationship of tones in an image using a series of 256 vertical bars, one for each brightness level. A histogram chart, such as the one the D70 can display during picture review, typically looks like a curve with one or more slopes and peaks, depending on how many highlight, midtone, and shadow tones are present in the image.

hot shoe A mount on top of a camera used to hold an electronic flash, while providing an electrical connection between the flash and the camera.

hyperfocal distance A point of focus where everything from half that distance to infinity appears to be acceptably sharp. For example, if your lens has a hyperfocal distance of 4 feet, everything from 2 feet to infinity would be sharp. The hyperfocal distance varies by the lens and the aperture in use. If you know you'll be making a grab shot without warning, sometimes it is useful to turn off your camera's automatic focus, and set the lens to infinity, or, better yet, the hyperfocal distance. Then, you can snap off a quick picture without having to wait for the lag that occurs with most digital cameras as their autofocus locks in.

image rotation A feature that senses whether a picture was taken in horizontal or vertical orientation. That information is

embedded in the picture file so that the camera and compatible software applications can automatically display the image in the correct orientation.

image stabilization A technology, called *vibration reduction* by Nikon, that compensates for camera shake, usually by adjusting the position of the camera sensor or lens elements in response to movements of the camera.

incident light Light falling on a surface.

International Standards Organization (ISO) A governing body that provides standards used to represent film speed, or the equivalent sensitivity of a digital camera's sensor. Digital camera sensitivity is expressed in ISO settings.

interpolation A technique digital cameras, scanners, and image editors use to create new pixels required whenever you resize or change the resolution of an image based on the values of surrounding pixels. Devices such as scanners and digital cameras can also use interpolation to create pixels in addition to those actually captured, thereby increasing the apparent resolution or color information in an image.

ISO See *International Standards Organization (ISO)*.

jaggies Staircasing effect of lines that are not perfectly horizontal or vertical, caused by pixels that are too large to represent the line accurately. See also *anti-alias*.

JPEG A lossy file format (short for *Joint Photographic Experts Group*) that supports 24-bit color and reduces file sizes by selectively discarding image data. Digital cameras generally use JPEG compression to pack more images onto memory cards. You can select how much compression is used (and, therefore, how much information is thrown away) by selecting from among the Standard, Fine, Super Fine, or other quality settings offered by your camera. See also *RAW.*

Kelvin (K) A unit of measure based on the absolute temperature scale in which absolute zero is zero; used to describe the color of continuous-spectrum light sources, and applied when setting white balance. For example, daylight has a color temperature of about 5500K, and a tungsten lamp has a temperature of about 3400K.

lag time The interval between when the shutter is pressed and when the picture is actually taken. During that span, the camera may be automatically focusing and calculating exposure. With digital SLRs like the Nikon D70, lag time is generally very short; with non-dSLRs, the elapsed time easily can be 1 second or more.

latitude The range of camera exposures that produces acceptable images with a particular digital sensor or film.

lens flare A feature of conventional photography that is both a bane and a creative outlet. It is an effect produced by the reflection of light internally among elements of an optical lens. Bright light sources within or just outside the field-of-view cause lens flare. Flare can be reduced by the use of coatings on the lens elements or with the use of lens hoods. Photographers sometimes use the effect as a creative technique, and Photoshop includes a filter that lets you add lens flare at your whim.

lighting ratio The proportional relationship between the amount of light falling on the subject from the main light and other lights, expressed in a ratio, such as 3:1.

lossless compression An image-compression scheme, such as TIFF, that preserves all image detail. When the image is decompressed, it is identical to the original version.

lossy compression An image-compression scheme, such as JPEG, that creates smaller files by discarding image information, which can affect image quality.

macro lens A lens that provides continuous focusing from infinity to extreme close-ups, often to a reproduction ratio of 1:2 (half life-size) or 1:1 (life-size).

matrix metering A system of exposure calculation that looks at many different segments of an image to determine the brightest and darkest portions.

midtones Parts of an image with tones of an intermediate value, usually in the 25 to 75 percent range. Many image-editing features allow you to manipulate midtones independently from the highlights and shadows.

mirror lock-up The ability to retract the SLR's mirror to reduce vibration prior to taking the photo (with some cameras), or, with the Nikon D70, to allow access to the sensor for cleaning.

NEF (Nikon Electronic File) Nikon's name for its proprietary RAW format.

neutral color A color in which red, green, and blue are present in equal amounts, producing a gray.

neutral density filter A gray camera filter reduces the amount of light entering the camera without affecting the colors.

noise In an image, pixels with randomly distributed color values. Noise in digital photographs tends to be the product of low-light conditions and long exposures, particularly when you've set your camera to a higher ISO rating than normal.

noise reduction A technology used to cut down on the amount of random information in a digital picture, usually caused by long exposures at increased sensitivity ratings. In the Nikon D70, noise reduction involves the camera automatically taking a second blank/dark exposure at the same settings that contains only noise, and then using the blank photo's information to cancel out the noise in the original picture. Although the process is very quick, it does double the amount of time required to take the photo.

normal lens A lens that makes the image in a photograph appear in a perspective that is like that of the original scene, typically with a field-of-view of roughly 45°.

overexposure A condition in which too much light reaches the film or sensor, producing a dense negative or a very bright/light print, slide, or digital image.

pincushion distortion A type of lens distortion in which lines at the top and side edges of an image are bent inward, producing an effect that looks like a pincushion. See also *barrel distortion.*

polarizing filter A filter that forces light, which normally vibrates in all directions, to vibrate only in a single plane, reducing or removing the specular reflections from the surface of objects.

RAW An image file format, such as the NEF format in the Nikon D70, which includes all the unprocessed information captured by the camera. RAW files are very large compared to JPEG files and must be processed

by a special program such as Nikon Capture or Adobe's Camera Raw filter after being downloaded from the camera.

rear-curtain sync An optional kind of electronic flash synchronization technique, originally associated with focal plane shutters, which consist of a traveling set of curtains, including a *front curtain* (which opens to reveal the film or sensor) and a *rear curtain* (which follows at a distance determined by shutter speed to conceal the film or sensor at the conclusion of the exposure). For a flash picture to be taken, the entire sensor must be exposed at one time to the brief flash exposure, so the image is exposed after the front curtain has reached the other side of the focal plane, but before the rear curtain begins to move. Rear-curtain sync causes the flash to fire at the end of the exposure, an instant before the second or rear curtain of the focal plane shutter begins to move. With slow shutter speeds, this feature can create a blur effect from the ambient light, showing as patterns that follow a moving subject with subject shown sharply frozen at the end of the blur trail. If you were shooting a photo of The Flash, the superhero would appear sharp, with a ghostly trail behind him. See also *front-curtain sync.*

red-eye An effect from flash photography that appears to make a person's eyes glow red, or an animal's yellow or green. It's caused by light bouncing from the retina of the eye and is most pronounced in dim illumination (when the irises are wide open) and when the electronic flash is close to the lens and, therefore, prone to reflect directly back. Image editors can fix red-eye through cloning other pixels over the offending red or orange ones.

RGB color model A color model that represents the three colors — red, green, and blue — used by devices such as scanners or monitors to reproduce color. Photoshop works in RGB mode by default, and even displays CMYK images by converting them to RGB.

saturation The purity of color; the amount by which a pure color is diluted with white or gray.

selective focus Choosing a lens opening that produces a shallow depth of field. Usually this is used to isolate a subject by causing most other elements in the scene to be blurred.

self-timer A mechanism that delays the opening of the shutter for some seconds after the release has been operated.

sensitivity A measure of the degree of response of a film or sensor to light, measured using the ISO setting.

shadow The darkest part of an image, represented on a digital image by pixels with low numeric values.

sharpening Increasing the apparent sharpness of an image by boosting the contrast between adjacent pixels that form an edge.

shutter In a conventional film camera, the shutter is a mechanism consisting of blades, a curtain, plate, or some other movable cover that controls the time during which light reaches the film. Digital cameras, including the Nikon D70, use actual mechanical shutters for the slower shutter speeds (less than 1/500 second) and an electronic shutter for higher speeds.

shutter-preferred An exposure mode in which you set the shutter speed and the camera determines the appropriate f-stop. See also *aperture-preferred.*

sidelighting Applying illumination from the left or right sides of the camera. See also *backlighting* and *front lighting*.

single autofocus Mode in which the camera seeks focus once when the shutter button is partially depressed, then locks it in until the button is pressed all the way, or released.

slave unit An accessory flash unit that supplements the main flash, usually triggered electronically when the slave senses the light output by the main unit, or through radio waves.

slow sync An electronic flash synchronizing method that uses a slow shutter speed so that ambient light is recorded by the camera in addition to the electronic flash illumination. This allows the background to receive more exposure for a more realistic effect.

specular highlight Bright spots in an image caused by reflection of light sources.

spot meter An exposure system that concentrates on a small area in the image. See also *center-weighted meter* and *averaging meter*.

subtractive primary colors Cyan, magenta, and yellow, which are the printing inks that theoretically absorb all color and produce black. In practice, however, they generate a muddy brown, so black is added to preserve detail (especially in shadows). The combination of the three colors and black is referred to as CMYK. (K represents black, to differentiate it from blue in the RGB model.)

through the lens (TTL) A system of providing viewing and exposure calculation through the actual lens taking the picture.

time exposure A picture taken by leaving the shutter open for a long period, usually more than 1 second. The camera is generally locked down with a tripod to prevent blur during the long exposure.

time lapse A process by which a tripod-mounted camera takes sequential pictures at intervals, allowing the viewing of events that take place over a long period of time, such as a sunrise or flower opening. With the D70, time-lapse photography is accomplished by connecting the camera to a computer with the USB cable and triggering the pictures with Nikon Capture.

tungsten light Light from ordinary room lamps and ceiling fixtures, as opposed to fluorescent illumination.

underexposure A condition in which too little light reaches the film or sensor, producing a thin negative, a dark slide, a muddy-looking print, or a dark digital image.

unsharp masking The process for increasing the contrast between adjacent pixels in an image, increasing sharpness, especially around edges.

vignetting Dark corners of an image, often produced by using a lens hood that is too small for the field-of-view, a lens that does not completely fill the image frame, or generated artificially using image-editing techniques.

white balance The adjustment of a digital camera to the color temperature of the light source. Interior illumination is relatively red; outdoor light is relatively blue. Digital cameras often set correct white balance automatically or let you do it through menus. Image editors can often do some color correction of images that were exposed using the wrong white balance setting.

Index

Continued

Continued